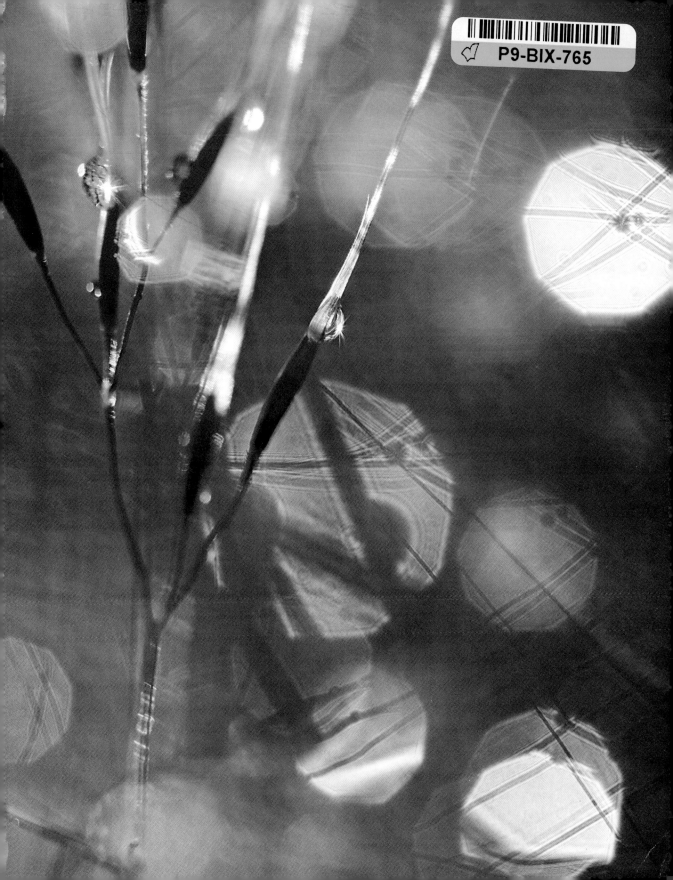

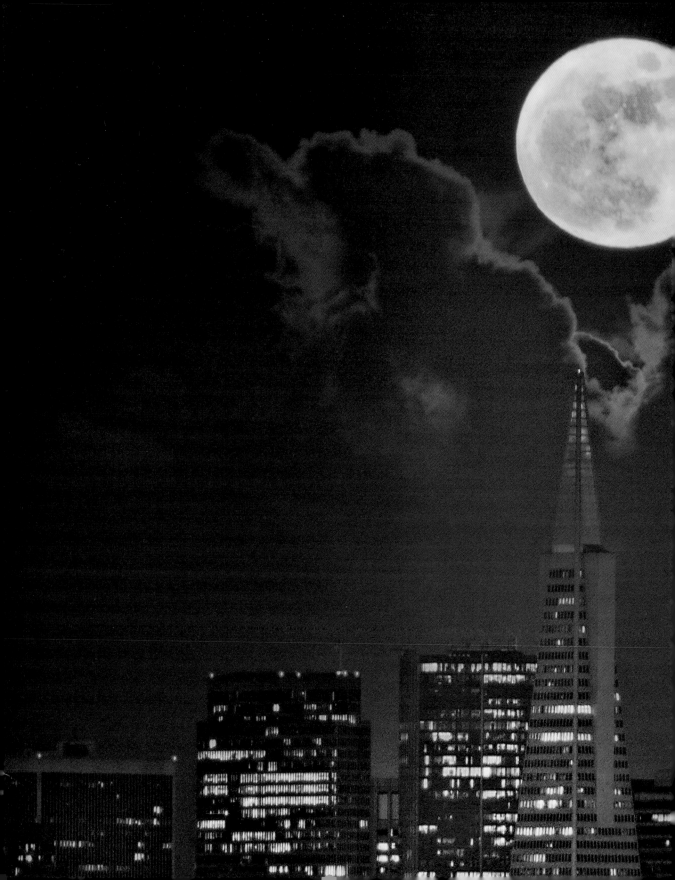

Creative Lighting

Digital Photography Tips & Techniques

Harold Davis

WILEY

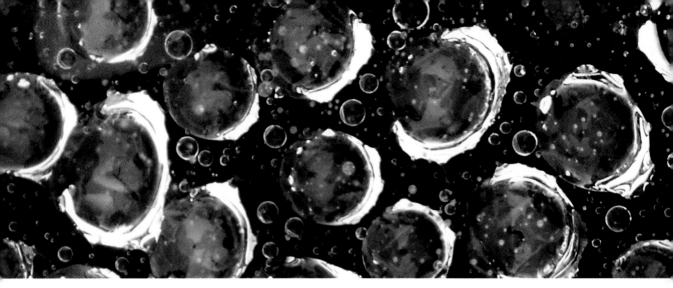

Creative Lighting: Digital Photography Tips & Techniques
by Harold Davis

Published by
Wiley Publishing, Inc.
10475 Crosspoint Boulevard
Indianapolis, IN 46256
www.wiley.com

ISBN: 978-0-470-87823-1

Manufactured in the United States of America

10 9 8 7 6 5 4 3 2 1

For general information on our other products and services or to obtain technical support, please contact our Customer Care Department within the U.S. at (800) 762-2974, outside the U.S. at (317) 572-3993 or fax (317) 572-4002.

Wiley also publishes its books in a variety of electronic formats. Some content that appears in print may not be available in electronic books.

Library of Congress Control Number: 2011920610

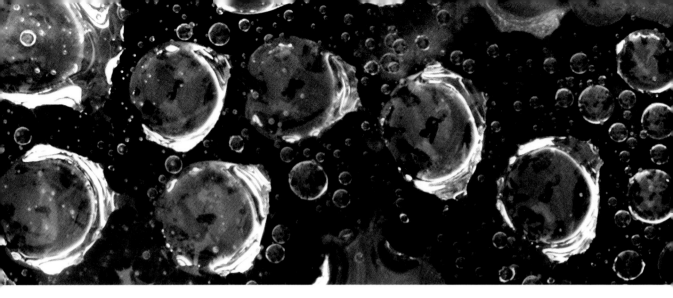

Acknowledgements

Special thanks to Courtney Allen, Graham Bird, Mark Brokering, Steven Christenson, Gary Cornell, Barry Pruett, Sandy Smith, and Matt Wagner.

Credits

Acquisitions Editor: Courtney Allen

Project Editor: Matthew Buchanan

Technical Editor: Chris Bucher

Copy Editor: Matthew Buchanan

Editorial Manager: Robyn Siesky

Business Manager: Amy Knies

Senior Marketing Manager: Sandy Smith

Vice President and Executive Group Publisher: Richard Swadley

Vice President and Publisher: Barry Pruett

Book Designer: Phyllis Davis

Media Development Project Manager: Laura Moss

Media Development Assistant Project Manager: Jenny Swisher

▲ Front piece: On my belly in wet grass, I pointed a telephoto macro lens directly at the rising sun, captured through the blades of grass and water drops. I intentionally used shallow focus to emphasize the refractions created by the sunlight.
200mm macro, 1/640 of a second at f/5 and ISO 100, tripod mounted

▲ Title page: To get the lighting right, I combined an exposure of the rising full moon with a longer exposure (to let more light in) of the San Francisco skyline.
400mm, 2 combined exposures at 1/30 of a second and 1/2 of a second, each exposure at f/5.6 and ISO 400, tripod mounted

▲ Above: The lighting was perfect on these water drops caught in a spider's web in the sunshine following a brief shower.
200mm macro lens, 24mm extension tube, close-up filter, 1/2 of a second at f/32 and ISO 200, tripod mounted

▼ Page 6: To bring out the drama inherent in this model's eyes and hair, I posed her so that her face was in the lighting but the background disappeared into dark shadows.
200mm, 1/160 of a second at f/5.6 and ISO 100, hand held

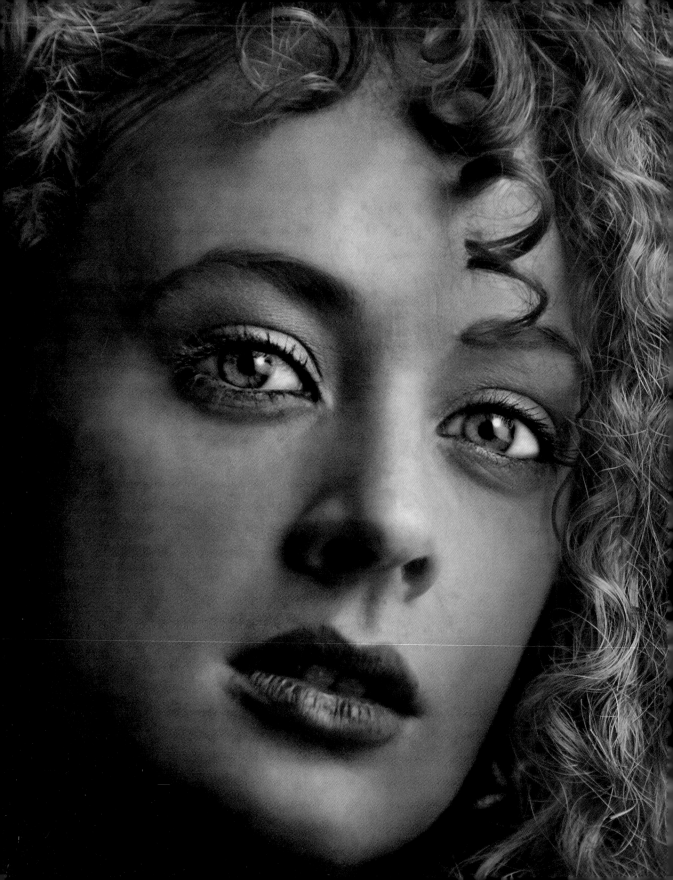

Contents

Introduction

Without light there is no photography. By using the gerund—"lighting" rather than light—an active role is implied: to some extent the photographer is involved in creating, manipulating or engineering the light used to create the photo.

In fact, active intervention by a photographer who manipulates or creates light varies on a spectrum from none to complete. For example, a photographer who creates a landscape may leave the lighting up to weather and chance circumstance. In this passive scenario, the photographer chooses moment, position, lens and camera setting—but the rest is left to nature.

At the other extreme, in the context of studio photography, the photographer completely creates an environment and set, as well as the lighting that will be used to illuminate it.

In between these extremes is the photographer who takes advantage of ambient lighting but adds some light of their own—or who improvises a combination of natural sunlight and artificial light to create a masterful still life or portrait.

It's a strange thing, but no matter how active the photographer is in creating light used in an image, the most crucial skill for the photographer is the ability to accurately and creatively observe light. Without encouraging and training this talent, all types of photographers—whether they shoot in the natural landscape using ambient light or in the studio with artificial illumination—will not be able to master lighting. If you cannot deeply feel and see the impact of lighting, you can't effectively use or modify lighting in your work—and you will not be the best photographer you can be.

With this in mind, *Creative Lighting: Digital Photography Tips & Techniques* starts with some ideas about how to nurture your talent for observing light. Note that this concern is pragmatic: I care about the impact of light on a photo, not light as a wave or light from the viewpoint of a physicist.

Lighting in a photo involves not only the illumination cast upon a scene but also the exposure settings used to capture that scene. I'll explain the variables in this exposure equation so that you'll understand how to use your camera to best respond to the light you observe.

Next, I'll show you how to best use lighting in the natural world. How can you take advantage of—and possibly modify and improve—ambient and directional lighting? And, how can you modify or manipulate existing lighting to get great creative images?

In the studio, the lights used for still life compositions generally give out continuous light. I'll show you how to master creative still life effects that involve transparency, reflectivity, shadow play, and more.

In contrast to the continuous lights used in still life work, the strobes used to capture people and motion produce short bursts of extremely intense light. I'll explain the

basics of studio strobe lighting—and show you how to create some great figure study and portrait lighting effects.

You can completely change the lighting of a photo in post-processing using software such as Adobe Photoshop. The extent of flexibility regarding lighting in the digital darkroom would have been unimaginable only a few short years ago. The final section of the book shows you how to use Photoshop to enhance the lighting in your photos.

My hope in *Creative Lighting* is to be your companion and guide by providing inspiration, ideas, and techniques as we work together to create photos that are masterfully lit—enjoy!

Best wishes in photography,

Harold Davis

▶ I used a polarizing filter to help emphasize the refractions created by lighting through a glass of water, with an apple and a pear positioned behind the glass.

200mm, circular polarizer, 10 seconds at f/32 and ISO 100, tripod mounted

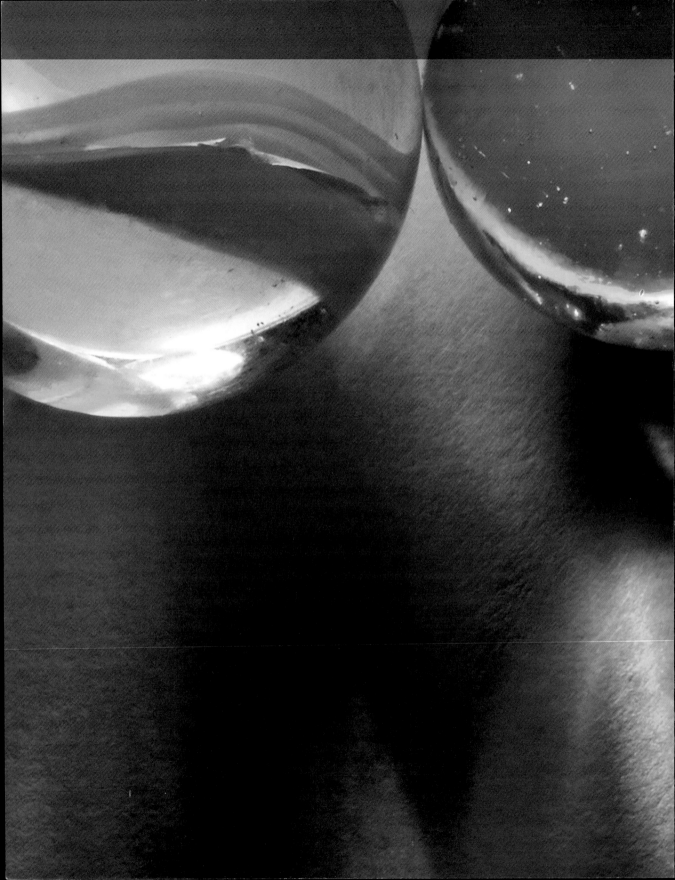

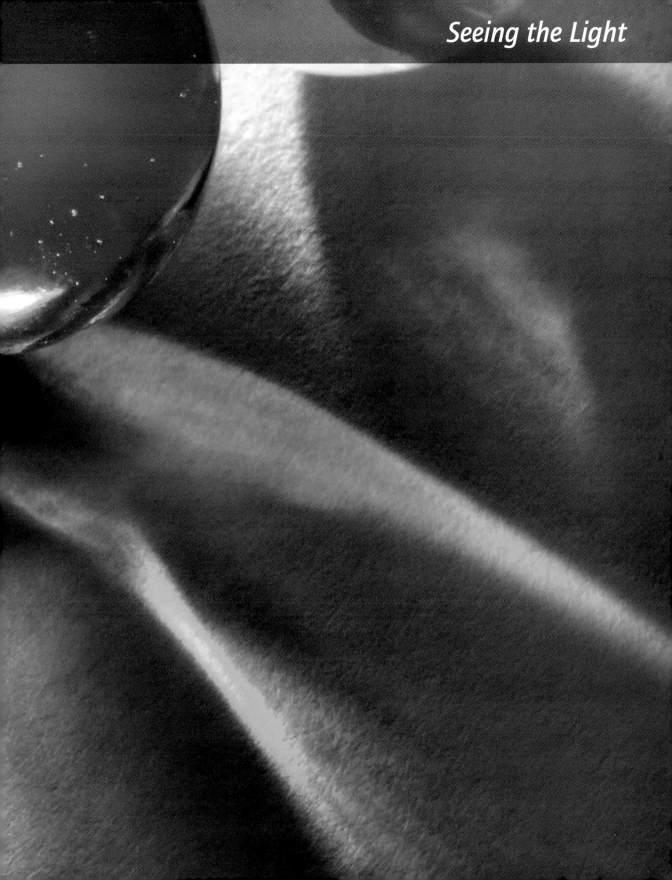

Quality of Light

Without light there is no photograph. But light bears a more important and subtle relationship to photography than this statement of absolutes suggests. In fact, the quality of light makes or breaks a photo across a wide range of potential subjects. No matter what the subject matter, when the photographer creatively and perceptively sees and captures light, then great photos are possible. But humdrum and ordinary use of light leads to boring and ordinary imagery.

Since you are reading this book, you probably agree that the quality of light is very important to good photography. Actually, I think it would be hard not to agree. But this assessment leads to more questions: What is this mysterious concept of "quality" associated with light? For that matter, what is this mysterious substance "light?"

Understanding Light

Anything you can see is a source of light, unless it is completely black. Otherwise, the world around us would be invisible. Things you can see are either transmitting light sources—for example, the sun, a light bulb, or a strobe—or are reflective light sources. A reflective light source is essentially anything that doesn't itself generate the light; if you shine a light on a model, and use this lighting for a photo, the model is a reflective light source.

In fact, we don't actually *see* things. If you stop to think about it for a moment, you'll realize that for an object to be visible it must be illuminated. What you are actually seeing is light creating apparent contours, shapes, colors, and so on. Light caresses objects to make them visible, so we think we see them—but we are actually interpreting the action of light in our minds (or cameras) rather than looking at objects themselves, and none of this would be possible without light.

Without us being consciously aware of it, our brains are continuously decoding the electromagnetic radiation that reaches our retinas and using this information to provide us with our "pictures" of the world—often with powerful emotional impact solely based on the perceived lighting.

▶ In creating this photo, I purposely underexposed the image because I realized that the point of the image was to show the light on the model's back—and that any other elements were extraneous. I used subdued side lighting, and worked hard to position the model and lights to create a sculptural effect.

48mm, 1/160 of a second at f/14 and ISO 200, hand held

▲ Pages 10-11: To create this studio shot of marbles, I put the marbles on a sheet of white paper and used a strong tungsten light to create intense and colorful shadows. This continuous light was positioned behind the marbles and beamed through them with the idea of making colorful shadows using backlighting.

200mm macro, 8 seconds at f/36 and ISO 100, tripod mounted

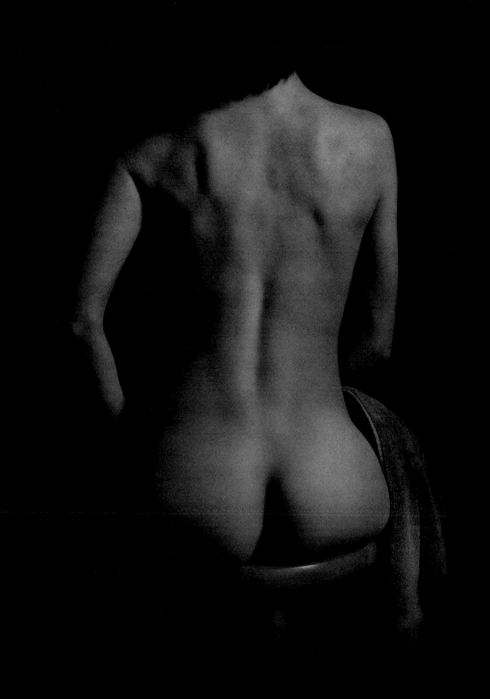

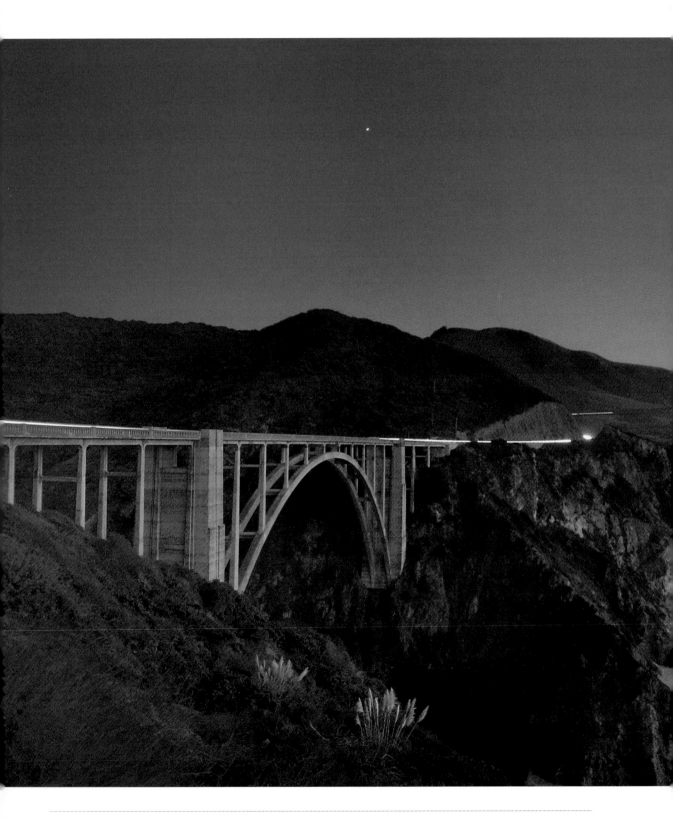

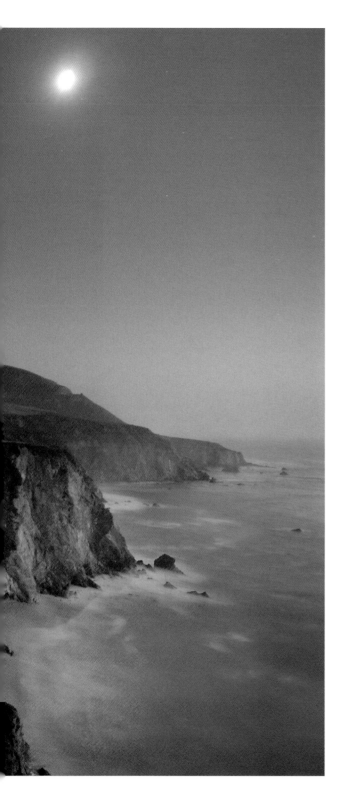

Light itself is not a substance in the normal way we think of things. Instead, it consists of waves of electromagnetic radiation. As these waves "wash" over and around objects over time, we (and our cameras) are able to create a visual impression of the objects that are illuminated.

Usually, this impression is created almost instantaneously—because light moves very quickly, and because the visual processing handled by our brains takes place mostly at a speed faster than conscious thought. But when cameras are involved, things slow down to the camera's shutter speed range, or to the pulse of a strobe if studio lighting is used.

It's important to note that in the context of photography time is always involved in lighting—whether it is the brief fraction of a second needed to light a landscape or studio scene or the hours needed to capture a dark landscape at night. An object is illuminated by waves of light energy over time—although the amount of time may be very short indeed.

The statement that "anything you can see is a source of light" is an oversimplification—particularly in the digital era—because there are energy waves close in frequency to visible light that our camera sensors can capture but we cannot see. In normal usage, light means electromagnetic waves on a spectrum—a

◄ The light as twilight turns to night often has very special characteristics, as you can see in this image of the Big Sur, California. Colors are rosy, and shapes are soft, but there is still enough light so that the shapes in the landscape are distinct.

The fairly long exposure (30 seconds) involves enough time so that the lights from objects in motion—such as the car headlights—are rendered in a path rather than in the crisp snapshot view that we are more used to.

12mm, 30 seconds at f/5.6 and ISO 100, tripod mounted

wavelength—that is visible to the human eye, but to scientists light can also mean electromagnetic waves on parts of this spectrum that are not visible to us.

If you can see something, it is certainly a source of reflective or transmitted visible light—but there are other sources of "near light" that our cameras can pick up and use in photographic imaging. Taking advantage of illumination from energy sources beyond the visible spectrum tends to only be important to a few specialized areas of photography, such as infrared and night photography (see pages 150-157). But it's important to realize that there are some sources of "light" that you may not be able to see—but your camera can.

Characteristics of Light

With the understanding that light itself is an electromagnetic wave, that people and objects only appear real if they are illuminated by light, and that time is always involved in photographic lighting, it's appropriate to give some thought to understanding what makes the elusive *quality of light* that is so essential to photography.

First, light quality is no one thing, no single effect or setting. Photographs in which the quality of light differ greatly in many important characteristics can each be said to have excellent quality of light. For example, an image with strong and harsh light might be a spectacular character study, while a delicate close-up might require subdued, subtle, and diffuse light. So there's no one-size-fits-all answer to what makes high-quality lighting, and it always depends upon the context. This implies that in thinking about light and lighting one should try to understand the palette of available options.

Since the lighting in a photo largely controls the mood and emotions that the image communicates, your understanding of the quality of light needs to take place at least partially at a gut or emotional level. You can spend your life parsing out the technical factors that go into lighting—and knowing these are a good thing—but knowing them cold won't lead to something more important. The ability to use lighting to manipulate the emotions of people looking at your images is an invaluable skill.

From the viewpoint of physics, a light wave has a number of properties. The most important of these are intensity, meaning the strength of the light (see pages 22-27), and the wavelength, which corresponds to the color temperature, or perceived color of the light source (see pages 34-39 and 102-107).

As I've noted, a light source is either transmitting light or reflecting light. It's very different photographing into the sun as compared with photographing something lit by the sun. This is the distinction between light transmission and reflectivity. Reflectivity is explained further on pages 52-55 and 186-189.

When I evaluate light and lighting, besides intensity and reflectivity, I try to understand a number of factors:

- The direction of light (pages 28 33)

- The color of the light (pages 34-39) and whether it is diffuse or harsh (pages 40-43)

- Whether my intentions are to create a dark or light image (pages 46-49)

- Whether transparency plays a role in the image (pages 56-59 and 178-181)

- The importance of strong shadows to the photo I have in mind (pages 60–63 and 182–185)

If I've pre-visualized a black and white photo, then I need to consider the impact of lighting on my monochromatic rendition (see pages 64–67).

It's worth noting that pre-visualization is an important part of understanding the quality of lighting. (For more on pre-visualizing the impact of lighting, see pages 108–111). Ultimately, I rely on my sense of what shifting a choice in lighting will do to inform the actual changes I make—so it is important to develop your skills relating to pre-visualization.

Justice Potter Stewart of the United States Supreme Court famously noted that he couldn't easily define obscenity, but he knew it when he saw it. The same thing is true about great photographic lighting. You won't necessarily be able to put your finger on why the lighting is great for a particular photo, but if you work to better understand lighting and hone your pre-visualization skills, you will come to know it when you see it—and become able to deliver great quality of lighting in your images.

▼ It rained overnight and then stopped. There were clouds overhead, but the day was getting bright. I hurried out with my camera because I knew that diffuse lighting from a bright but overcast sky can lead to stunningly soft and sensuous flower imagery, as in this early morning image of an iris.

200mm macro, 1/125 of a second at f/16 and ISO 100, tripod mounted

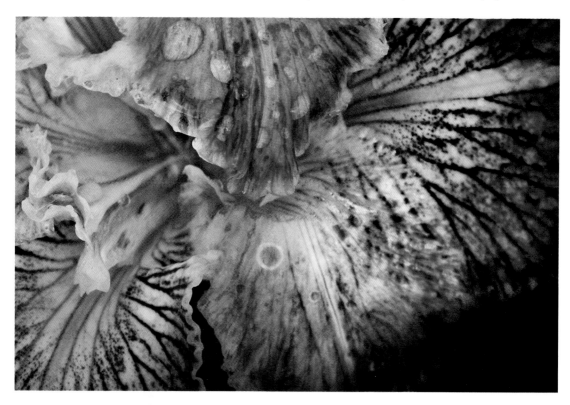

The Golden Hour

It is hard to define great lighting—and good quality of light differs from photographic situation to situation. However, there's one kind of lighting that almost always produces good results: photographs taken outdoors during the so-called "golden hour."

Depending upon who you talk to, atmospheric conditions, time of year, and your geographic location, golden hour lighting extends before and after sunrise and sunset, perhaps about an hour in either direction. This time of great lighting lasts longer at sunset than it does at sunrise. I've heard a quip from professional location photographers that they could photograph at sunrise, go to sleep for the bulk of the day, and wake to photograph at sunset—there's not much point working outdoors at any other times.

What makes golden hour lighting so great? To answer this question it makes sense to carefully observe what happens to the lighting at sunset. Colors get yellower and redder as the color temperature becomes warmer. Things seem more heavily saturated. As the sun hits the horizon line, the quality of the light becomes more diffuse due to haze and atmospheric distortion. At the same time, the light stays intense and strong until the sun has literally set.

These are qualities to emulate if you are creating light wholly or partially by artificial means—warm, diffuse, and strongly directional lighting seems to inherently produce a significantly positive emotional response in those who see it.

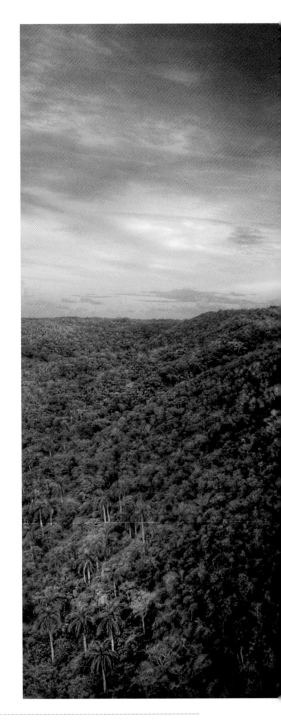

▶ The Puente Bacunayagua is the longest and highest bridge on the island of Cuba, built before the Soviets abandoned the country. I was lucky enough to reach the observation point above the bridge just at the golden hour because I could capture both the sky and the bridge in the glowing, colorful tones of the "golden hour."

15mm, six captures at shutter speeds ranging from 1/6 of a second (lightest) to 1/160 of a second (darkest), each capture at 15mm, f/8 and ISO 100, tripod mounted, captures combined in Photomatix and Photoshop

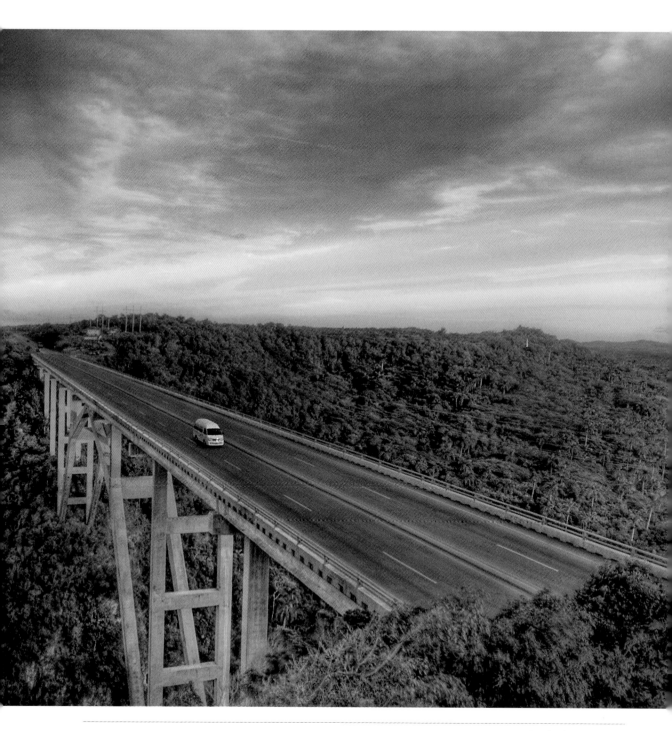

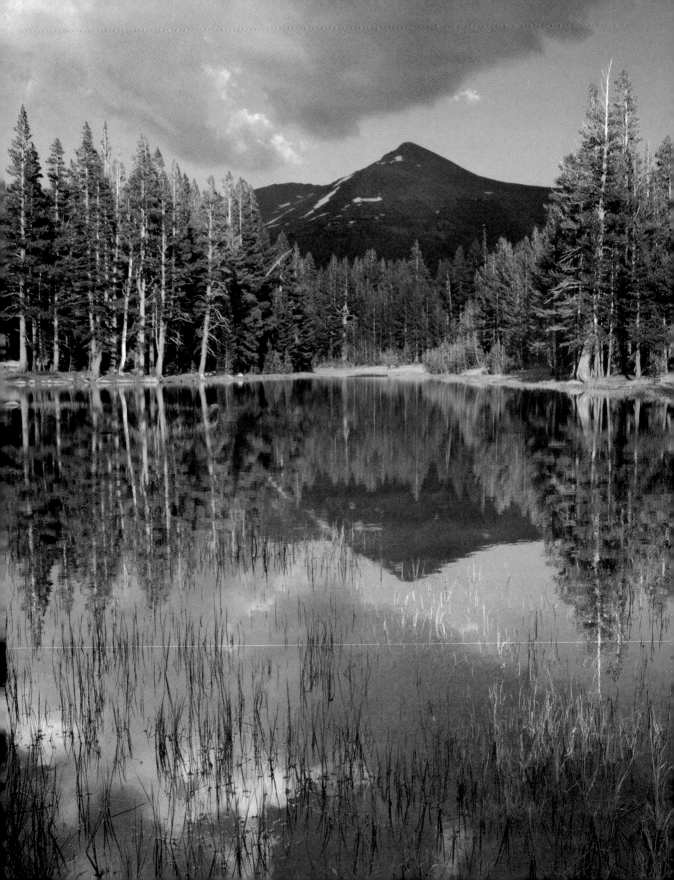

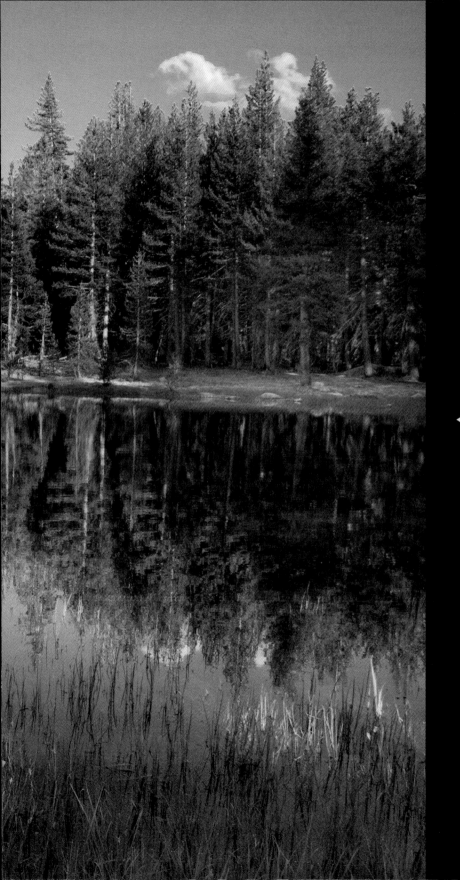

◄ This high-country lake in the Sierra Nevada mountains of California is just off the Tioga Pass highway. In the late afternoon and early evening it starts to glow, and comes alive as an interesting subject for photography.

Unfortunately, photographers aren't the only creatures aware of the golden hour. Mosquitoes seem to emerge just as the light gets good. In the couple of hours I spent photographing this lake, I fended off hordes of the little buzzing winged carnivores.

I like using a polarizer filter to amp the colors of golden hour landscapes even further. This is particularly true when water and reflections are involved. Using a polarizer can help bring out reflections, and it also serves to make golden hour lighting seem even more grand and spectacular than it already is.

18mm, circular polarizer, 1/60 of a second and f/11, tripod mounted

Intensity of Light

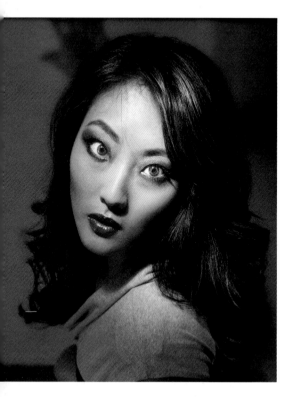

▲ I lit this model's face with intense light using a snoot, a circular tube placed over a studio strobe. My idea was to create an interesting high-contrast portrait that emphasized the unusual planes of her face, allowing the face to be lit while the rest of her body faded into the background.

24mm, 1/160 of a second at f/8 and ISO 100, hand held

▶ This portrait works because of the overall evenness of the low-contrast lighting. The model was literally in the water in an outdoor swimming pool. I achieved the lighting effect by filtering the relatively harsh sunlight bouncing off the water through a beach umbrella (you can see the umbrella as red in the background), and by using a fill card to bounce sunlight into the shadowed areas of the model's face.

200mm, 1/250 of a second at f/5.6 and ISO 100, hand held

Light intensity refers to the strength of the light—and this is something that can, of course, be measured by your camera or an external light meter. This kind of measurement can be a helpful starting place. But as I'll discuss later in this book in the Exposure section (pages 68-111), the point of an exposure—and of knowing the strength of your lighting—is not to use this data in a preset formula; rather, it is useful as a basis for making creative decisions.

It's worth noting that effective light intensity depends upon the distance of your subject from the light source, as well as the intensity of the light itself. For some lighting sources, this fact is irrelevant—for example, you can't move the sun. However, you can position artificial lights—and it's helpful to realize that intensity has an inverse ratio to the distance of light to subject. Actually, light intensity falls off roughly according to an inverse-squared ratio. For more on lighting placement, see pages 162-209.

In a photographic rendering, the absolute intensity of lighting is not usually the most important thing about the intensity. What matters is the contrast, or perceived relative intensity of lighting, compared to the darker areas of a photo. A photo in a dimly lit room with a single shaft of strong sunlight can seem to be more intensely lit than a photo taken on a bright sunny day outdoors. Objectively, there is far stronger lighting in the outdoor scene—but the mixed lighting seems more intense.

A great deal of the emotional power in a photo comes from the photographer's ability to control the dynamic range—tonal range from lights to darks—in a photo. Using digital darkroom controls and specialized techniques designed to increase dynamic range (see pages 210-247), along with the ability to extend and modulate the range of tones in a photo gives modern photographers more power over their image creation than ever before.

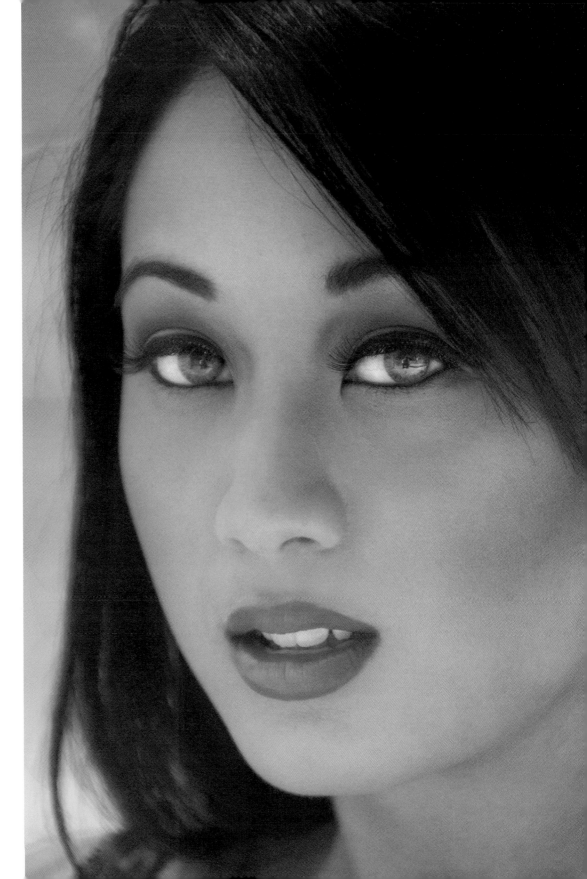

When working with light intensity in your photos, you should first understand whether the emotional appeal of lighting in your photo comes from overall flat lighting without high contrast, or whether the difference between dark and light areas makes the image.

In either case, your next goal should be to emphasize the effect you desire. If the image works because the lighting is overall flat, diffuse, and at the same time glowing—make sure your lighting, exposure, and post-processing delivers the impact you have pre-visualized.

If the emotional appeal of the image comes from the contrast between a few bright, overlit areas and dark background shadows, make sure that your technique follows your intentions. In this kind of image, apparent intensity combined with deep shadows can enhance compositions by cloaking unwanted areas—and adding an overall sense of tension and mystery.

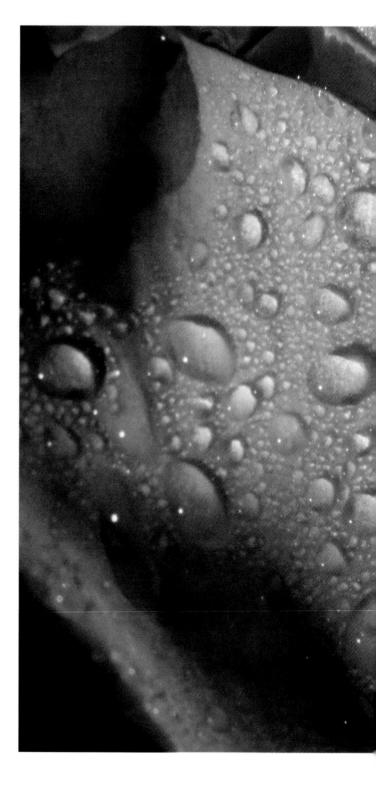

▶ Intense but dappled early morning sunlight helped create an interesting and unusual image of a rose, photographed as the sun made its way over the horizon. Normally, direct sunlight is too intense to create effective flower images without diffusion, but in this case the contrast between lights and darks worked—in part because the angle of the sun was not overhead and high in the sky yet. In addition, the hot spot reflections of sunlight in the water drops themselves add interesting texture and contrast to the image.

200mm macro, 1/180 of a second and f/40 at ISO 200, tripod mounted

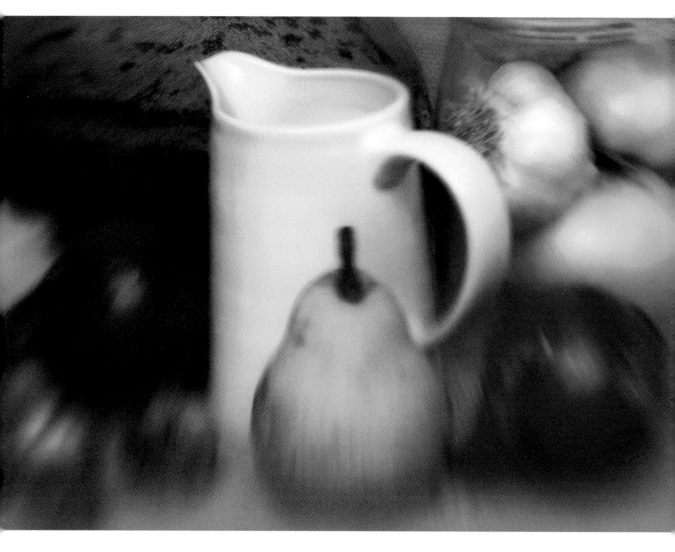

▲ To create this "soft" still life composition, I taped tracing paper over the continuous lights I used. Then I enhanced the diffuse effect using a Lensbaby, which throws parts of the image other than the "sweet spot" out of focus. The combination of gentle, soft light and selective focus creates a dream-like effect.

Lensbaby Composer, 1/160 of a second using f/5.6 aperture ring and ISO 500, hand held

▶ The direct sunlight illuminating this photo appears quite intense because of the strong shadow cast by the glass vase and the strong contrast between the light and dark areas in the composition. Without the strong, and almost harsh, lighting the patterns in the shadow of the vase wouldn't be clear enough to be interesting.

82mm, 1/125 of a second at f/32 and ISO 200, tripod mounted

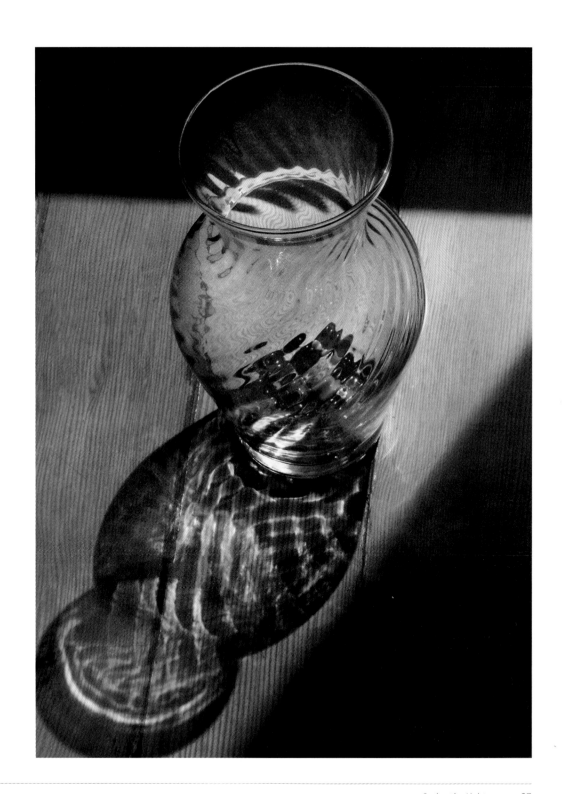

Direction of Light

When I compose a photo in my camera's viewfinder—whether I am working in the field or in the studio—the direction of the lighting is always foremost on my mind. As I've noted, without lighting there is no perception, or photographic rendition, of anything. Flowers, people, landscapes, and the night sky do not show in the absence of light, and one of the most crucial properties of light is its direction in relationship to the photographic subject.

It's important to have a common vocabulary when discussing light direction, so do bear in mind that when I talk about the direction of light I am describing how the light strikes the subject, not the direction of the light in relation to the camera. If you know the direction of light relative to the subject, and you understand reflectivity (explained on pages 52–55 and 186–189), then you'll be able to have a pretty good idea about the direction of light related to the camera as well. Of course, this is assuming that your subject is not a light source and is reflecting light that is retransmitted to the camera.

Light that strikes an object on its front is called *front lighting* (Figure 1). Light that comes in from the sides is called *side lighting* (Figure 2).

Logically, there's no clear angle at which side lighting becomes front lighting, or front lighting becomes side lighting—and many situations involve combinations of side and front lighting. Nevertheless, it's important to get a sense for the prevailing direction of light because that can help you

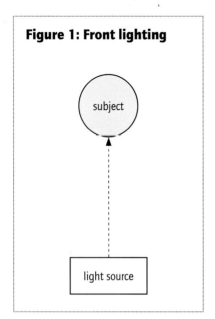

Figure 1: Front lighting

subject

light source

Figure 2: Side lighting

subject

light source

light source

camera

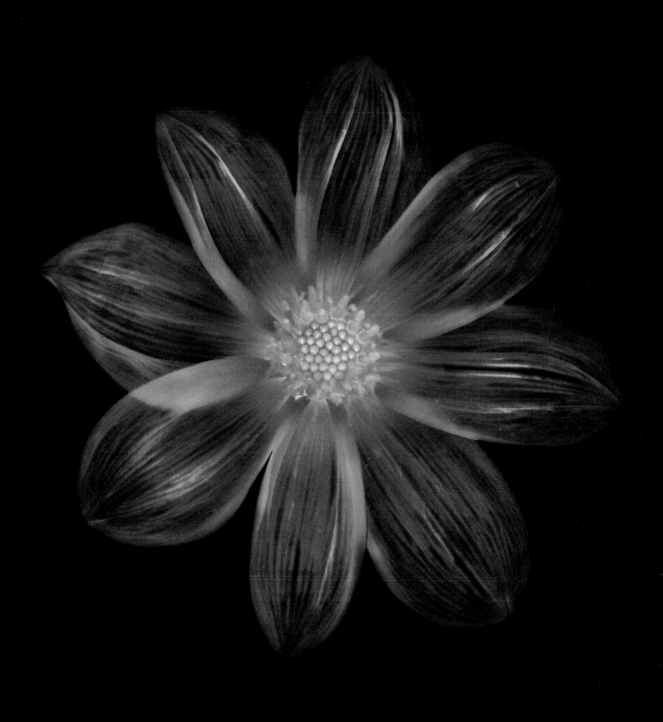

▲ I placed this Dahlia from my garden on a black background, and lit it from the front using a small LED flashlight. Using a low-intensity front light combined with a long exposure allowed me to create an almost "spot-like" effect on the center of the flower.

50mm macro, 3 exposures combined using Photoshop layers at 1 second, 2 seconds, and 4 seconds; each exposure at f/32 and ISO 100, tripod mounted

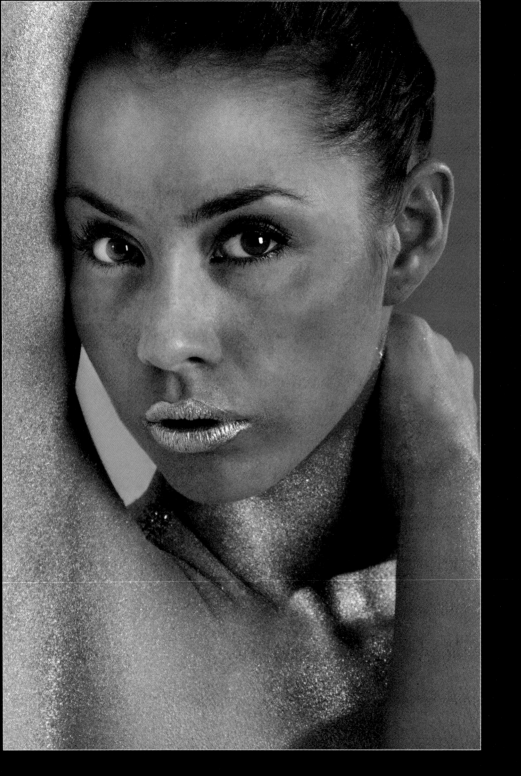

tweak both the lighting and the position of the subject to create a more effective photo.

In some situations, lighting becomes generalized enough that there isn't really a clear sense of the direction of the light. In this kind of lighting situation the overall light is said to be *ambient*. With ambient lighting it is often true that clarity about its direction isn't obvious; however, if you take the time to really look you can probably determine the various directions and sources of illumination.

It's not uncommon to add specific directional lighting to an ambient lighting situation.

To fully round out the picture of all possible light directions, consider *backlighting*, (Figure 3) which is further discussed on pages 44–45. The problem with backlighting is that the rear of the subject is illuminated and unless the subject is translucent, there's no illumination on the front of the subject—you only see light peeking around the edges of the object.

Note that we live in a three-dimensional world, so in one sense a four-points-of-the-compass directional analysis doesn't tell the whole story. Light can also come from above or beneath a subject. You should be on the lookout for top lighting and bottom lighting, as well as the lighting's directional characteristics.

Figure 3: Backlighting

light source

subject

camera

▼ Pages 32–33: In winter, when trees are bare, the stark shapes of trunks and branches make for seeing the direction of light clearly.

I was in the mountains above Santa Fe, New Mexico when I came across this grove of Aspens. The winter light was low, harsh and intense, coming from the left-hand side.

The strong directional lighting created a situation that was graphically interesting. With my camera on a tripod, I used an average exposure intended to create an image that was essentially about the side lighting—and about how the contrast between lights and darks created a pattern.

105mm, 1/180 of a second at f/14 and ISO 200, tripod mounted

◄ This model had been elaborately painted in silver, but I thought her most striking feature was her eyes. If you look carefully at the catch lights in her eyes, you can determine the predominant direction of the lighting—side lighting from the model's left.

200mm, 1/160 of a second at f/11 and ISO 100, hand held

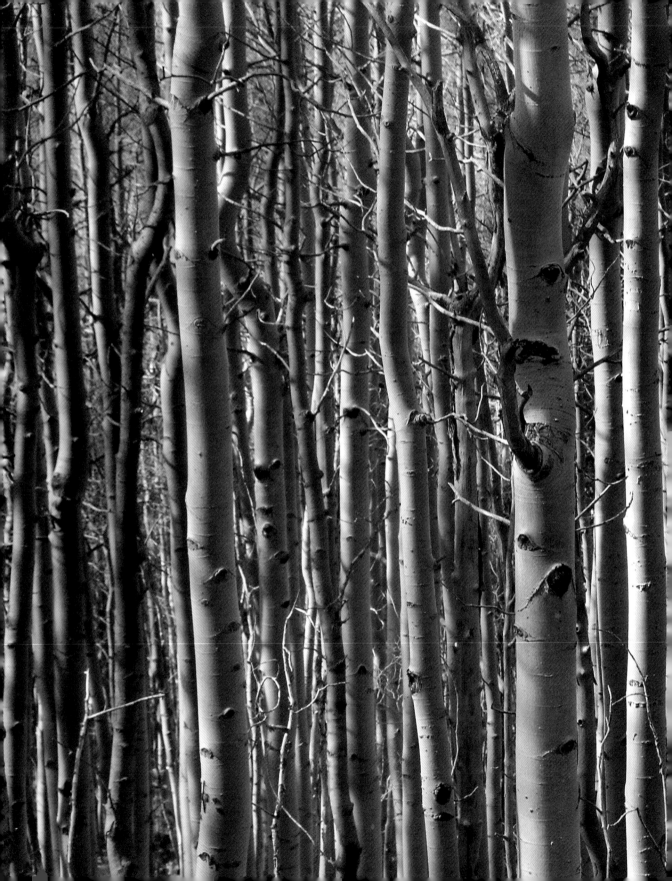

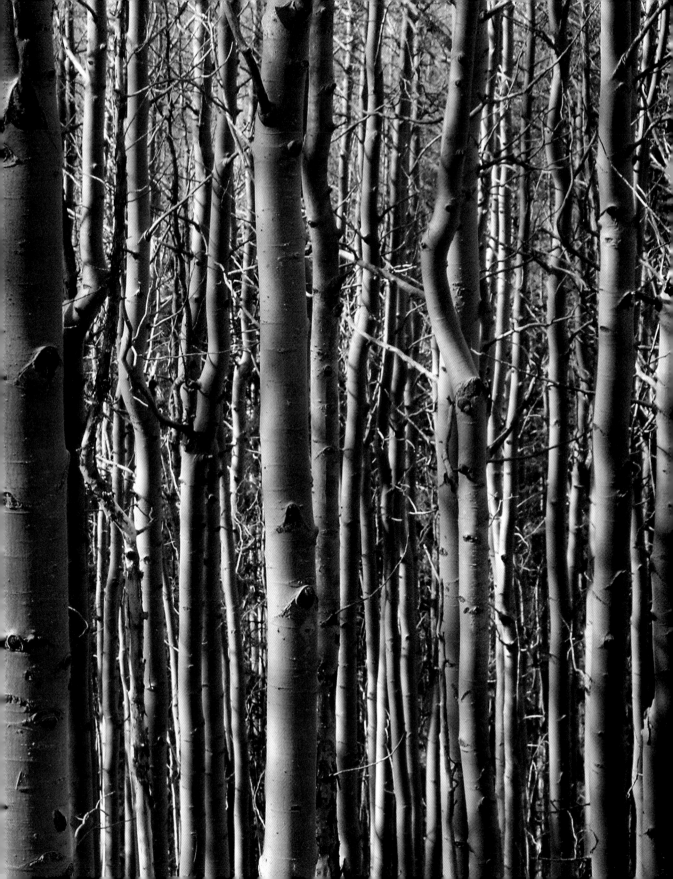

Color of Light

Intuitively, almost all human beings have an emotional response to the color of light. Light that is perceived as warmer shows scenes that are more likely to be viewed as attractive, friendly, and even intimate—provided the light doesn't get *too* warm. For example, scenic photos taken during the golden hour (see pages 18-21) are almost always perceived as attractive, due to the warmth of the lighting.

Conversely, light that is perceived as cool is not considered attractive, and adds an emotional distance to a photo. However, in some circumstances this emotional coolness may be just what a particular image needs.

Clearly, the issue of the perceived color of light—where the light falls on a warm to cool scale—is very important to a photographer's ability to conceptualize the impact of lighting on a photo, because this issue plays such an important psychological and emotional role.

However, the terms "warm" and "cool" seem a little vague. What is actually meant?

The color temperature of light is measured as emitted from a theoretical black body in degrees Kelvin (abbreviated K), an increment of temperature related to the Celsius scale. The lower the color temperature of light, the warmer the light will seem and the higher the color temperature,

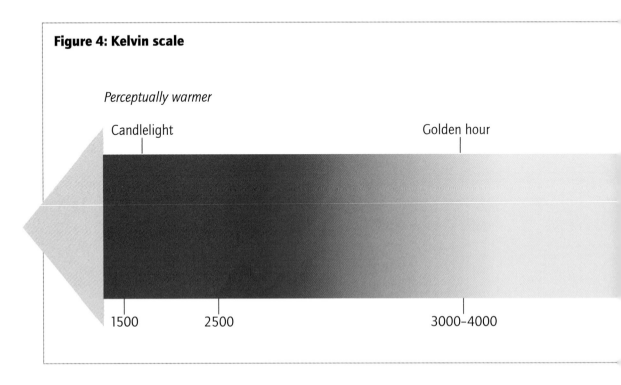

Figure 4: Kelvin scale

Perceptually warmer

Candlelight

Golden hour

1500 2500 3000–4000

the bluer the light will appear.

Very warm light is perceived as quite reddish at about 1500K, somewhat warm light is perceived as yellow in the 3000K to 4000K range, and anything over 7500K will seem blue. Daylight varies considerably, but open sunshine in the middle of the day will probably register at the 5200K to 5500K range.

The Kelvin scale, along with some common light sources and where they are likely to fall on the Kelvin scale, is shown in Figure 4.

When I first learned about color temperatures and the Kelvin scale, it didn't really make sense to me that the higher the number—meaning warmer from the view-

point of physics—the more blue the color. But if you think about this for a moment it actually does make sense. If you've ever toasted marshmallows on a camp fire, you'll know the hottest part of the fire has blue flames, and that yellow flames are hotter than red ones. Color temperatures measured using the Kelvin scale are showing how much heat the light source emits. This happens to be backwards from our psychological perception of color, but then there's no reason that our psyches should know the actual color temperature of light.

White Balance is the setting your camera uses to record the color temperature of

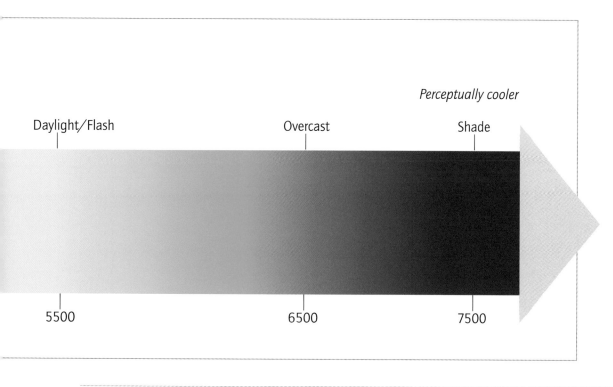

a given scene. Your camera's Auto White Balance feature actually does a pretty good job of reading the color temperature of most scenes, but it is also possible to use a white balance that you've chosen.

For information about how you can use color temperature and white balance to creatively enhance your photographic technique see page 102 for a discussion of the in-camera White Balance setting, and pages 104–107 for information about working with color temperature in the RAW conversion process.

▶ I wanted to create a photo that showed the sumptuous and well maintained public architecture of the Cuban National Capitol in Havana, Cuba. The warm glow of window light reflected on the marble walls, floor, and ceiling help to convey the visual effect I was trying to convey.

10.5mm digital fisheye, 1/4 of a second at f/13 and ISO 100, tripod mounted

▼ Pages 38–39: I shot this image after sunset near China Beach in San Francisco Bay. There's a very blue cast to the lighting in this photo of tidal mud flats due to lingering light caught in the low-hanging clouds.

18mm, 3 exposures combined using Photoshop layers at ¼ of a second, 1 second, and 4 seconds; each exposure at f/5.6 and ISO 100, tripod mounted

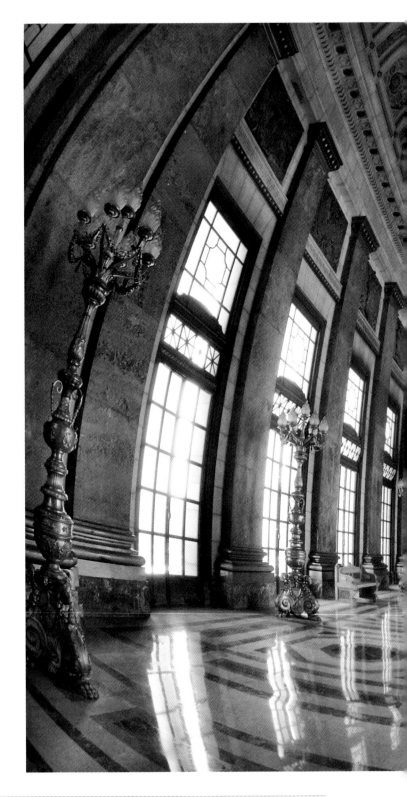

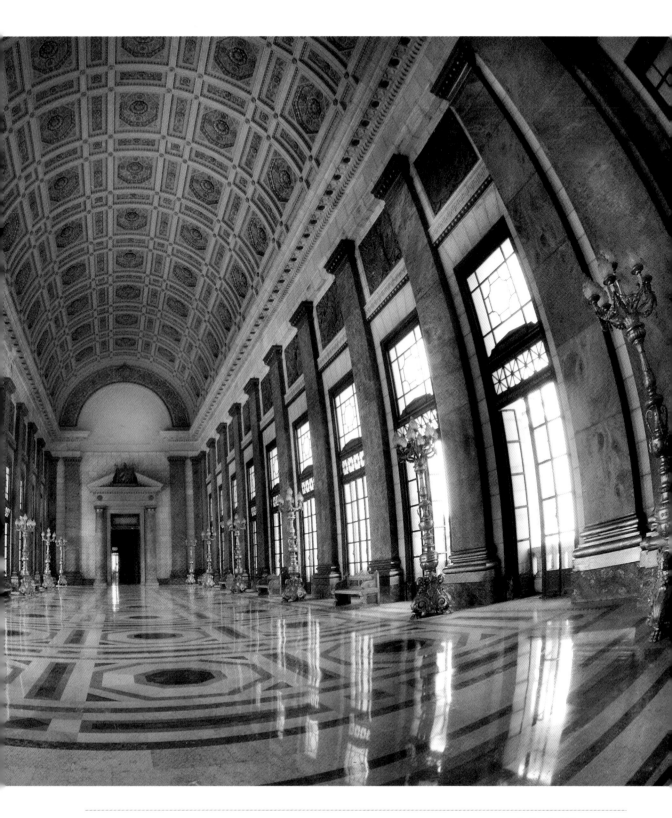

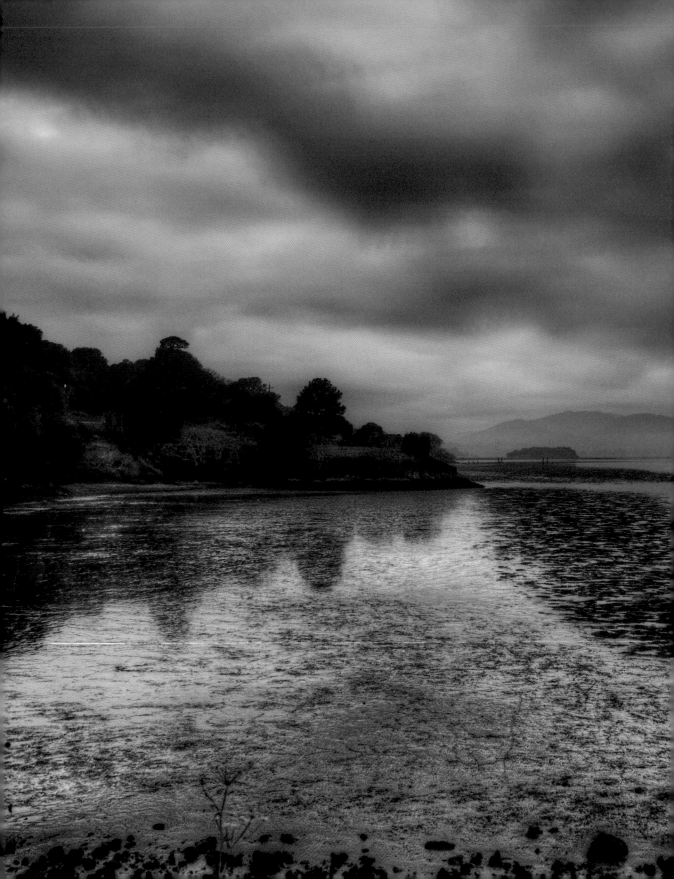

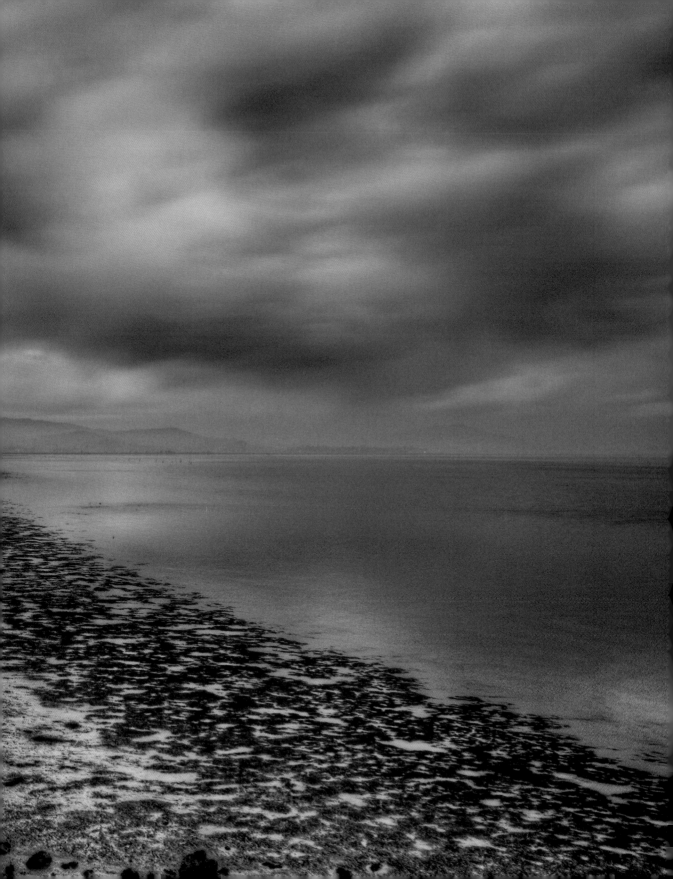

Diffusion

To diffuse a light source means to cut down and spread the glare from a transmitting light source. In the studio, you can diffuse a light source by shining the light through a translucent device such as an umbrella or soft box. It's easy to recognize diffusion in the studio when you send light through translucency.

Outdoor shooters usually need to look for diffusion that occurs naturally. Clouds often diffuse sunlight, and fog makes one of the world's best diffusers.

Light transmitted directly from a source can be harsh and undiffused unless it has been modified by sending it through something translucent, as I just described. On the other hand, the more the light is reflected before it illuminates your subject, the more diffuse it becomes (see pages 52-55 for more on reflectivity and diffusion).

Diffused light is perceived as "soft" in contrast to harsh undiffused light. Learning to sense where on the spectrum between soft (diffused) and harsh (undiffused) light falls is an important part of learning to see light. Soft light brings out details and makes scenes appear romantic and serene. Harsh light helps delineate contours and shapes strongly and can be used to make emotional statements implying likes and dislikes.

To diffuse or not to diffuse? This is an important choice in lighting—so you should make a point of learning to see the difference as you observe light.

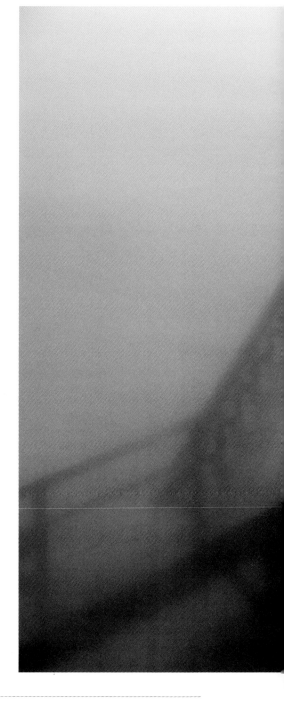

▶ I was looking down from the second story of the historic Coast Guard Boathouse in Point Reyes National Seashore, California straight out to sea at the tracks that were used to launch rescue boats. The window pane was covered with rain and salt spray. Shooting through the dirty window produced this highly diffused and almost abstract image.

40mm, 1/200 of a second at f/5 and ISO 100, hand held

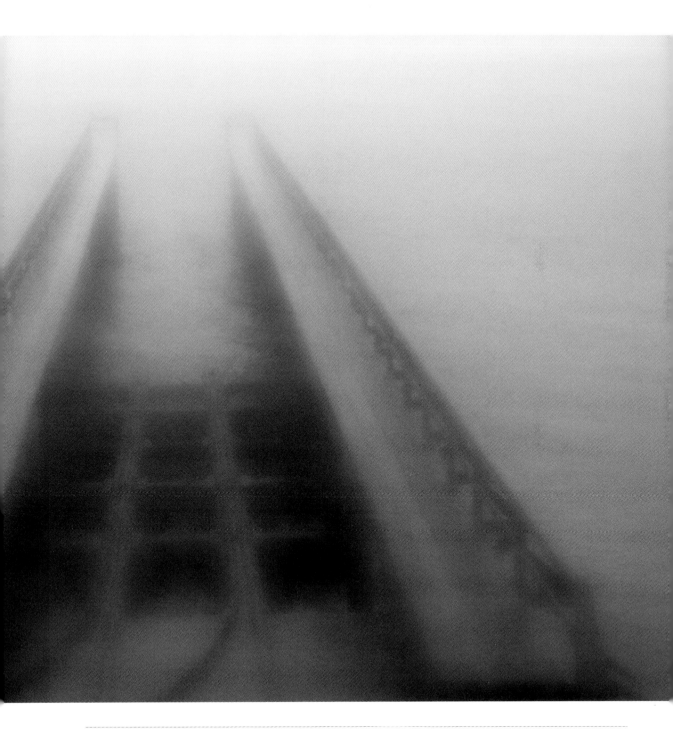

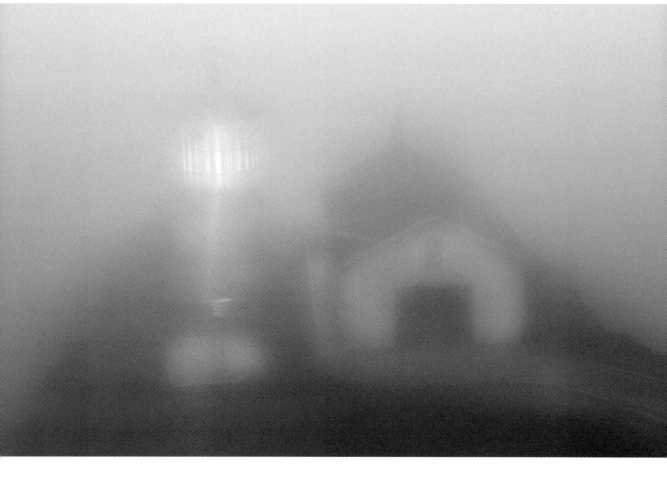

▲ Leading a night photography workshop to the lighthouse at the tip of Point Reyes National Seashore in California, I was disappointed by the dense fog. I had forgotten that fog works as a great natural diffuser. The soft lighting of this shot in the clinging fog turned out to make a photo as interesting as any of the images I have made of the Point Reyes Lighthouse in clearer weather. My biggest problem: keeping camera and lenses dry in the intense wetness.

50mm, 1/2 of a second at f/8 and ISO 200, tripod mounted

▶ The sun shining through pockets of fog in this woodland valley created a perfectly diffused lighting source. I used a long exposure and a small aperture for high depth-of-field so I could fully capture the effect of going from the darker details of the path on the valley floor to the diffused sunlight higher up in contrast to the tree trunks.

19mm, 15 seconds at f/22 and ISO 100, tripod mounted

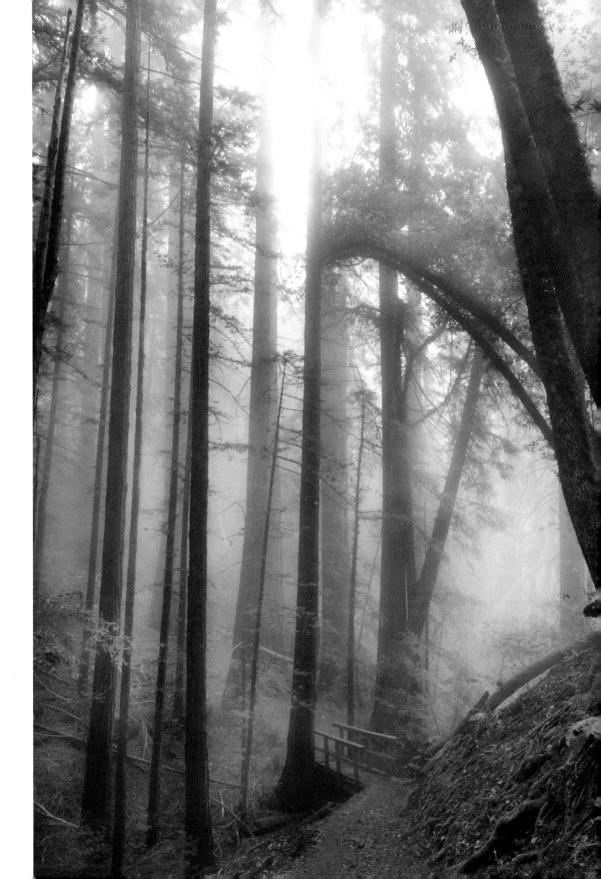

Backlighting

Backlighting is light that comes from behind the subject as explained on page 31 (also see Figure 3). If the subject is opaque, this may mean no light at all on its front—the plane that you will be photographing. A solid black object only lit from behind will not be illuminated on the unlit front side—unless light is reflected into the unlit, black areas.

So the use of backlighting needs to be regarded as something to be used in special situations, for example:

- The subject is translucent, and you are photographing to give an impression of transparency (see pages 56–59 and 178–181 for more about transparency).

- There's interesting interaction between the edges of the object and the backlighting.

- Your intention is to create an image primarily showing a silhouette.

Because of the visual power of these uses of backlighting—and because effective use of backlighting is rare even among otherwise accomplished photographers—backlighting has become an important tool of mine. However, you should bear in mind that backlighting is almost never pure. It's an extremely rare photo that effectively uses backlighting without some kind of fill lighting effect—either in the photography or in the digital darkroom.

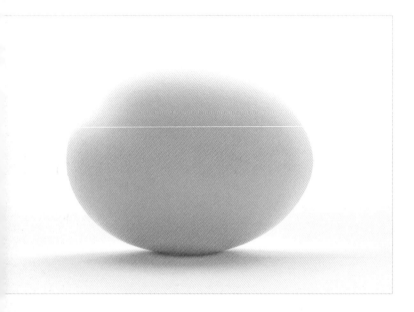

◀ Backlighting this egg creates a gentle glow effect around the edges of the egg. I used a white fill card to reflect some light into the front of the egg, so that the front wasn't in deep shadow.

200mm macro, 10 seconds at f/36 and ISO 100, tripod mounted

▶ I photographed this poppy cut from my garden using strong, late afternoon sunlight strategically beamed through a sheet of translucent paper in front of a window to backlight the flower.

200mm macro plus 36mm extension tube, 3/10 of a second at f/36 and ISO 100, tripod mounted

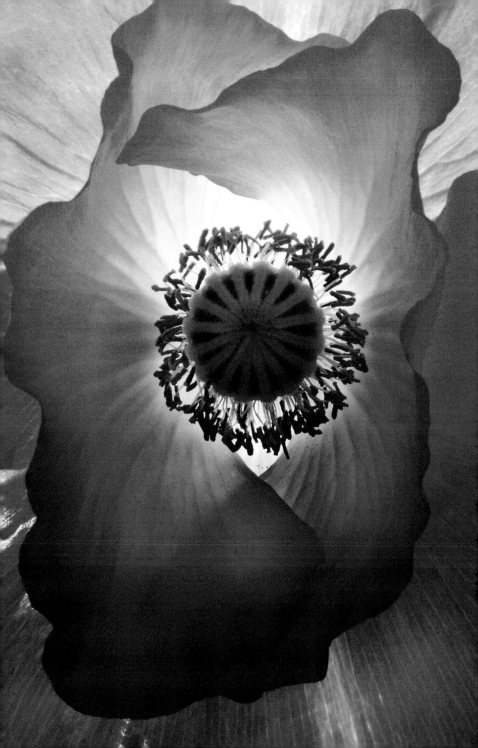

High-Key and Low-Key Lighting

High-key photos are white, or bright, and tend to involve some translucency or transparency. Low-key images are mostly very dark, or even black. A high-key photograph is often intentionally overexposed for artistic reasons and a low-key photo is often intentionally underexposed.

The absolute amount of light on the subject is not the issue. You can have scenes with low levels of lighting that are captured as high-key photos, and scenes that are well lit but dramatically underexposed to result in low-key images.

The important thing is to recognize the pattern of an overall high-key (or low-key) image and to understand that you won't get there without human, creative intervention. Left to its own devices, your camera will never expose in a way that successfully uses lighting in a way that makes for interesting high-key or low-key photography. See pages 206–209 for information about exposing for high-key and low-key imagery.

To create a successful high-key image, look for subjects that are bright and well lit. Often, white predominates in these photos. At the same time, most successful high-key images don't have highlights that are blown-out—so the typically successful high-key image is range-bound on the bright side of things.

Low-key images that work are predominantly dark, with some areas of relative lightness that work in contrast to the mystery around them.

When they work well, high-key and low-key images are very special. As part of my discovery of the light around me, and my pre-visualization of lighting effects that might work well with specific subject matter, I always look to see if there is a high-key or low-key solution that might fit the bill.

◀ High-key lighting gives this oregano petal the flavor of an old-fashioned botanical drawing.

200mm macro, 2 1/2 seconds at f/36 and ISO 100, tripod mounted

▲ I photographed this coneflower on a white background and intentionally overexposed to create a high-key effect.

200mm macro, 4 seconds at f/36 and ISO 100, tripod mounted

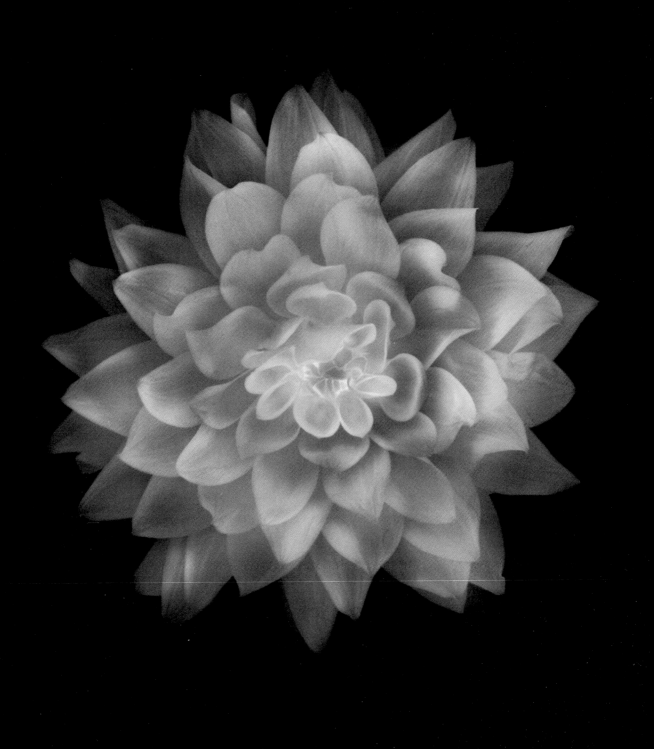

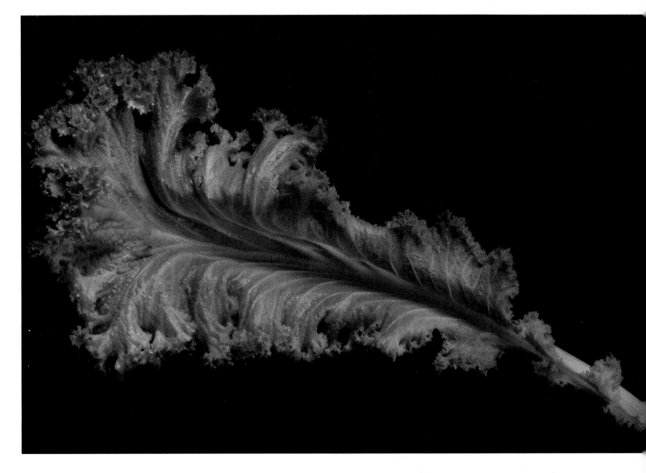

▲ Low-key lighting makes this mustard leaf look like a mysterious sea creature. By controlling the exposure to keep the image low-key, I added an element of saturation to the color—and took this image a step beyond a "straight" shot of salad material.

85mm macro, 5 seconds at f/51 and ISO 100, tripod mounted

◄ Photographing a white flower is a challenge in a color photo because the final image can seem to lack interesting colors. I underexposed this Dahlia to create a low-key image with subtle color variations on a black background.

85mm macro, 20 seconds at f/64 and ISO 100, tripod mounted

Chiaroscuro

▲ The contrast between the dark background and the 25-watt lamp light on my daughter Katie Rose's face creates a chiaroscuro effect.

105mm, 1/25 of a second at f/5.6 and ISO 1600, hand held

▶ The shaft of light striking this bride positioned in an otherwise dark underpass creates a chiaroscuro effect. The contrast between the white wedding dress in the light and the almost totally dark background adds warmth and visual interest to a photo that would otherwise be a cliché.

50mm, 1/250 of a second at f/4.8 and ISO 200, hand held

Chiaroscuro is a term derived from lighting in some classical paintings—lighting that shows great contrast between lights and darks, with both light and dark important to the composition. On the whole, many photographic compositions that use chiaroscuro lighting tend also to be low-key—so there is some conceptual overlap between these lighting categories.

Can there be light without darkness? Probably not. In photographic terms, chiaroscuro is more about the contrast between the dark and light areas than it is about the overall tone of the image—even though, as I've noted, images that take advantage of chiaroscuro lighting tend to also be low-key.

Chiaroscuro is almost always interesting lighting. It's hard to imagine boring chiaroscuro. So when I encounter situations that seem a little too bland for my taste, I see if I can "jazz them up" by throwing an element of chiaroscuro into my lighting.

If I'm working in a natural light environment, I try to see if there is a high contrast of lighting I might take advantage of. For example, can I position my model in a dark exterior in such a way that a single shaft of light will fall on her? Or, can I use a dappled light source to exaggerate the darks and lights in the scene in front of me?

Indoors, in a controlled environment, the question becomes one of accentuating the contrast between lights and darks. I'll improvise and use extremely low levels of illumination if this means that I can get the light to fall off in an interesting way.

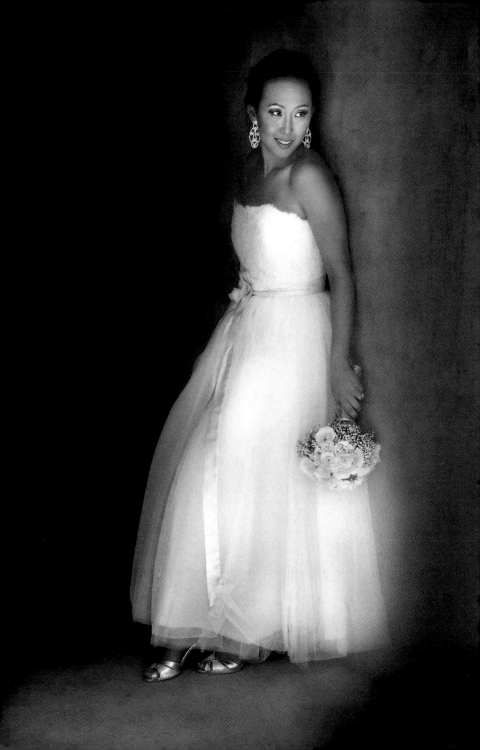

Understanding Reflectivity

I've noted that without light nothing can be seen—or photographed. Furthermore, unless an object is a light source, such as the sun or a light bulb, it can only be illuminated by reflectivity. Therefore, it's crucial to understand reflectivity if you want to understand lighting.

First of all, the Fundamental Law of Reflection states that the angle of incidence equals the angle of reflection (Figure 5). In other words, the angle of light shining on an object determines the angle that the light will leave the object.

However, the kind of reflection depends upon the characteristics of the lighting and the surface doing the reflecting. *Diffuse reflections* don't change in brightness when you shift your angle of view. *Direct reflections* are a mirror image of the light source that made them and vary from bright to nonexistent depending upon your angle of view.

A completely white card produces diffuse reflections, and the light is reflected equally in all directions from the white card (Figure 6).

In contrast, a mirror produces direct reflections. As you can see in Figure 7 on page 54, a camera located at the angle of incidence will see a very bright version of the reflected light source, while a camera located anywhere else will not.

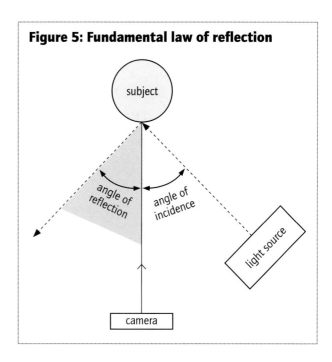

Figure 5: Fundamental law of reflection

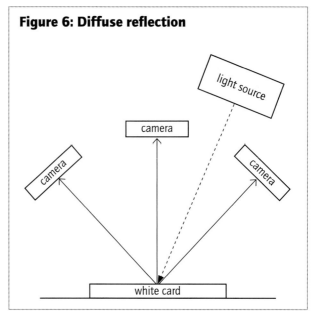

Figure 6: Diffuse reflection

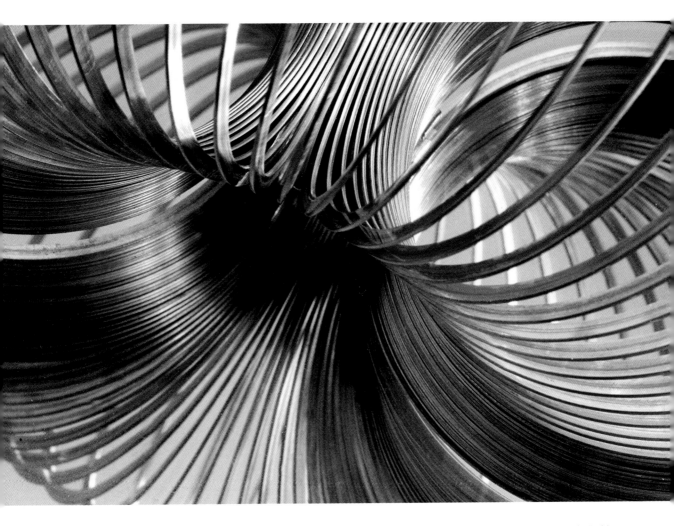

▲ Metal objects, like this slinky, are among the hardest things to photograph. A minor technical issue is that reflective surfaces will foil most autofocus mechanisms—so you should plan to focus your camera manually.

The overall picture is that a very reflective surface is like a blank slate. How it looks depends on the color that you reflect into it. Also, if you are not careful, the reflections will show the setup you used to photograph the metal object—and even the photographer.

To make shiny metal look its best, reflect warm color into it. In this case, I placed a colored board just out of the camera view, but where the reflections appear as colors in the slinky.

105mm macro, 2 seconds at f/32 and ISO 200, tripod mounted

Note that most of the surfaces you will want to photograph are neither white cards nor mirrors, but rather somewhere in between in regard to reflectivity.

Each ray of light within the family of angles (Figure 8) complies with the Fundamental Law of Reflection and heads out of the reflecting surface at the angle of incidence. This is important because if your camera is positioned within the incident angle range formed by the family of angles you'll capture direct reflections. A camera that is located outside this range captures diffuse reflections.

The kind of reflection you want depends upon your intended photo. For example, if you are photographing flat artwork you'll never want to see direct reflections because these will appear as glare and spots with high-contrast reflections. The solution is to arrange your lighting and camera so the camera is outside the reflections from the family of angles.

On the other hand, if you are trying to create an interesting image of color in a highly reflective object, such as a mirrored or metallic surface, you'll want to carefully position your camera within the incident family of angles to achieve the effect you want.

You'll find information about creative lighting effects using reflectivity on pages 186–189.

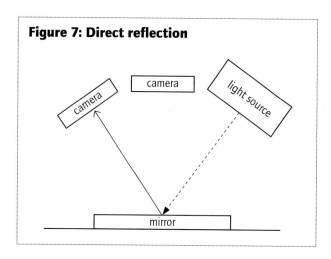

Figure 7: Direct reflection

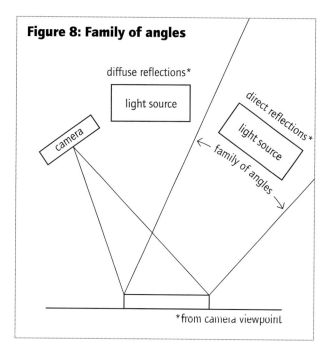

Figure 8: Family of angles

▶ In this photo of my son Mathew at the San Francisco Zoo, the lighting is coming from above and to the left of the photo's edge—this is side lighting. You can see that this is so by looking at the direction of the shadows on Mathew's face. What may take a closer look to notice is that the light is reflected off Mathew's light-colored hair back at the white wall behind him. And then, the light is reflected back towards the camera, creating a kind of halo effect. I usually try to notice this kind of secondary reflection because it often adds interest to the lighting in a photo.

56mm, 1/400 of a second at f/10 and ISO 200, hand held

Transparency versus Opacity

▲ This image of a poppy shows partial transparency. Where the petal of the flower has been backlit by the sun, the image appears translucent. Elsewhere—for example the stems—the flower seems fully opaque.

200mm macro, 1/20 of a second at f/32 and ISO 100, tripod mounted

▶ My thought in creating this photo was to tell a story in a single frame. The narration shows the birth and full bloom of a poppy (*Papaver rhoeas*). If you look at the discarded skin from the flower bud, you'll learn why this flower is called a "poppy" in the first place. To achieve this narrative, the poppy is lit from the front and sides, and appears fully opaque.

100mm macro, 1/60 of a second at f/11 and ISO 200, tripod mounted

Objects you photograph have an impact, on their own lighting—and not just in terms of surface reflectivity. One very important issue is whether an object is transparent or opaque.

If something is fully opaque, then light cannot pass through it. The object appears solid and three-dimensional, and has a sculptural presence. It is usually lit from the front or sides, although occasionally opaque objects can be backlit as silhouettes for a special effect.

On the other hand, partially transparent objects can be backlit (see pages 44-45) and create a translucent effect rather like that of stained glass. In fact, stained glass is a classic subject for backlighting and transparency—it only comes into its own when it has been appropriately back lit. You can think of translucency in flowers or other natural objects as the natural analog to a stained glass window.

Photographs that intend to present a coherent narrative are rarely backlit. If you want to show something straightforward, then it is best to use straightforward lighting. After all, for the most part we are used to seeing objects that are lit from the front or sides. In contrast, backlighting is a relatively unusual lighting style (and technique).

When a transparent subject is backlit, it glows liked stained glass. Viewers of images based on this kind of lighting take away the impression that they've penetrated inner secrets of the objects themselves.

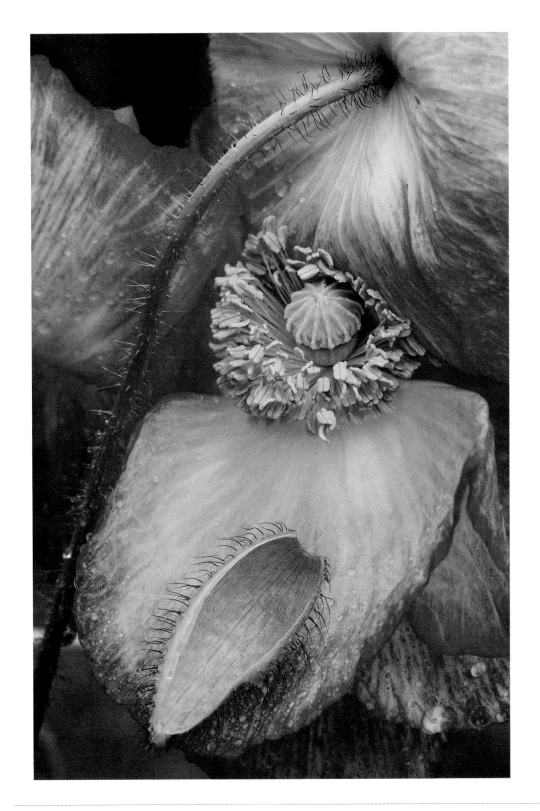

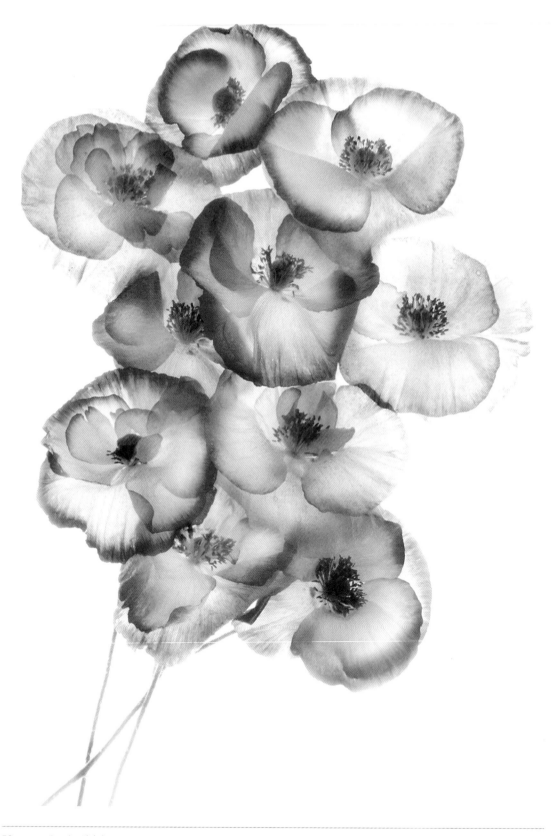

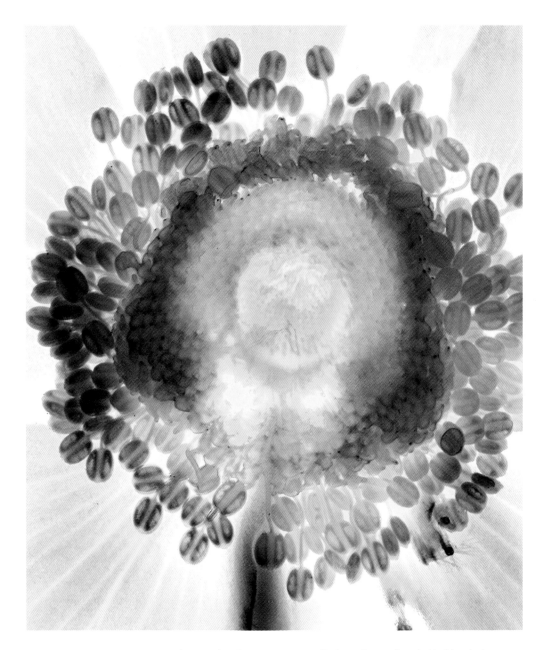

To create images showing transparency, I lit these flowers from behind by placing them on a light box. This is one of my favorite techniques with cut flowers. When the photography is accomplished with precision, this kind of lighting can create wonderful and magical imagery that is hard to achieve in any other way.

▲ *Anemone: 200mm macro, 8 seconds at f/40 and ISO 100, tripod mounted*

◄ *Poppies: 50mm macro, six captures at shutter speeds ranging from 10 seconds (lightest) to 3/10 of a second (darkest), each capture at f/32 and ISO 100, tripod mounted, captures combined in Photoshop*

Lure of Shadows

An important property of lighting is its ability to create and manipulate shadows. It's well known that shadows have magical associations. In some cultures, if you lose your shadow you've lost your soul—exactly similar to the supposed result of being photographed. In our own culture, we've grown up with Peter Pan's anguish at losing his shadow, and his frenzied search to find it again.

Photography can use lighting to take advantage of the emotional associations we all have with shadows.

In some photos, you really don't want to see shadows. If you don't want shadows, you'll have to work with the lighting and camera and subject position to eliminate this element. For example, portrait photographers can have to work hard to make sure that lighting doesn't cast an awkward shadow of a nose on someone's face.

The shoe is on the other foot when a shadow plays an important role in a composition, or when a photo is partially about the shadow that

▶ I was fascinated by the way strong morning light filtered through the bushes near the eastern wall of our house, and spent some time considering how I could best take advantage of the shadows this lighting created.

To set this shot up, I moved a potted plant with a recently opened flower into position, sprayed it with water, and lit it from the front with a small LED light to fill in the shadows on the front of the flower.

This photo of an Icelandic poppy (*Papaver nudicaule*) is interesting because it shows a strong shadow (from side lighting) in combination with direct front lighting that shows the details of water drops on the flowers.

50mm macro, 1/40 of a second and f/32 and ISO 100, tripod mounted

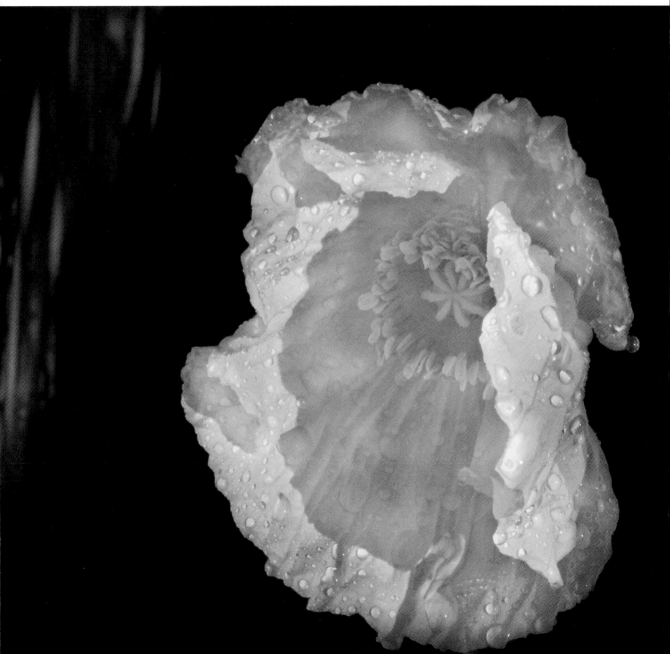

is being cast. You'll find some techniques for effectively generating interesting shadows on pages 182–185.

With intentional shadows, lighting plays a more active role than you may be used to. True, light is used to reflect the contours of an object. However, the lighting also creates entirely new subject matter—the shadow. The interplay between this creative element and the more traditional prime subject is what creates the interest in compositions that rely heavily upon shadows.

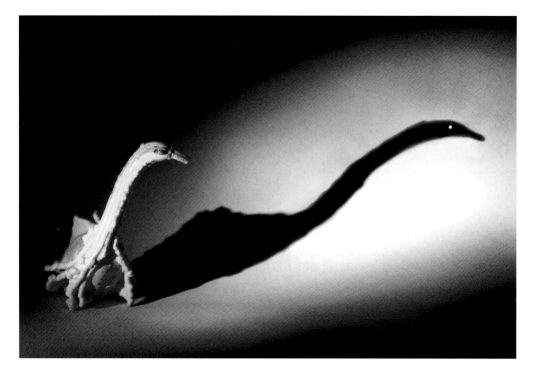

▲ I placed a very attractive autumn gourd on a background of white seamless paper. My assistant held a single light as I gave precise directions about how to best position the light so that the shadow of the gourd looked like a dinosaur (white "eye" added in Photoshop).

82mm, 1/8 of a second at f/8 and ISO 100, tripod mounted

▲ My idea was to photograph an everyday object—a saw blade—lighting the object to create a shadow that seemed alive. Accomplishing this vision required precise placement of both the object and its lighting. I was able to hold the saw blade in place simply by sticking the sharp points of the blade firmly into a Styrofoam block (you can see the blade holes if you look closely).

The light had to be carefully positioned to the left and below the photo frame so that as much as possible the resemblance to a smiling face was clear on the shadow. To achieve this lighting goal, the light needed to come through the holes in the blade with a directional component that emphasized the desired features.

105mm macro, 2 seconds at f/32 and ISO 100, tripod mounted

Light and the Monochromatic Vision

Black and white—monochromatic—photography shows lighting stripped to its bones. Color is no longer part of the lighting equation—there is no warm light or cool light, and you can forget about the Kelvin scale. What's left is lighting in its purest form: a Zen marker of greater or lesser intensity that is used with purity to denote patterns of lights and darks in monochromatic imagery.

It takes a certain amount of discipline to evaluate lighting without regard to the color of the light, but this discipline is what I aspire to when I approach creating monochromatic photos. In black and white, it doesn't matter what color a flower is, or how the color changes when a light with specific characteristics shines upon it. What matters is the patterns you can make using the intensity of the light that illuminates the subject.

From a visual perspective, monochromatic photography is about the contrast between lights and darks. So, in a way, lighting is more important to the monochromatic image than to the color image. There's no way you can camouflage the compositional impact of the lighting—and composition is essentially all there is.

Apart from the very specific visual delights of the monochromatic photo—and these are not inconsiderable, even in the digital era in which monochrome means intentional simulation of an older aesthetic—there's good reason for creating monochromatic images to improve your skills with seeing lighting.

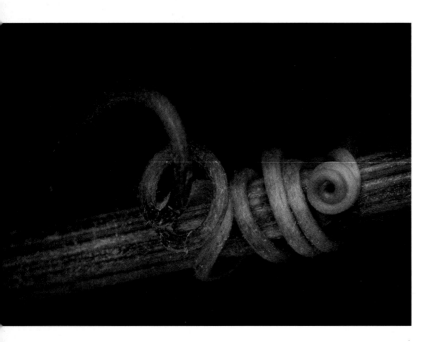

◄ I underexposed this detailed view of a Passiflora vine to create a low-key, mysterious effect when converted to monochrome.

200mm macro, 1/30 of a second at f/16 and ISO 100, hand held

▶ For dramatic impact, I lit the flute of this calla lily but not the background, and exposed for the illuminated areas of the flower, allowing the rest of the image to go black. My idea here was to present a visually ambiguous image: for a moment you don't really understand the scale of what you are looking at. It could be a shaft of light on a cliff, or it could be (as it is) a specially lit flower.

100mm macro, 1/320 of a second at f/11 and ISO 500, tripod mounted

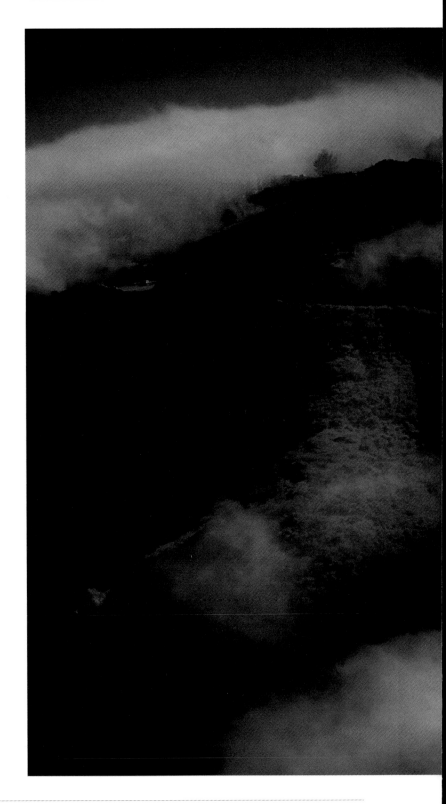

▶ The fog rushed in over the hills of San Francisco Bay. Standing on the top of a ridge in the Marin Headlands, I noticed how the extreme white of lit banks of fog contrasted with the dark features of the landscape.

I composed this photo to emphasize the contrast between the lines of fog, illuminated by the sun, and the dark coastal hills in the background.

75mm, 1/640 of a second at f/8 and ISO 100, tripod mounted

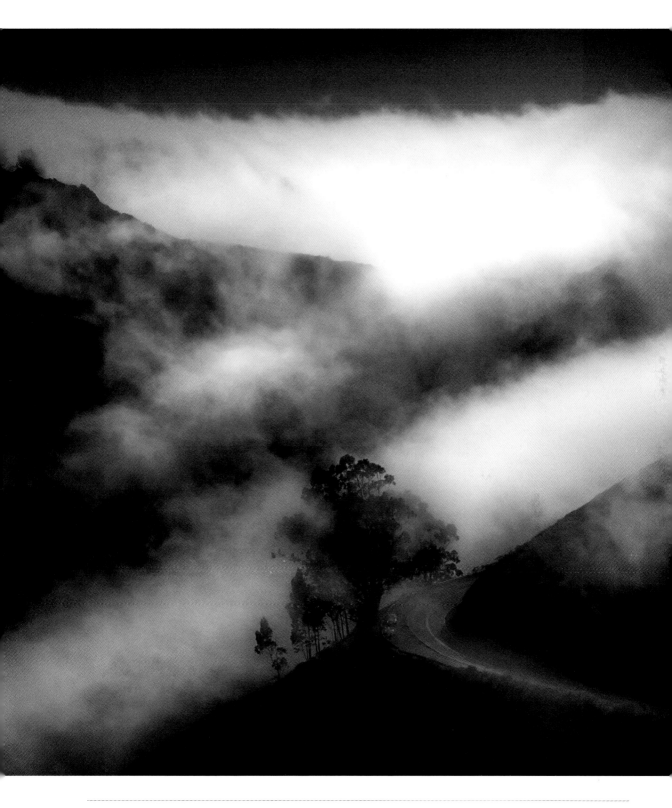

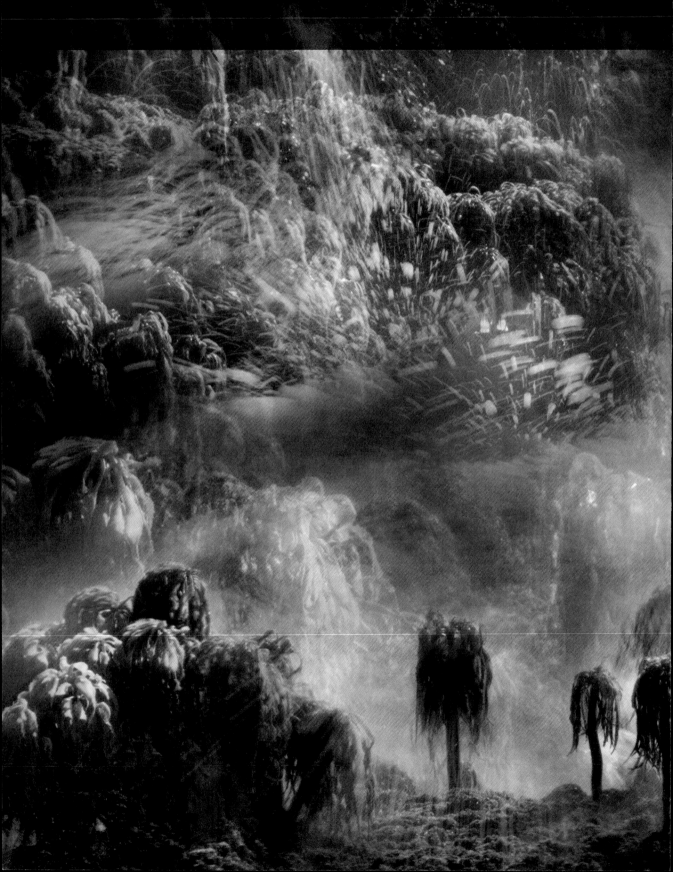

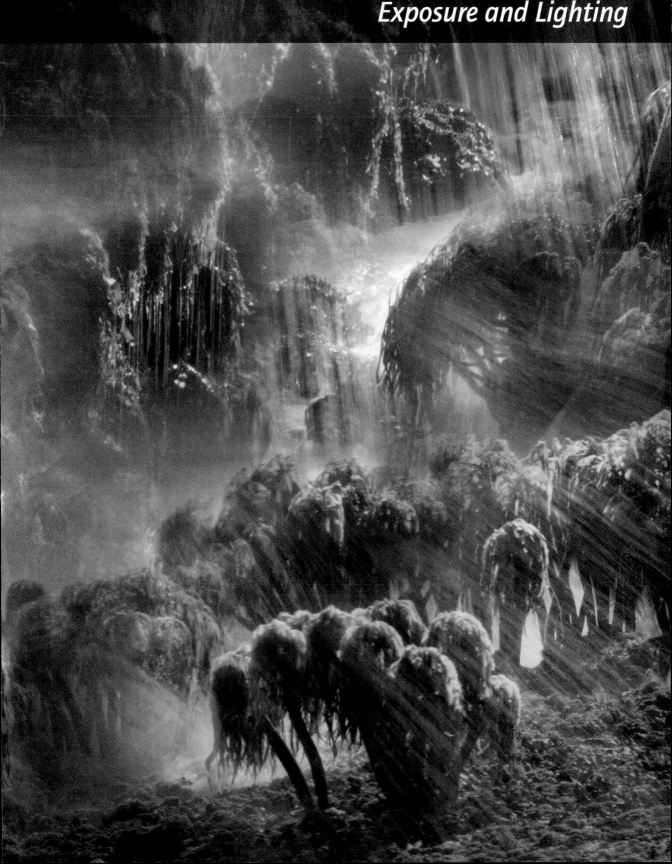

Understanding Exposure

To make a photo, light enters through a camera's lens and proceeds to hit the sensor. From the viewpoint of the camera—and the photographer—the exposure settings used by the camera translate this incoming rush of light via hardware and software into a file that can be viewed or printed.

If the exposure settings are wrong, the resulting photo may not be usable. Extreme overexposure—where the camera's controls are set to allow in too much light—will produce an all-white photo without any details. At the other extreme, very underexposed photos haven't let enough light in to the sensor—and there's no detail to be seen because the image is all black.

When there is detail to be seen in a photo, the exposure settings control how the incoming light is rendered. In other words, unless you are using a *camera obscura*—a pinhole device without optics or exposure controls—how an image is rendered is a two-step dance. This dance involves both the light transmitted or reflected by the scene the camera is capturing, as well as what the camera does with that light.

This relationship, or balancing act, between incoming light and the camera's exposure controls has often been referred to as an equation (sometimes called the *exposure equation*). In other words, when incoming light is exactly balanced by the camera settings, then you get a theoretically "correct" (or "proper") exposure.

Don't start worrying that you are going to have to use equations and algebra to be a good photographer! For one thing,

▶ This is a bedroom in a simple country inn that rests on the slopes of Mount Tamalpais above San Francisco, California. It can only be reached by hiking along a trail on the sides of the mountain. When I reached the inn in the late afternoon, light was streaming in through the window of this back bedroom. I set my exposure to capture some detail in the room, while showing that parts of the room were in deep shadow in contrast to the brilliant sunshine coming in through the window.

20mm, 3 seconds at f/22 and ISO 200, tripod mounted

▲ Pages 68-69: Along the rugged northern California coast near Point Arena, I stopped to photograph a bed of sea palms—a kind of kelp—as the plants were struck by surf in the intertidal zone. To get a sense of the scale, one of the sea palms in the foreground of the image was about one foot high.

My son Nicky and I were alone on a rocky cliff facing the pounding ocean. Even though we were not in danger, he was worried that we would be swept away and kept running up to higher ground.

My goal in making the image was to show each individual sea palm in motion caused by the pounding surf. But the problem was that the individual plants didn't move synchronously. I knew that if I held my shutter open long enough to capture all the plants in motion, my image would be way overexposed (and maybe even white). So I took 45 individual exposures, spaced out over about an hour, at settings that would correctly render the individual plants. When I post-processed the plants, I combined them using a technique called *stacking* (see pages 150-157)—essentially creating a still version of time lapse photography.

48mm, 45 exposures at shutter speeds from 1/6 of a second to 1/20 of a second, exposures combined in Photoshop, each taken at f/29 and ISO 100, tripod mounted

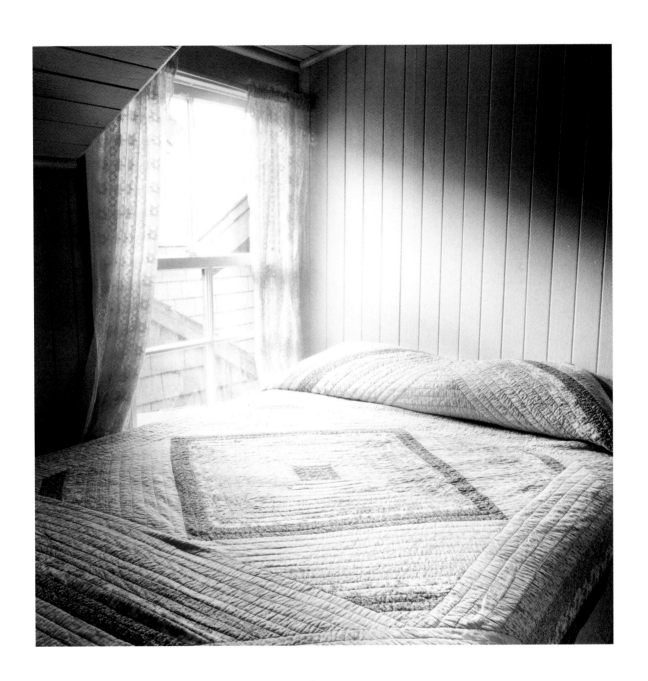

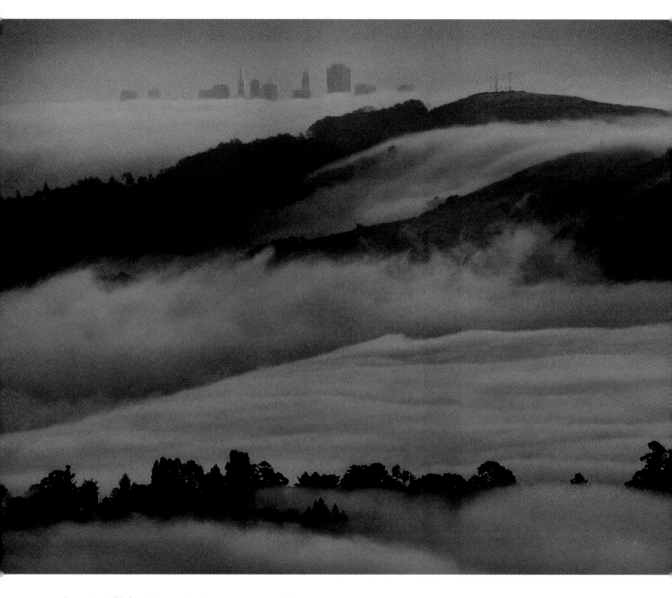

▲ I knew that if left to its own device my camera would create an average exposure of the scene of San Francisco, California shrouded in afternoon fog. In making this average exposure, the camera would be fooled by the prevailing bright light coming off the fog, and everything would seem way too light and bright. So I made sure to considerably "underexpose," letting the clouds go gray and the hills and trees become very dark—which led to a more pleasing overall image.

200mm, 1/250 of a second at f/9 and ISO 200, tripod mounted

theoretical correctness in exposure is truly unimportant to how a photo comes out. For another, there are only a few variables you can use to set a camera, and their relationship is pretty simple. It's amazing—but true—that much of the technical craft of taking photos can be understood and mastered as long as you understand what goes into an exposure.

The three exposure controls you can use on your camera to adjust for incoming light are aperture, shutter speed, and ISO.

Aperture is easily understood as the size of the opening inside your lens that lets light through. The larger the opening, the more light reaches the sensor—and the smaller the opening the less light gets in. Aperture is explained in more detail on pages 82-85.

Shutter speed is not really a speed at all; rather, it is a duration of time—how long the shutter is left open to allow light to pass in through the lens to the sensor. For more about shutter speed, see pages 86-91.

ISO, also called *sensitivity*, is used to set how light sensitive the sensor is.

In the days of film, ISO was mostly set depending on the film you used (although some films could be processed to raise or lower effective ISO). In the digital era, one can dial-in ISO on a per-exposure basis—with trade-offs explained in detail on pages 92-97.

Aperture, shutter speed, ISO—this is the triangle used to control the way incoming light is rendered by creating an exposure. The point is that if these three are set to match the incoming light, they are in a kind of balance. If you decide you need to change one of them, you'll have to compensate by changing another to keep the balance!

You'll find that if you start thinking in terms of the three exposure variables as you make photos that pretty soon you'll unconsciously know how to set your camera—and your images will greatly benefit.

Get your camera off Automatic

There are several good reasons for taking your camera off Automatic exposure control, and never turning Automatic back on. I like to think I am smarter than my camera, and usually I am!

Your camera is only a bunch of electronic circuits connected to a lens. Your camera can read light—but not think creatively. So become the boss of your camera by not letting the Automatic exposure setting take over.

If you don't set your own exposures—using

Manual exposure—you won't learn about the subtle, and not-so-subtle, impact that changing your exposure settings can have.

Sure, there's a place for Shutter-preferred or Aperture-preferred exposure modes. And, sometimes I even use fully Automatic exposure—for example, when the subject is moving faster than I can think or react.

But in most situations you will do yourself a big favor by using Manual exposure. It's also the only real way to get a sense of your exposure controls that will become intuitive, unconscious, and second nature.

Overexposure and Underexposure

Imagine Goldilocks, the aspiring photographer, entering the cabin of the three bears. Each bear has left a digital camera for Goldilocks. She tries the first camera (by the way, it belongs to Papa Bear and is a big, honking DSLR). It's apparent when she looks at the LCD that her shot was way, way overexposed.

Next, Goldilocks tries the medium-size Four Thirds camera left out by Mama Bear, but—as you may be expecting by now—this camera is set to underexpose, and the image in the LCD screen is all dark.

Finally, Goldilocks tries the tiny point-and-shoot left behind by Baby Bear. Because my fable is about exposure and not hardware, the shot taken by this little camera is just right in terms of exposure.

As Goldilocks thoughtfully taste-tests the porridge, and prepares to take a nap, she muses, "So just what is so gosh darn important about being just right with exposure? And what does it mean, any way, to use the right exposure?"

These are both good questions. Generally, when people say an exposure is "right," "correct," or "proper" they mean that the exposure settings are balanced for the incoming light, according to an average reading of the light. There are many technological nuances to how cameras attempt to accomplish determining an average exposure. However, the method used to determine average exposure is not really as important as camera manufacturers would have you believe, and a complication that I won't get into.

What I will tell you is that the so-called right exposure is almost always wrong!

Usually, the subject of a photo has a spectrum of exposure ranges within it. There are light areas, dark areas, and midtones. The right exposure will be wrong for most of these areas, and the photo will work with the so-called "right exposure" only if what you are most interested in happens to be in the middle of the exposure range.

In other words, the part of the subject that is most important is usually what should be exposed properly. For example, if you are photographing a portrait on a dark background you probably want to expose for the subject's face, not the average between a dark background and the face (which would end up overexposing the face to get the dark background right).

Furthermore, sometimes a photo needs to be underexposed. For example, a night scene really doesn't look like night if it is as light as day. Other photos need to be overexposed. For example, if you want to convey transparency on a white background it is effective to somewhat overexpose your image.

So there really is no such thing as a "right," "correct," or "proper" exposure—or, at least, thinking about these concepts doesn't lead to good photography. Instead, realize that the exposure you want to use depends on a

▶ In this light and airy image of a blossoming cherry branch on a white background, I intentionally overexposed by several f-stops for creative impact.

100mm macro, 4 seconds at f/22 and ISO 100, tripod mounted

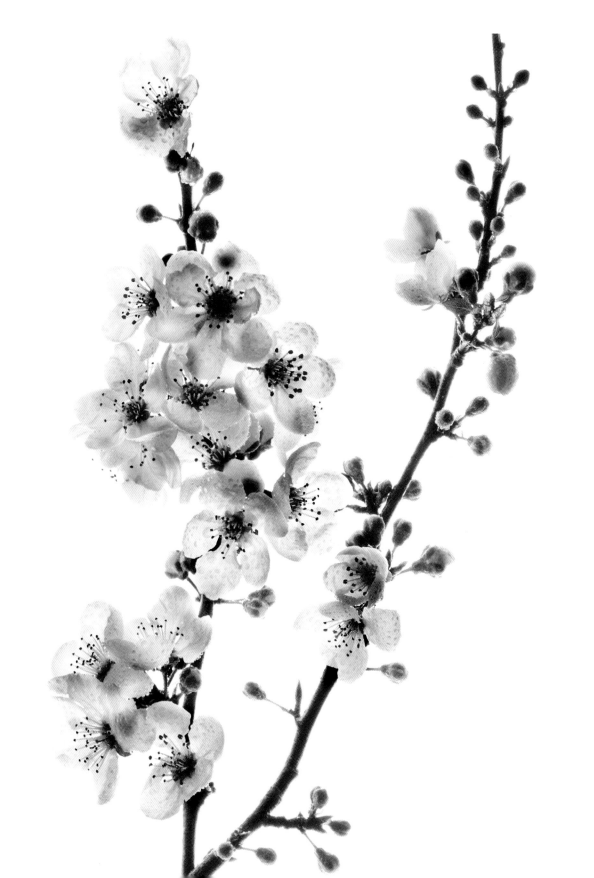

number of creative factors—such as which element in your photo is most important, and whether you want the photo to look dark or light overall.

You need to decide how you want to expose a photo based on your read of how the subject is lit, and your individual taste. This brings up an interesting question: since exposure can be substantially corrected in processing digital RAW files, does it generally make sense to bias your exposures to the under-or-over direction—that is, compared to the exposure you've derived as aesthetically correct, not some notional "right" exposure?

This turns out to be a surprisingly complex and controversial issue. The fact that you can adjust exposures in post-processing means that there are a number of variables.

The orthodox position is that RAW exposures that are slightly biased to the overexposure side have a greater range of tonality—and make better prints. However, while you can recover from many exposure problems in the RAW conversion process, highlight blowout can often not be fixed—and this argues against overexposure. In addition, I find that exposures tend to appear more colorful and saturated when they are slightly biased towards the underexposure side.

Personally, I tend to shoot biased slightly towards underexposure—unless I am trying intentionally for an overexposed, high-key look. If this issue concerns you, you'll have to run some tests and see what works best for you.

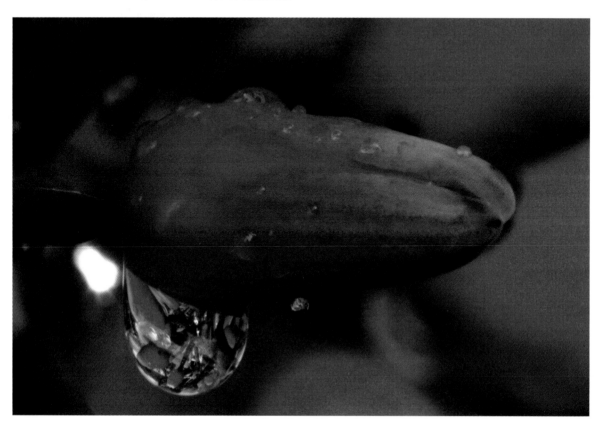

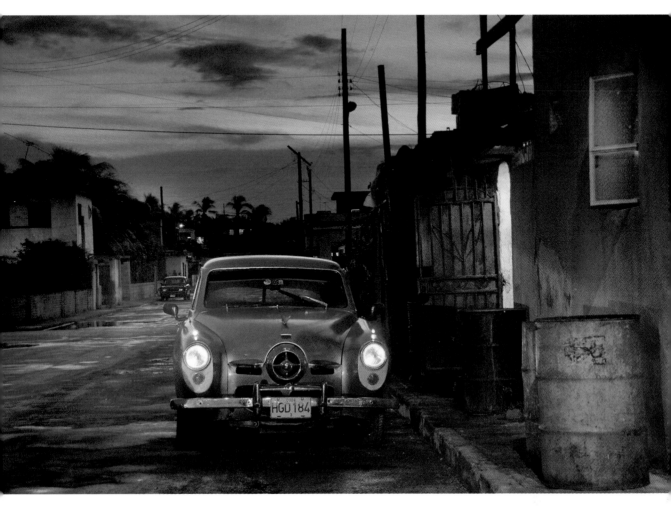

▲ Hemingway hung out in a café in this small fishing village, Cojimar, in Cuba near Havana. In making this image on a back street in Cojimar as dusk turned to night, I wanted to make sure I underexposed to leave the image dark and saturated with the colors of the night.

52mm, 2 seconds at f/6.3 and ISO 200, tripod mounted

◀ Clearly, with this image of a water drop underneath an aloe blossom, the key area for exposure is the water drop. I was okay with the background going dark, and the star burst of sunshine to the left of the bud blowing out with overexposure.

200mm macro, 36mm extension tube, 1/4 of a second at f/40 and ISO 200, tripod mounted

Using a Histogram

Knowing the difference between over and under exposure is important to photographers. For a fable concerning Goldilocks and the three photographing bears that partly explains why this matters, see pages 74–77.

If you are concerned that it will be difficult to tell underexposure from overexposure, never fear—a visual aid is here!

A histogram is simply a bar graph of values. An exposure histogram is a graph of tonal values in a photo, usually from dark to light (see examples on pages 78–81).

The tonal values from black to white are shown along the bottom of the histogram. Any time a tonal value appears in a photo, a line is shown going up. The higher the line, the more of the tonal value.

In aggregate, the lines representing tonal values form a kind of curve. As you get to know histograms, you can tell a great deal about your exposure by looking at the curve shown by the histogram.

A curve that is primarily to the left (this kind of exposure histogram is sometimes called "left-biased") usually represents underexposure, while a curve that is primarily leaning to the right means overexposure (this kind of curve is called "right-biased").

In this real world, life is never as simple as one would like, and the issue of reading a histogram is complicated by the fact that it graphs real world values of light and dark. For example, the photo you are creating may contain a great deal of dark subject matter. If you want to keep these dark things looking dark, then the appropriate histogram would be biased to the left.

Conversely, if you want to keep bright subject matter light, then you want to have a right-biased histogram.

In other words, the validity and utility of an exposure histogram depend upon your subject matter, lighting, and the goals of your image. There is never an absolutely correct histogram independent of these factors.

You can take advantage of the information inherent from an exposure histogram in all parts of the digital photography workflow: before you make an exposure, after the

▶ With its white background and overexposure to create a transparent look, this image of poppies shows a substantial presence along the right side of the histogram (below), and relatively few tonal values elsewhere. Despite the unusual graph of values, the image is exposed the way I wanted.

50mm macro, 4/5 of a second at f/11 and ISO 100, tripod mounted

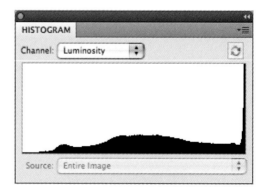

Poppy histogram in Photoshop following RAW conversion

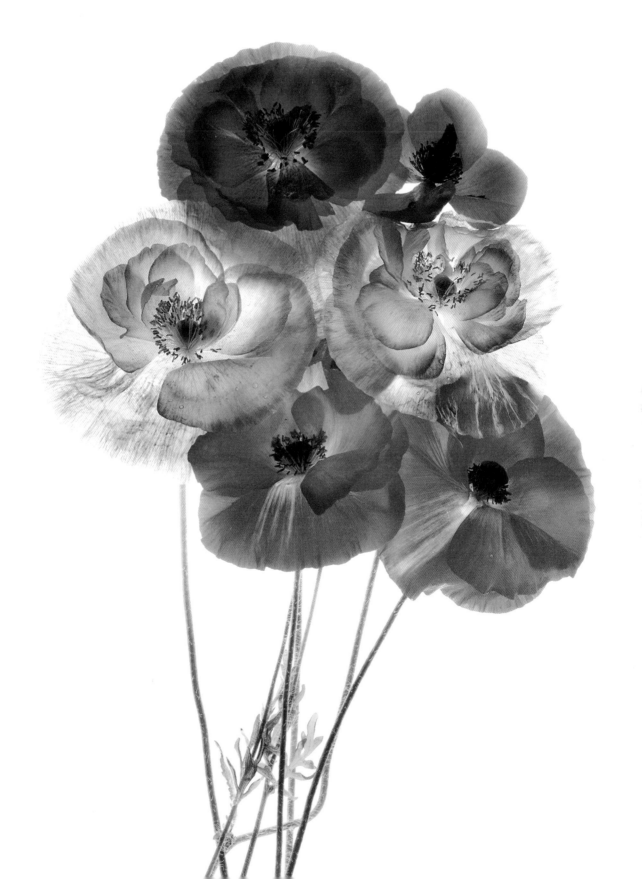

▲ With its black background and predominantly saturated colors, the histogram for this finished image (right) shows a substantial presence along the left side, with minimal tonal values elsewhere. This distribution of values is what I would normally expect—and desire—when I'm shooting a subject on a black background.

Lensbaby Composer with fisheye attachment, lens at maximum aperture (about f/2), six exposures at shutter speeds from 1/5 of a second to 1/50 of a second (exposures combined in Photoshop), each exposure at ISO 100, tripod mounted

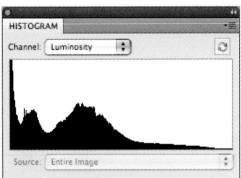

Passiflora histogram in Photoshop

exposure in the camera, while processing a RAW photo in the digital darkroom, and when you make adjustments using post-processing software such as Photoshop.

This leads to an extremely important point. It's a mistake to try to read a histogram in a vacuum. The values you see in an exposure histogram depend upon the values in the photo. Your ability to size a scene up for lighting, combined with the way it looks in your LCD following exposure (or using Live View), combined with the exposure histogram create a far better "picture" of an exposure than any of these three tools by itself.

For best results, check out the situation by eye. Review it visually on your camera's LCD. Note that the LCD can be wildly inaccurate—particularly in situations where the exposure choices aren't very good and have stretched the capabilities of the digital file, but the camera has compensated for the LCD display. So it is important to compare the visual input you get from the LCD with the data in the exposure histogram. Extreme spiking on the left or right of the histogram may reveal problems that don't show up when reviewing images on the LCD; if you are in the field, and find this kind of problem, hopefully you can fix it by changing your exposure settings while there is still time.

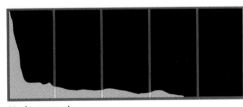

Underexposed

◀ This histogram shows an exposure that is bunched to the left, meaning that it is likely to be underexposed. However, since a histogram graphs the light-to-dark values in a capture, if what you are photographing is predominantly black (for example, a vase containing flowers on a black velvet background), then this graph may, in fact, represent the exposure you want.

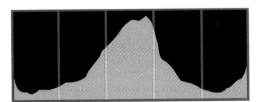

Midtone exposure

◀ This histogram shows a roughly normal distribution of exposures, provided that the subject being captured includes a full range of lights and darks. Of course, the actual histogram will depend upon the lights and darks in the subject, as well as your exposure settings. You can see in this fairly middle-of-the-road histogram that there are some black values and some white values, with the bulk of the exposure values in the midtone (the center of the graph).

Overexposed

◀ This histogram shows an exposure that is likely to be overexposed—you can tell because the exposure values are bunched to the right. However, if your subject includes a great deal of very bright or white tonality (for example, a transparent flower on a white light box), this may be the histogram you get—and it may be perfect for the capture you want to make.

Aperture

Aperture is one of the three factors you can use when setting an exposure (as I explained on pages 70–73, shutter speed and ISO are the other two). The aperture is, er, well, an aperture or hole on the inside of the lens. You can make this hole bigger, to let more light into the sensor, or smaller to let less light into the sensor.

If this sounds pretty simple, it is. However, as I'll explain in a moment, your aperture setting has a major creative impact on aspects of your photo besides just the exposure.

Note that if you want to change your aperture without changing your overall exposure—because the exposure is balanced where you want it—you need to make an appropriate countervailing adjustment to either shutter speed, or ISO, or both.

The mechanism used for setting your aperture depends upon your camera, and perhaps upon the lens you are using. If you don't know how to set your aperture in manual mode, you'll need to check your manual—but it's most common with digital SLRs to set aperture using a command dial. Aperture is set on some older, or manual lenses, using a dial on the lens itself.

Believe it or not, there's at least one contemporary lens—the Lensbaby—in which aperture is controlled by dropping a physical disk with a hole into the barrel of the lens.

Beyond how you set it, you may find aperture somewhat confusing because of the notation used to describe it. Aperture is referred to using f-stop notation, for example, f/5.6. In this example, 5.6 is called the *f-number* and f/5.6 is the *f-stop*.

Now for the confusing part: the larger the f-number, the smaller the opening. f/36 means a much, much smaller opening than f/2.8.

When a lens aperture is set as small as possible, the lens is said to be *stopped down*. A lens set to the maximum aperture is *wide open*.

Here's a technical explanation of how f-numbers work. Don't worry, if this makes your eyes glaze over, you can skip the next paragraph, as long as you remember that bigger f-numbers mean letting less light in.

The *focal length* of a lens is (roughly speaking) the distance light travels from the end of the lens to the sensor. An *f-number* is the ratio of focal length to the aperture diameter. An f-stop is one over the f-number, notated f/n where n is the f-number. Each *full f-stop* lets in half the light of the preceding full f-stop (see the diagram below and the table on page 84); a logarithmic relationship is involved because f-stops are defined using the diameter of a circle.

Aperture, Depth-of-Field, and Focus

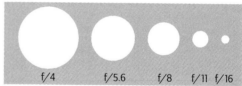

F-stops (shown in relative scale)

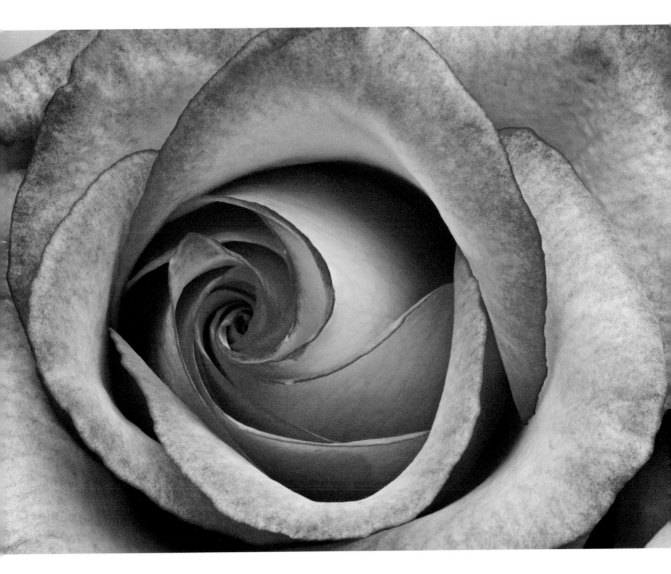

▲ I knew I wanted this rose to be entirely in focus, so I used as small an aperture as possible (f/32) to have increased depth-of-field to work with.

50mm macro, two exposures at 2 seconds and 4 seconds (exposures combined in Photoshop), each exposure at f/32 and ISO 100, tripod mounted

For a given sensor size and lens, the creative control that aperture provides is related to how much of an image appears to be in focus. In some cases, it's nice to have an image that is only partly in focus—for example, an out-of-focus background can help emphasize something important in the foreground of a photo.

In other photos, the desired creative effect is to have the entire image be tack sharp.

The range of focus provided in a photo by an aperture setting is called *depth-of-field*. The greater depth-of-field you have because the lens is stopped down, the greater the range that is in focus; when a lens is wide open you have the least depth-of-field (see the table for a hypothetical example showing the relationship between aperture, the light it lets in, and depth-of-field).

To get the most possible subject matter in focus, you should focus somewhere in the middle of the depth-of-field range. If this is an absolutely critical creative issue, try a number of focus points to see which works best.

Infinity (marked with ∞ on the focusing ring of most lens barrels) is—despite its name—a finite distance: beyond the infinity point for a lens everything is in focus when the lens is set to focus to infinity, even at the maximum lens aperture. In other words, infinity is the farthest distance a lens can focus, and once your subject matter is at infinity or beyond your aperture doesn't matter from the viewpoint of focus.

The *hyperfocal distance* takes the depth-of-field generated by the aperture into account—and is the point at a given aperture past which everything is in focus. These days, there are mobile applications for iPads and other devices that can help you calculate the hyperfocal distance for specific lenses and apertures.

Depth-of-field controls which elements of your photo appear to be in focus, not the overall sharpness of the image.

There are a number of other causes of unsharpness besides focus—for example, when the camera or subject moves. Also, you can have plenty of depth-of-field, and still be out of focus. Furthermore, you should also be aware that most lenses are optically sharpest at moderate apertures in

Full F-Stops	Light allowed in, compared to the maximum aperture	Depth-of-field
f/1.4 (max aperture)	N/A	Lowest
f/2	1/2	Shallow
f/2.8	1/4	Shallow
f/4	1/8	Shallow
f/5.6	1/16	Medium
f/8	1/32	Medium
f/11	1/64	Medium
f/16	1/128	High
f/22	1/256	High
f/32 (min aperture)	1/512	Highest

the f/5.6 to f/11 range—neither fully wide open nor fully stopped down.

Like most aspects of the technical craft of photography, aperture and focus can involve trade-offs.

In terms of focus itself, don't neglect the importance of taking care with camera-subject positioning. Particularly in low depth-of-field images, it is important to keep the camera as parallel as possible with the subject. In some situations this can be measured but in others determining parallelism is a seat-of-the-pants kind of thing.

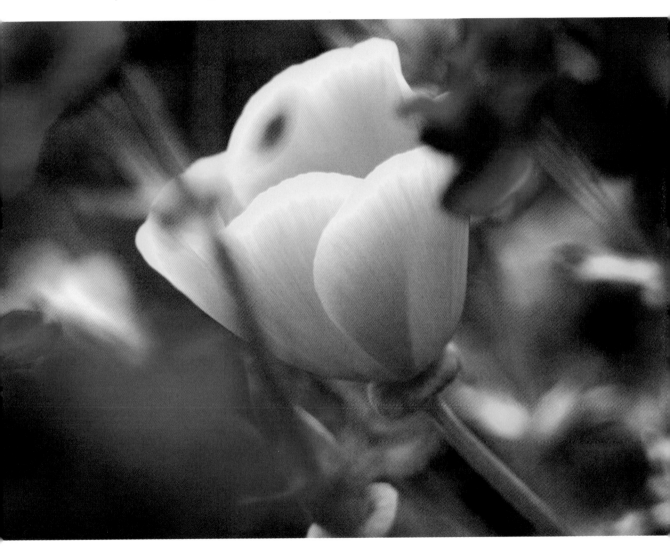

▲ I knew this shot would be most interesting if I could get the foreground and background out of focus, with only the single orange flower sharp. So I used a wide-open, large aperture (f/5.6) to create the effect that I had pre-visualized.

130mm, 1/125 of a second at f/5.6 and ISO 200, tripod mounted

Working with Shutter Speed

When you set the shutter speed on your camera, as I've mentioned, you are actually setting a duration of time. A slow shutter speed lets more light into the sensor, and a fast shutter speed lets in less light. For example, a shutter speed of 1/2000 of a second allows very little light in to be recorded, while a shutter speed of ten minutes allows a great deal of light in.

It's important to understand that shutter *speed* is badly misnamed. This setting doesn't control a speed at all; rather, it controls an interval of time. Once you realize that the true nature of the setting is duration rather than speed, you won't have any trouble understanding how to set your shutter.

The goods news is that it is easy to work with shutter speeds when you calculate exposures because the setting has an entirely linear effect. A shutter speed of 1/2000 of a second lets in half the light as a shutter speed of 1/1000 of second, and 2 seconds lets in twice as much light as a shutter speed of 1 second. The simplicity of this arithmetic makes exposure changes involving shutter speed very easy to calculate.

Just like with aperture, if you want to change the shutter speed setting for creative or technical reasons while keeping the exposure in balance, you need to effect an equal-but-opposite change using one or both of the two other exposure controls, aperture and ISO.

The main visual impact in a photo of changing shutter speed is how motion is rendered. By motion, I'm referring to two different kinds of motion: camera motion and subject motion.

Camera motion is a simple phenomenon to understand. Depending on a number of variables including lens focal length and whether image stabilization technology is in use, shutter speeds that are too slow produce photos that are blurry and not tack sharp.

Of course, sometimes moving the camera can produce—either on purpose, or taking advantage of serendipity—interesting effects (for example, see the image of surf on page 90).

When it is the subject that is in motion, the choice of shutter speed determines how objects that transmit or reflect light, and are in motion, are rendered. Fast shutter speeds stop movement crisply, while slow shutter speeds can create an appealing motion blur.

▶ I made the creative decision to use as long an exposure as possible to render the flowing water as poetically as possible. Considering the lighting conditions, with my lens stopped all the way down (to f/25), this meant an exposure of 2.5 seconds. With a shutter speed duration of 2.5 seconds, you can see that the fastest moving water becomes completely blurred. On the other hand, water that is moving more slowly—for example, slow drips beneath the rocks—is rendered more crisply, almost the way we "see" it without a camera.

200mm, 2.5 seconds at f/25 and ISO 100, tripod mounted

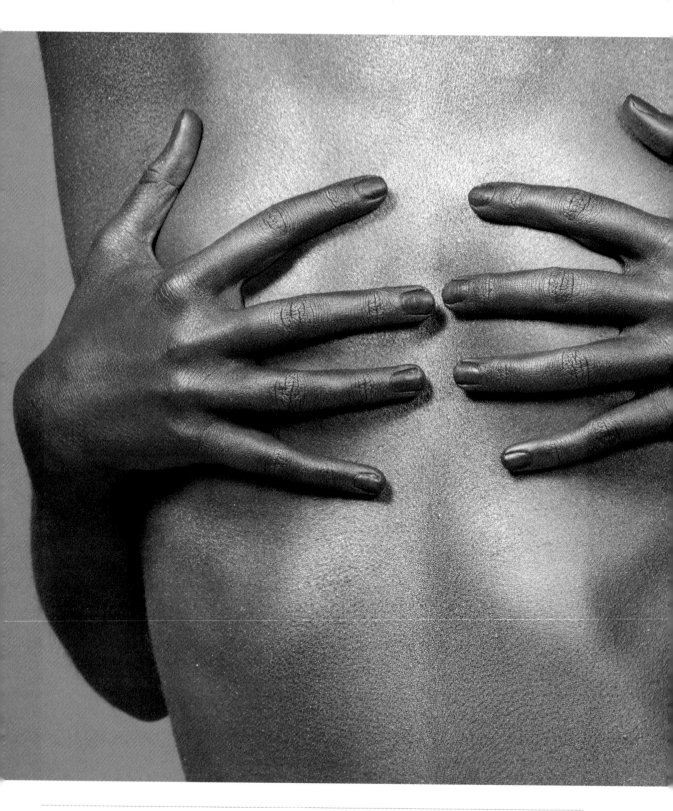

If you've ever photographed moving water, you've probably noticed this effect. Shutter speeds of about 1/250 of a second or faster create crisp trails of water, apparently stopping in its tracks. Shutter speeds of about 1/10 of a second or slower turn flowing water into long, delicate white tendrils.

There's one exception to the principle that the shutter speed controls the rendition of motion. That's when the effective duration of the exposure is actually controlled by a light source, and not by the shutter speed setting. Most commonly, this occurs when a photo is lit using flash, for example in the studio. In this case, the effective duration of the exposure is the length of the pulse of the strobe lighting. Studio lighting is discussed starting on page 162.

In a less common situation, if you are photographing lightning, your shutter speed is essentially irrelevant so long as the shutter is open when the lightning strikes.

◀ In this studio shot of models, the effective duration of the exposure was determined by the strobes, not the camera's shutter speed, which was set to the maximum shutter speed for synching with flash (1/160 of a second for my camera model).

200mm, 1/160 of a second at f/16 and ISO 100, hand held

▲ I was standing at a spot where a small, seasonal creek comes down to the beach. My camera was on the tripod, and I was making an exposure. In the middle of the exposure, a wave came in and I had to grab my tripod and camera to move it out of harm's way.

In the photo you can see the view straight down on the surf (my original photo), as well as the curve of the bluffs surrounding the beach (the second portion of the exposure after I placed the tripod down on safer ground).

While I didn't intentionally move my camera to create this effect—I only moved it to save it from the surf—I find the results a bit eerie, mysterious, and surreal. I've tried to duplicate the idea by intentionally moving the camera during an exposure of the surf, but so far none of my intentional efforts with camera motion have come out as well as this accident.

28mm, 1/4 of a second at f/22 and ISO 100, tripod mounted

▶ This complex exposure involved putting together a number of different captures so that each area in the photo appeared to be well lit. I chose the separate captures that were pieced together to make the final image based on how they rendered the water in motion. The result is as I pre-visualized, with the water in the foreground more blurred than the water further away.

18mm, circular polarizer, six exposures from 1/2 of a second to 8 seconds (exposures combined in Photoshop), each exposure at f/22 and ISO 100, tripod mounted

ISO

If your photo is going to look dark and underexposed—and you don't want it to—the easiest approach to fixing the problem is to boost the ISO, or sensitivity. This is particularly true if the other two exposure controls are up against their limits: you can't use a slower shutter speed without risking loss of sharpness from camera motion or changing the way subject motion is rendered; and you can't change the aperture to one that is more wide open without altering the depth-of-field so that your area that is in focus is lost.

ISO is a number on a scale that the International Organization for Standardization came up with. With film, the ISO was determined by the chemical sensitivity to light of the medium.

In digital photography, you can dial up or down the ISO—meaning light sensitivity—of a digital frame in just the way you could have decided to use a "faster" (more light sensitive) or "slower" (less light sensitive) film. The great news here for digital photographers is that you can set the ISO on a per-frame basis: you don't have to wait to change your roll of film to change your sensitivity. You can decide to dial it up for one shot, then dial it right back down for the next!

No great technical facility comes without a price, and indeed—as I've mentioned—most of the craft of photography concerns the cost-benefit trade-offs of making various decisions bearing in mind what is possible. Boosting the ISO for photography in low-light conditions is not an exception to this principle, with the downside trade-off being increased *noise*—or digital static—as you push the ISO higher.

Note, however, that each generation of digital cameras gets better at shooting at higher and higher ISOs—the capabilities of today's cameras make possible shooting in some situations that would not have been feasible in the past.

In fact, increased noise is not always bad. There's a "toothiness" in noise that can make images appear sharper, and in these cases if you remove the noise as part of post-processing your photo can seem unsharp and lose a sense of definition.

In addition, noise can have an appealing aesthetic of its own. Just as photographers came to prize high grain film images for the look of the grain, there are some photographers that go after noise for the sake of the way the noise looks. These "noise pioneers" actually try to increase noise rather than reduce it.

▶ I wanted this image of the full moon rising over San Francisco Bay to be impressionistic—and almost grainy—so I used an extremely high ISO (3200) and was able to hand hold the shot. The moon was far brighter than the surrounding sky, so I underexposed with the idea of rendering the moon, clouds, and reflection on the water, and letting the rest of the photo go black. This underexposure was an additional source of the noise, which I regard as part of the visual effect I wanted in this shot.

65mm, 1/30 of a second at f/5 and ISO 3200, hand held

Causes of Noise*

Noise is good; noise is bad. For the moment, I'm assuming noise is bad, and you want to remove it when possible. (If you actually want the pernicious stuff, then do the opposite of what I suggest.) The table below shows the most common causes of noise, and what (if anything) you can do about them.

Note that noise as "static on the line" is a fact of physics and digital life, and will always be with us—although often in such minimal quantities that you have to magnify to the pixel level to even begin

Cause of Noise	Comments
High ISO	The higher the ISO, the more noise; the lower the ISO the less noise—this is an incontrovertible fact of basic physics. However, ISOs that are no more than twice the native ISO of a DSLR (typically, native ISOs are 100 to 200, so from ISO 200 to 400) will probably not be a significant cause of noise.
	If your camera has a high ISO noise reduction setting, making sure this is on will help with the noise.
	It is smart to get to know the noise characteristics of your particular camera, as there are many differences between camera models. Making test shots can help you learn about your camera's noise characteristics, allowing you to figure out how far it is "safe" to boost the ISO.
Long Exposures	Exposures longer than about 8 seconds tend to add significant noise; if your camera has a long exposure noise reduction setting, turning this on will help. However, this noise reduction setting is inconvenient because it adds a delay after the exposure during which the camera cannot be used, and it cannot be used in a stacked composite.
Underexposure	Underexposure can add significant noise, subject to the trade-offs discussed on pages 74-77.
Noise "signature" of camera sensor and processing software	Not much you can do about this one except getting a newer model camera if the age of your current one is an issue.
Sensor size	For a given size digital file, the smaller the sensor, the more noise there will be.
Temperature	Unless you shoot really long exposures, sensor temperature is unlikely to be a problem for you. However, when a sensor starts to overheat, noise tends to increase. If you are shooting in warm temperatures, you might consider cooling your sensor with a cold pack to compensate. Ambient temperatures are an overlooked cause of noise—you are far less likely to get a noisy image when shooting in a cold climate. Also, as your sensor heats up because the camera is in use, you start to get more noise—you can help with this by giving your camera a rest, if possible.

and what you can do about them!

to see it. Not only are digital cameras getting better at processing noise, so is software that processes shots, such as the most recent version of Adobe Camera RAW (ACR). This means that you can shoot without flash in low-light conditions that would have been impossible in the past.

If you shoot in the RAW format, you actually get two cracks at removing noise—first when you convert your RAW image to bring it into a program such as Aperture, Lightroom, or Photoshop; and then second as part of your post-processing workflow using a plugin such as Noise Ninja.

▲ I wanted to photograph my daughter Katie Rose in the Newborn Intensive Care Unit (NICU) shortly after she was born very prematurely. However, the conditions posed a considerable challenge because of how little light there was. Making matters worse, tripods and flash were not allowed in the hospital ward. So I boosted my ISO extremely high (to 3200) and made a series of photos that would not have been possible with older technology. Although you can see a bit of noise in the final image, for a photo that tells a story, this level of noise is perfectly acceptable.

80mm, 1/50 of a second at f/5 and ISO 3200, hand held

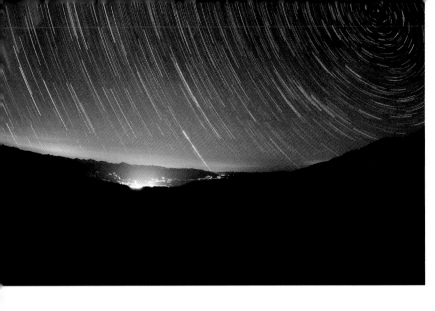

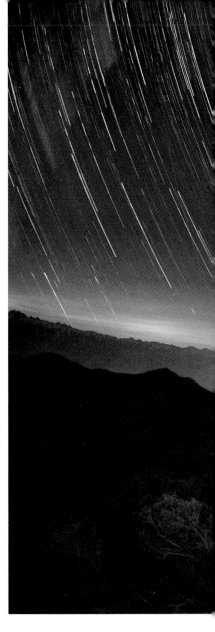

▲ Top: High in the White Mountains of Eastern California, I shot this view of stars over Bishop, California. The composite of 15 exposures (for a total exposure time of about an hour) renders the stars, but left the foreground black.

10.5mm digital fisheye, 15 stacked exposures, each exposure 4 minutes at f/2.8 and ISO 320, tripod mounted

▲ Bottom: The foreground was pitch black, and I couldn't see the proverbial nose in front of my face. To create foreground detail for the image of stars with the black foreground, with the tripod and camera exactly in place, I shot a high ISO (2,500) version of the foreground, exposed to show details.

10.5mm digital fisheye, 30 seconds at f/2.8 and ISO 2500, tripod mounted

▲ I combined the star circles (top left) and the high-ISO foreground (bottom left) in Photoshop using a layer mask and a gradient. The final, combined image shows the star trails as well as the foreground detail. Without the detail in the foreground, this image would have been too dark to be interesting despite the spectacular star trails.

Since I was only able to get into position after dark, boosting the ISO was the best way to achieve an exposure that rendered detail in the foreground. With modern digital equipment, it was possible to boost the ISO high enough to shoot in almost pitch blackness and maintain an acceptable level of noise.

Although the ambient light levels were extremely low, interestingly the city lights of Bishop, California were bright enough to produce highlight blowout—even though Bishop was quite distant from where I was standing.

Background: 10.5mm digital fisheye, 15 stacked exposures, each exposure 4 minutes at f/2.8 and ISO 320, tripod mounted. Foreground: 10.5mm digital fisheye, 30 seconds at f/2.8 and ISO 2500, tripod mounted

Using Exposure Controls with Lighting

The rubber meets the road when you combine knowledge of the controls used in your camera to set the exposure with knowledgeable observations about lighting (which is the subject of the first part of this book, pages 10-67). As I explained earlier (pages 70-77), the light meter in your camera will indicate that an exposure is correct when the camera settings balance the light reflected or transmitted by your subject, most often on an average basis.

As I've explained, this theoretically correct exposure is only the starting place. Taking advantage of your careful examination of the way your subject is lit, you need to understand the implications of the lighting for the image you have pre-visualized (for more on pre-visualization, see pages 108-111).

What's important about the lighting? Is it the shadow areas, bright areas—or both? Or, does the contrast between lights and darks make your image interesting? How does the quality of light work for—or against—the kind of image you are trying to create?

Try to pinpoint the interplay between lighting and exposure, so you can use your exposure controls to their best advantage. It's interesting that fairly minor adjustments in exposure can make a huge difference to your final image—and in many cases are the margin between a banal and uninteresting photo, and one that sings with majesty and clarity.

Also, don't forget to think about the direction of lighting (see pages 28-33). Front lighting produces the most uniformly well-lit subjects—without, however, as much opportunity for creative exposure effects. Side lighting can create strong shadows with the opportunity for creative underexposure—to emphasize the shadows—or overexposure, to bring out dark areas. Backlighting often tends to call for overexposure, either to create the illusion of transparency or to bring out areas in the front of the subject that are not well lit.

There's no one-size-fits-all formula that you can use to establish an exposure—or the correction to an exposure based on the specifics of your subject. Armed with understanding about how to observe light, and knowledge of what the exposure controls in your camera do, you can begin to make exposures that utilize your creativity.

Experiment! Often, an exposure that diverges radically from the camera's idea of the correct exposure produces interesting results. After all, there's really no cost to trying various ideas: as we like to say, "Film is so expensive!"—an ironical comment, because expense of the capture media is no longer a factor in the digital era.

By trying many different responses to various different kinds of lighting you'll learn what works—and what doesn't work—in relationship to your own sense of the kinds of images you'd like to make.

▶ This photo of a rose is seen as a contrast between bright, luminous areas and very dark shadow areas because I lit the rose at a low angle from the sides (to make the strong shadows) and then underexposed the image to create the compelling effect that you see here.

200mm macro, 1 second at f/36 and ISO 100, tripod mounted

▲ In this landscape taken from the edge of the volcanic table lands in Owens Valley, California, the prevailing light direction was from the west, where the late afternoon sun was starting to set—in other words, from the upper right of the image, essentially backlighting my subject.

Long, dark shadows were cast, particularly on the lower right. A single, largely dark image that showed this contrast might have been interesting, but instead I chose to show several versions that I could later combine—because I wanted to make sure that viewers could clearly see the road on the right vanishing into the distance. The idea behind this combination was to use a substantially overexposed version of the image to "paint in" the dark foreground areas—and create an image that essentially has no directionality to the lighting. For information about combining captures to enhance lighting, see pages 210–247.

20mm, six exposures at shutter speeds from 1/13 of a second to 1.6 seconds (exposures combined in Photoshop), each exposure at f/22 and ISO 100, tripod mounted

◀ In a dark alley in central Havana, Cuba, I happened to look up. Lying flat on my back, and composing with a wide-angle lens, I used the pattern of light in the sky against the decaying buildings to create an interesting composition. I had to shift the position of the camera to make sure that the direct sun was not included—the contrast between super bright sun and relatively dark buildings would have been impossible to render effectively in my final image.

12mm, 1/400 of a second at f/10 and ISO 100, hand held

White Balance and Color

I noted earlier that the color of light is an important part of our perception of light quality. The color of light is measured on the Kelvin scale as temperature. Perceptually warmer colors (those toward the red end of the spectrum) have a lower color temperature than perceptually cooler colors (those colors that are bluer) which have a higher color temperature. For more on the color of light, see pages 34–39.

It's important for photographers to be able to differentiate between different colors on the spectrum, because the rendition of color has a huge impact on the final appearance of a photo. The color in your photo will primarily be rendered according to the color temperature of the lighting and the white balance settings applied to that lighting.

Most digital cameras have a built-in color spectrometer, which is what sets the color temperature when you leave White Balance on Auto. If you think you know better than your camera (which can often be the case) you can set the White Balance, either to a Preset such as Daylight or to a specific Kelvin temperature.

Of course, it is possible to accurately calibrate color temperature, particularly in situations where the lighting is controlled. However, accurate color calibration is not often really possible in the field. The light may be coming from various sources with different colors, and going by the "seat of your pants" is good enough. Put another way, for creative impact I care about the color rendition in the final image and the emotional response it elicits, not the degrees Kelvin at the time I took the photo.

Shooting in RAW means never having to say you are sorry. Your White Balance settings are not actually applied to a RAW file until you process it. (Actually, they are never applied directly to the original RAW file, which you should archive for safety.)

This means that the consequences of your in-camera White Balance settings with a RAW exposure are limited to how the capture looks in your LCD, and the default settings when you open the file to process it in a program such as Adobe Camera RAW (ACR) or Lightroom.

Since the White Balance setting can make a huge visual difference, the appearance in the LCD is important. I remember shooting a forest in radiant diffuse lighting, and seeing dull images on my LCD. It wasn't until I adjusted the White Balance that I saw the scene on the LCD the way it looked to my eyes. As in this scenario, tuning White Balance can be significant to the feedback you are getting about your shooting—even though it is not irrevocably applied to the image.

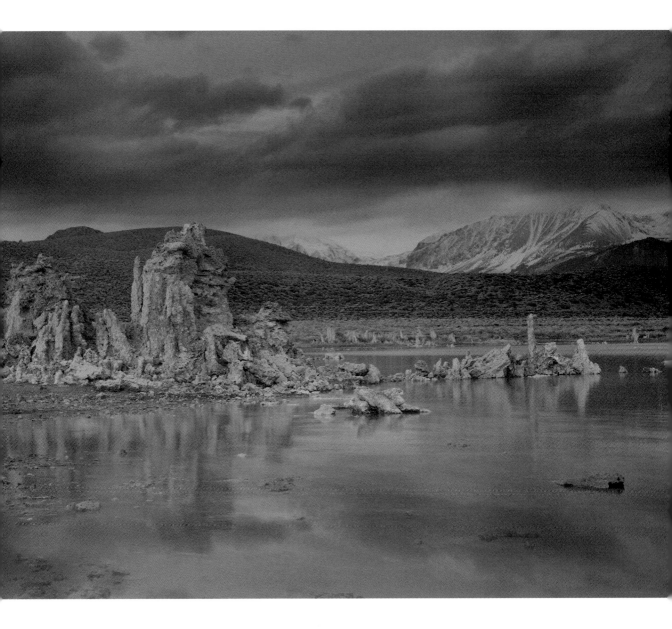

▲ This image, taken at dawn of the tufas of Mono Lake, California, with snowy mountains in the background, has been cropped and adjusted for color as it was processed (see pages 104–105).

34mm, 1/2 of a second at f/9 and ISO 100, tripod mounted

Processing a RAW file in a program such as ACR or Lightroom is the first—and best—place to adjust any issues with color temperature. You can use the color settings when you interpret the RAW file to improve the image, or to bring it more in line with the way the subject seemed to you when you shot the image. Essentially, this is a place for you to exercise your visual taste.

For example, I arrived at the shores of Mono Lake, California in the middle of the night in the freezing rain. Waking at dawn, I found a blue world around me, and I shot an image of the Mono Lake tufas with the snow of the Sierra Nevada Mountains in the background (photo on page 103).

When I opened the image in ACR, by default it displayed the As Shot White Balance settings (Figure 1).

My impression of the scene at the time I took the photo was that everything was much more blue. To adjust the overall color values in the image towards the blue side, I pulled the Temperature slider to the left (towards lower numbers) as shown in Figure 2.

The blue adjustment helped, but the photo was still not quite where I wanted it to go—further adjustments would need to wait for Photoshop!

If I had wanted to *remove* blue from the image—a very valid aesthetic choice, by the way—I would have moved the slider in the opposite direction, to the right, as shown in Figure 3.

By the way, the controls in the White Balance block of the ACR window allow you to shift color along two axes: The Temperature slider changes color by making the color more yellow or blue, whereas the Tint slider changes color along a scale from green to magenta.

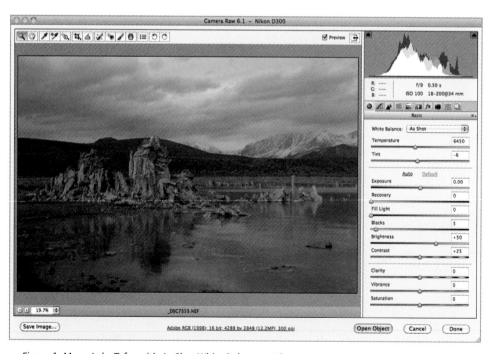

▲ Figure 1: Mono Lake Tufas with As Shot White Balance settings.

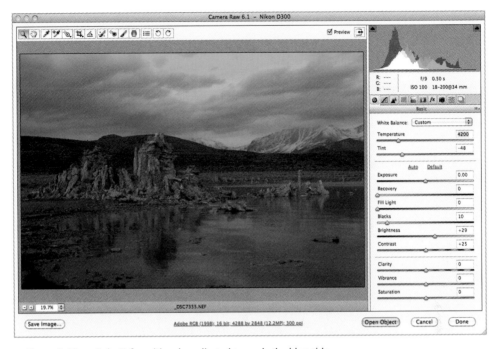

▲ Figure 2: Mono Lake Tufas with color adjusted towards the blue side.

▲ Figure 3: Blue has been removed, and yellow added to the image.

In another example, I shot a plate of peaches using daylight to bring out the luscious color of these locally grown peaches. The lighting setup was very simple, with only a white fill card to cut down on shadows.

Opening the image in ACR (Figure 4) I found the As Shot White Balance settings had lost some of the appeal of the peaches.

Moving the Temperature slider to the left added some blue and made things worse (Figure 5).

However, sliding Temperature to the right boosted the intensity of yellows (Figure 6), and gave the peaches the appearance I wanted. Note that I didn't want the background quite as yellow as the peaches, so I applied two separate adjustments: one for the plate of peaches, and one for the background.

▶ Figure 4, top: Peaches, using the As Shot White Balance settings.

▶ Figure 5, middle: Peaches, with blue added by moving the Temperature slider to the left.

▶ Figure 6, bottom: Peaches, adjusted to add yellow to the color temperature.

▲ I photographed these peaches using natural daylight, shown here cropped and with the White Balance adjusted (see page 106). With simple images that don't have a great many visual elements, color rendition set via White Balance can make or break the visual appeal of your final photo.

50mm macro, 1/20 of a second at f/11 and ISO 100, tripod mounted

Pre-Visualizing the Impact of Lighting

Ansel Adams popularized the concept of pre-visualization, which he defined as the "process of 'seeing' the final print while viewing the subject." Adams explained that "with practice the photographer can anticipate the various influences of each stage of photographic procedure, and incorporate these intuitively in visualizing a final image."

With the advent of digital, pre-visualization skills are even more important than they were in Adams's era. Every RAW file can be processed and adjusted in myriad ways—and the final image depends as much upon these procedures as it does upon the original capture.

While greater variations are easily possible before one even gets to the print-making stage, the skills needed for pre-visualization are essentially the same as they were before digital. Some fundamental rules will always apply. The most important idea is to understand the emotional response you want to engender in someone looking at your image, and carefully consider how the lighting in your photo will work to achieve that response.

What is most important in your image? Where is the emotional "punch" in an image going to come from? Are you going to show your viewers something they wouldn't have seen before because it appears

shrouded in darkness? In this case, exposure can be used in response to the lighting to "open up" dark areas of the photo, making the viewers of your image feel that they are privy to deep and dark secrets.

If the emotional point of your photo is to show an intricate and interesting object against a dark background, then you need to light the object so that it appears radiant, and expose for the object, letting the background possibly go dark.

Images intended to convey a bright and almost ethereal effect need to be exposed so that they are very light—but at the same time no important details are lost.

If the point of your composition is to show an interesting and unexpected pattern, then you must be sure your lighting and exposure renders repeating elements so that viewers will regard them as a pattern.

Whatever the image you've pre-visualized, using lighting to your advantage is the first—and probably most important—step in a process that involves all facets of digital image processing. It's important to consider your lighting in the context of digital procedures—and make your exposures armed with experience about what is possible in the context of how you plan to process your image.

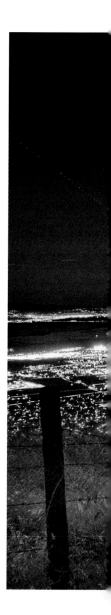

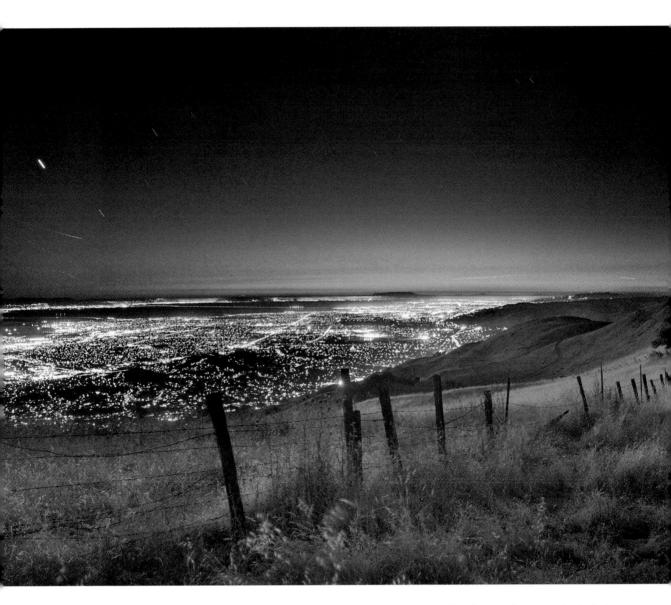

▲ The view from the slopes of Mission Peak—above Fremont, California—was almost completely dark in the foreground, with the lights of the San Francisco Bay region twinkling in the distance. While shrouded in darkness, I knew there was a rustic, wooden cattle fence along the slopes. I pre-visualized a photo showing the contrast between the dilapidated fence and the modern city beyond, and picked an exposure long enough for the fence and foreground to become clearly rendered.

18mm, 3 minutes at f/5.6 and ISO 100, tripod mounted

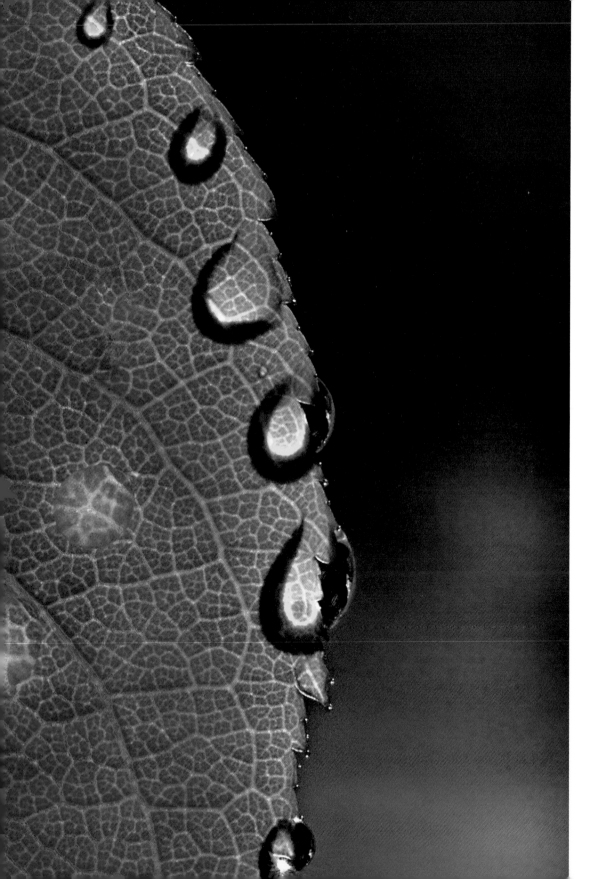

▲ My idea was to expose this image so that only the light reflected by the red pepper would show and the rest of the image—consisting of out-of-focus dark green peppers—would go very dark. In other words, the pepper would be viewed as if it was floating in space.

85mm perspective-correcting macro, 8 seconds at f/51 and ISO 100, tripod mounted

◀ Shooting this image of water drops on a leaf's edge in the early morning sun, I pre-visualized—and exposed for—an image that showed the pattern in the leaf, and the back lit water drops, while allowing the background to go very dark. Besides the backlit water drops, the most important element in this composition is the edge of the leaf.

200mm macro, 1/160 of a second at f/16 and ISO 200, tripod mounted

Understanding Ambient Light

Imagine you are adrift in an uncharted sea on a small life raft. You are in luck—it is not too hot because there's an overall haze. But it's hard to tell one direction from another because there's no clear direction of lighting and you don't know where the sun is.

In your imagination, you've just pictured classical *ambient* lighting. When someone says "ambient light" they are essentially using a fancy term for the light that is there anyway—often (but not always) with the implication that the ambient light has no clear directionality.

A related term is *available* light—which simply means the light that is present from any source not supplied by the photographer. If you didn't bring a flash or continuous light, then you are using available light. However, available light can be highly directional—for example, the sun at the horizon just before it sets. So ambient and available light are basically the same thing—with the expectation that

ambient light tends to be more overall and less directional.

When you hear a photographer talking about ambient light, it is usually kind of dismissive. For example, "Oh, I just used ambient light." This isn't because the photographer is actually contemptuous of ambient light. Rather, it is because except in the studio—where almost all light is intentionally created—we expect ambient light to be with us, in the background, surrounding us. Because it is something we take for granted, it is not something we pay too much attention to. Big mistake!

The trick is to pay close attention to ambient light conditions. Even subtle variations in ambient light can make a big difference in your photos if you learn to manipulate ambient light conditions via the design and conception of your photo, exposure (pages 68-111), camera position—and, often, by adding to the existing ambient light. If you pay attention to the subtleties of ambient light, your effort will certainly be rewarded.

24mm, 7 seconds at f/25 and ISO 100, tripod mounted

18mm, 2 seconds at f/22 and ISO 100, tripod mounted

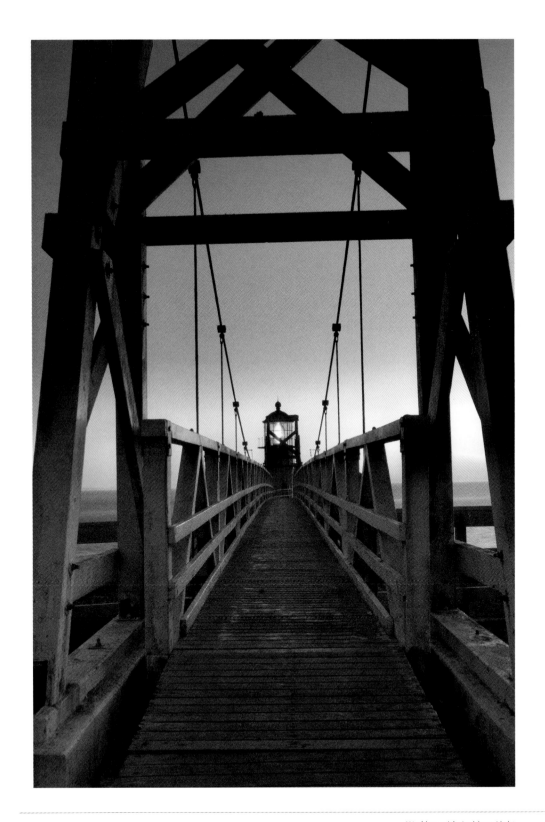

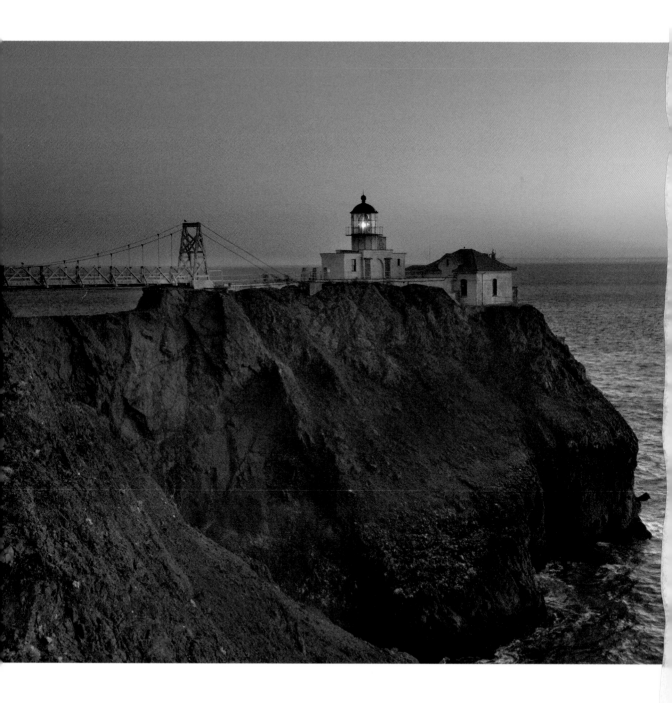

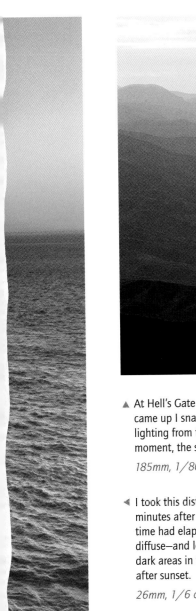

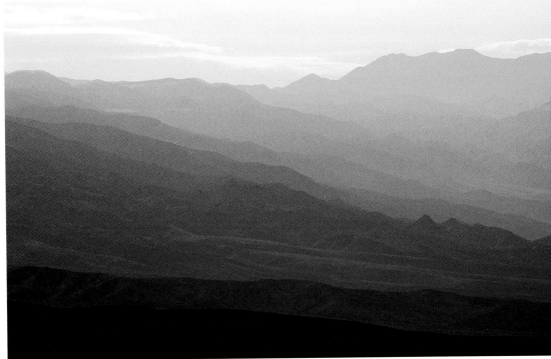

▲ At Hell's Gate in Death Valley, California, I waited for sunrise. Just before the sun came up I snapped this shot, lit generally by ambient light with some directional lighting from the rising sun beyond the range of mountains shown. In the next moment, the sun came over the horizon and the lighting changed entirely.

185mm, 1/80 of a second and f/29 at ISO 200, tripod mounted

◀ I took this distant shot of the Point Bonita, California lighthouse about ten minutes after I shot the image shown on page 115. After the short amount of time had elapsed between the two shots, the ambient light had grown more diffuse—and less intense—so there was no great contrast between the light and dark areas in the photo. Generally, look for great ambient light conditions shortly after sunset.

26mm, 1/6 of a second at f/10 and ISO 100, tripod mounted

▼ Pages 118-119: As the storm cleared in Yosemite Valley, the valley was lit by ambient light that radiated off the sides of cliffs and the clouds. A single shaft of sunlight hit Bridalveil Falls and created some contrast in what would otherwise be an overall bright, but overcast, scene.

18mm, 1/320 of a second at f/9 and ISO 100, tripod mounted

Sunshine on a Cloudy Day

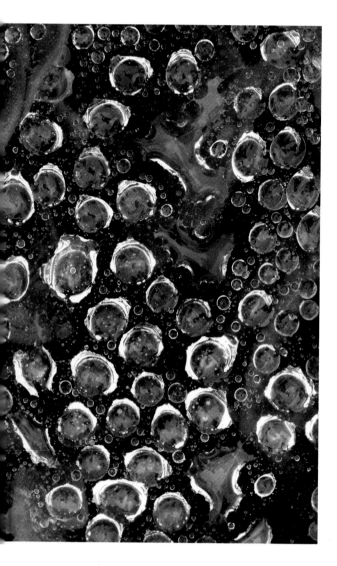

▲ I ventured out as the rain seemed to slow down. The skies were threatening continued rain, but a patch of sunshine illuminated these water drops on a spider web with wonderful, almost iridescent, colors.

200mm macro, 1/2 of a second at f/32 and ISO 200, tripod mounted

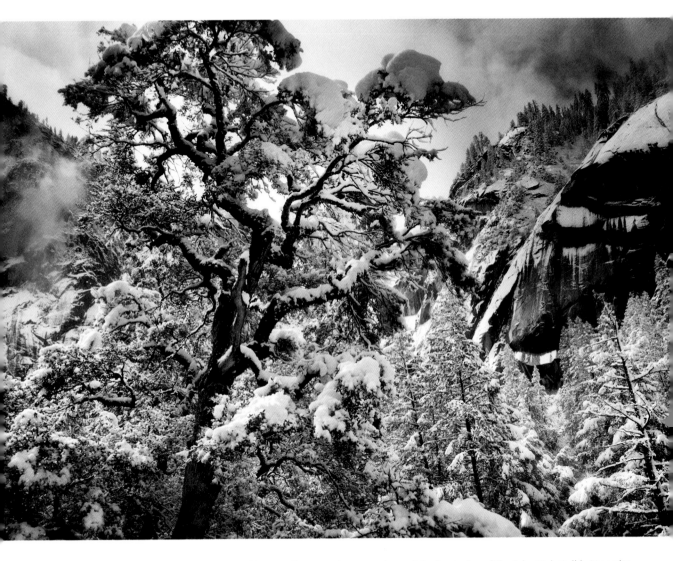

▲ We started out wearing snow shoes at the beginning of the John Muir Trail in Yosemite Valley, California, on our way to Vernal and Nevada Falls. Then the snow stopped, and the sun came out. I took off my snow shoes and enjoyed a few minutes of glorious photography before the winter sun disappeared and the snow began again.

22mm, 1/500 of a second at f/11 and ISO 100, hand held

Landscapes

The classic form of the existing light photo is, of course, the landscape. By definition, a landscape is shot using ambient, available light. Furthermore, the scale of landscape photography does not lend itself to supplemental lighting. Thus, a paradox: the grand and masterful landscape is one of the most sought after photographic subjects, and one in which the lighting is the least under the control of the photographer.

To perfect landscape photography I believe that you must observe carefully, become extremely patient, wait for the right moment, and capture the scene when the getting is good.

Observation means particularly paying attention to lighting. Suppose you've found your vantage point, and understand the camera angle and lens you are going to use. What remains is to wait for the perfect lighting. This wait can take hours, or even days!

I've previously noted the virtues of "Golden Hour" lighting when it comes to landscapes (see pages 18-21). For the most part, it is hard to beat the Golden Hour—the time surrounding sunrise and sunset—when it comes to landscape photography, but there are some exceptions. Storms forming, or breaking up, can be wildly dramatic and lead to very interesting photos (see pages 120-121). Personally, I am particularly partial to landscape photography at night because of the great colors you can get at night (see pages 150-157)—and also you don't have to rush to be there for sunset!

Landscape photography is a discipline that seems simple—but to achieve good landscape photographs requires subtle understanding of lighting worthy of a Zen master.

▶ For millennia, these petroglyphs have been open to the sky, positioned in an area of volcanic tableland. The petroglyphs were in deep shadow from overhanging rocks in the morning. I waited until late afternoon so I could combine the petroglyphs in the foreground with a dramatic view of mountains and sunset in the background.

14mm, 1/25 of a second at f/22 and ISO 100, tripod mounted

▲ Photography in the middle of the day was not possible—reflected sunlight led to many unattractive bright areas—so I waited until late afternoon to take this photo of The Wave in the Arizona Grand Canyon uplands near the Utah border.

10.5mm digital fisheye, 1/13 of a second at f/22 and ISO 100, tripod mounted

◄ On a snowy day in Yosemite Valley, California, there was a break in the weather and I was able to shoot this image of Vernal Falls. Ambient light reflected off the clouds, illuminating what would otherwise be a fairly dark view of the chasm created by the Merced River.

70mm, 1/250 of a second at f/8 and ISO 100, hand held

City Light

From a distance, and in the daytime, photographing cities can be viewed in much the same way as photographing landscapes: relatively distant structural masses are lit by available light. As with landscapes, the key variable is the quality of the ambient light, and the directionality of the daylight—and successful photography of cities as landscape is primarily an issue of patience, observation of lighting, and timing.

As day turns to twilight, twilight turns to dusk, and dusk turns to night, lighting issues change because of the many different kinds of light that can contribute to the ambient light—car lights, street lights, and interior lights. Besides light from the sun and moon, these kinds of light can become individualized light sources in and of themselves.

You've got light from tungsten incandescent, fluorescent, and mercury vapor fixtures—all of which have different color temperatures. Besides the issues of wildly varying light sources within a single exposure, you have a great dynamic range as things get dark—from the bright lights of the city to the darkness of a hidden alley. For more about night photography, see pages 150–157.

Taking advantage of city lighting can mean more than photographing urban vistas as a kind of landscape. Sometimes the details are more than the sum of the parts. When I photograph in an urban environment, I am careful to keep my eyes open for interesting images that are not vistas—and that take advantage of the color and energy of life in a city.

▶ Caledonia Street, in downtown San Francisco, California is famous for its graffiti. If you visit in the daytime, you are likely to find tourists and other photographers because some of the artists who have "tagged" Caledonia Street have gone on to be quite well known. But when I visited in the early evening, I had it to myself. This relatively long exposure (15 seconds) uses ambient light as well as at least seven different light sources from different kinds of lights, each with its own color temperature.

29mm, 15 seconds at f/11 and ISO 100, tripod mounted

▲ Sometimes the angle of view can be enough to partially counteract difficult ambient light conditions when you compose a cityscape photo. Somewhat harsh, midday light directly over downtown Havana, Cuba appears less distracting in this panorama than it would have in a more conventional photo.

To make this image, I placed my camera vertically on the tripod, and rotated from left-to-right using the same exposure for each of the 18 captures. I stitched the captures together in Photoshop and applied some minimal retouching to the results.

18 exposures stitched together using Photomerge in Photoshop, each capture taken at 18mm, 1/250 of a second and f/8 at ISO 100, tripod mounted

▼ Pages 130–131: From high on a hill in the Marin Headlands, I photographed the Golden Gate Bridge and San Francisco at sunset. The sunset was behind my camera position, front lighting the San Francisco cityscape. I waited for a container ship steaming through the Golden Gate to come precisely into position to help form an interesting composition.

If you stop to think about it, the Golden Gate Bridge in San Francisco is one of the most photographed subjects in the world. However, if you pay attention to the direction of the lighting and have the patience to wait in the right place for the right time, then it is quite possible to make images that stand out from the crowd.

32mm, 1/80 of a second at f/4.2 and ISO 100, tripod mounted

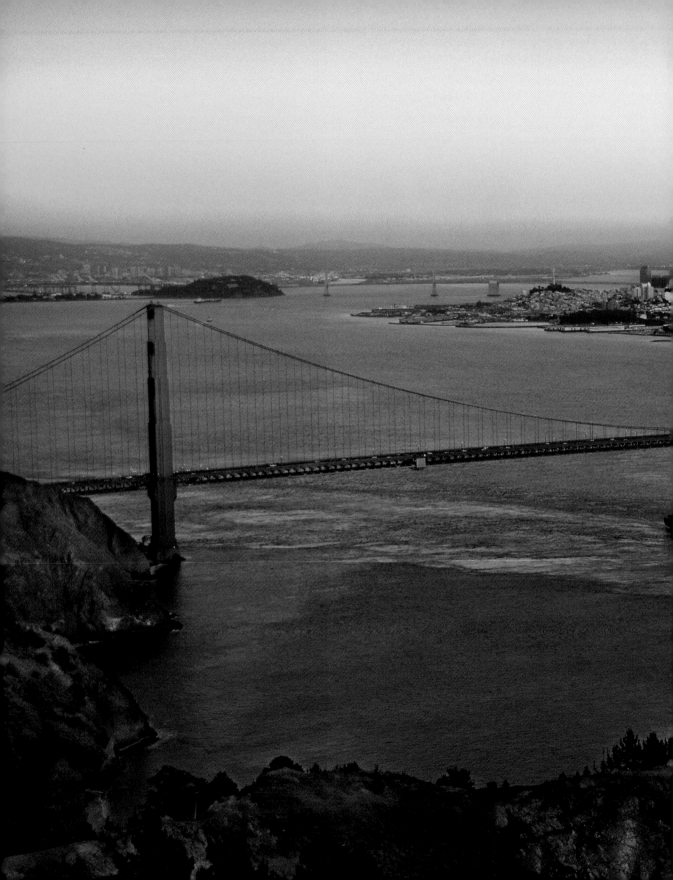

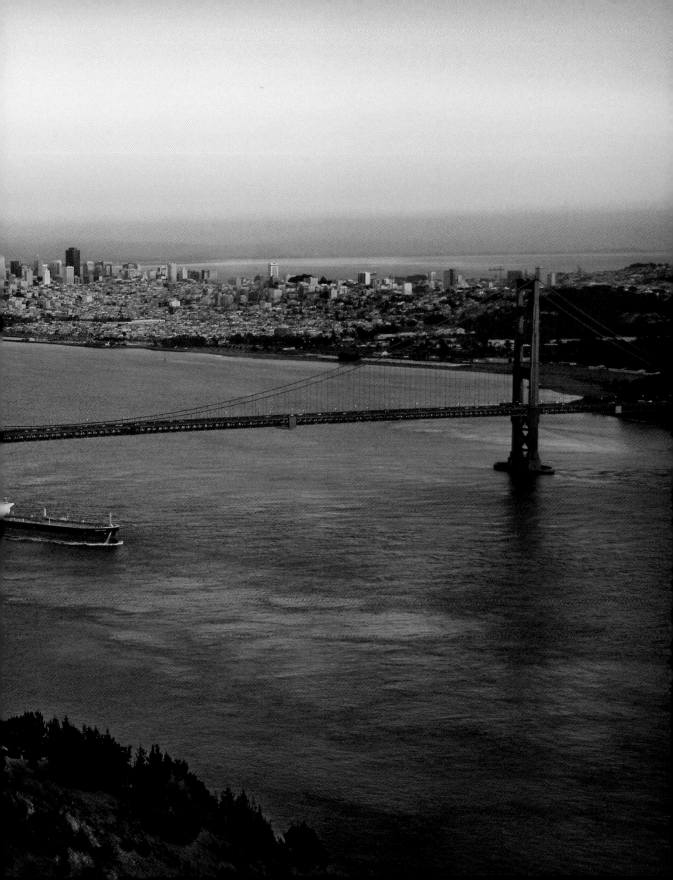

Close-up photography in the studio with controlled lighting, stylists, and wonderful miniature sets leads to the perfect images of watches and liquor bottles that we've come to expect in our advertising. Close-up and macro work in the field using primarily existing light is a completely different kettle of fish—with different pleasures, rewards, and pitfalls.

It's important to remember with existing light close-up photography that, unlike studio work, you cannot expect perfection. Sure, go ahead and rearrange your tiny subject matter to improve the composition—if you can. All too often, I've had the experience of thinking I'll just move a little twig a little bit, only to have my entire scene collapse. The truth is that real life has imperfections, and natural light still life photography is partly about capturing these irregularities.

In my opinion, it is fine to adjust your natural macro subject to take advantage of the lighting—but you risk making the scene worse, not better.

Lighting makes or breaks a close-up or macro. Because these images seem contained and like their own little world, how they are lit adds the touch of drama that a miniature world needs. The sun

◀ One water drop captures the sun reflected as a starburst, another the garden reversed and upside down. The miniature drops of water create a magical universe where lighting is everything and it takes a moment to get one's bearings—but is worth taking the time to visually explore.

200mm macro, 1/3 of a second at f/40 and ISO 200, tripod mounted

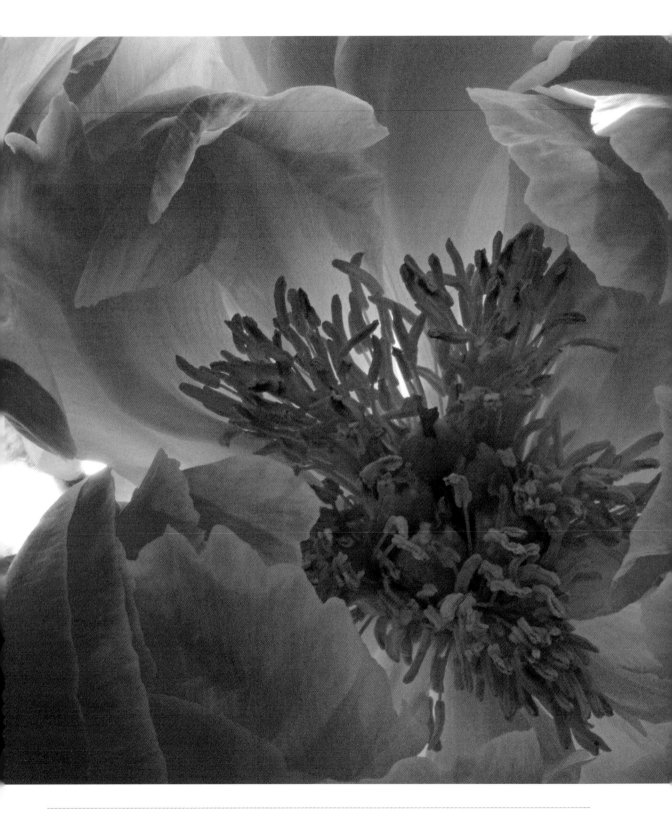

reflecting as a starburst in a water drop shows as much lighting power, relatively speaking, as the real sun does to a full-scale landscape.

The directionality—or lack of direction—of the lighting also has a big impact on the macro level. Glowing, backlit elements add drama to an otherwise ordinary capture no matter what the scale. Overall diffuse ambient light powers color details on a small scale, and gives you the opportunity to create interesting compositions.

I find ambient light close-up photography a great deal of fun. The challenge is to see on a small scale to create a plausible miniature world or universe—and this can only be done by clearly observing the lighting you have to use, and framing a composition that uses that lighting to good effect.

You can hone your skills on natural macros and go on to take the same facility with the observation of light when you point your lens at objects on a larger scale.

◄ By concentrating on the center of the peony, which would ordinarily be quite dark, I emphasized the glowing effect of the unusual natural backlighting on this flower, caused by the early morning sun.

105mm macro, 1 second at f/36 and ISO 100, tripod mounted

Using Fill Lighting

In any situation where the predominant lighting is not frontal—in other words, when the lighting mostly comes from the back or the side, or even is overall and ambient—the camera-facing portion of your subject is likely to be too dark. Details may not show, shadows may be unattractive, and the frontal darkness will likely work no wonders for your composition.

This lighting conundrum is true without respect to how gorgeous the quality of the light is. In other words, the need for *fill lighting*—supplemental lighting that works in a countervailing direction to the primary lighting—is primarily an issue of lighting direction, and not lighting quality.

In fact, photographers often find themselves in the situation of needing to salvage a lighting situation where the lighting is attractive but the most important part of the subject is either way too dark or shows nasty shadows coming from one direction or another that are not a planned part of the composition.

Studio lighting setups usually plan to balance the lighting, with fill lights if necessary, but the same lighting problems occur frequently on location, in the field, and when one is shooting using natural light.

There are a number of possible solutions to this lighting dilemma, including:

- Reflecting light into the subject to ameliorate the darkness and shadows

- Using a light source to add fill lighting to the

▶ I drove 27 miles down a four-wheel drive road in the remote northwestern corner of Death Valley National Park to reach the Racetrack, the dried lake bed shown in this photo. The Racetrack playa has become well known for the rocks that are thought to move around on the surface in the winter, leaving strange tracks in the mud.

I set up my tripod shortly after sunset in the diffuse, glowing ambient light. My idea was to capture both this rock and the surface of the lake bed. While there was no real directionality to the light, the front of the rock facing the camera was deep in shadow, particularly when I positioned the camera with an extreme wide-angle lens (10.5mm) as low as I needed to make this composition work.

To brighten the rock, I used a collapsible portable metallic fill disc I had with me to reflect light into the shadows in the rock.

10.5mm digital fisheye, 1/13 of a second at f/22 and ISO 100, tripod mounted

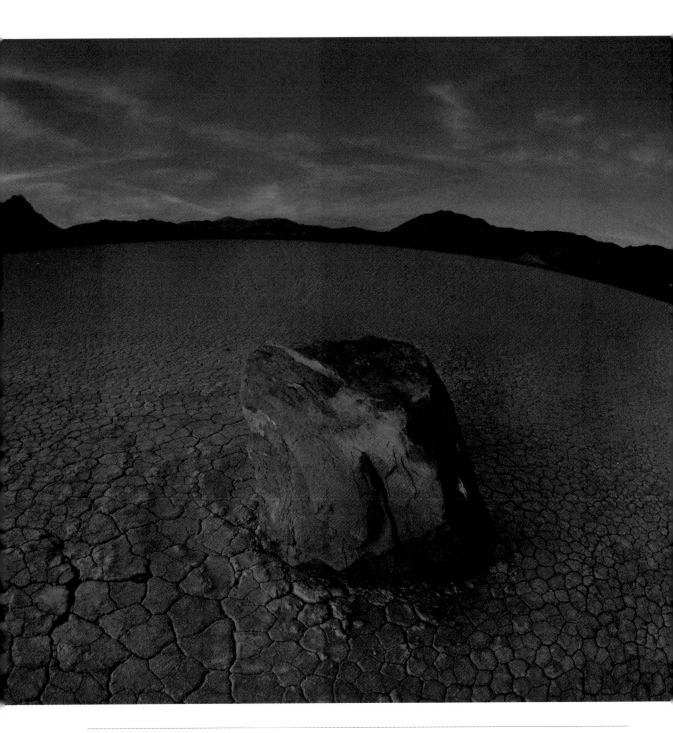

dark face of the subject; this can be either a continuous light or flash (see pages 162–209)

- Correcting the lighting problem in post-production software such as Photoshop

Fixing a lighting problem when the front of your subject is too dark is certainly a possibility in Photoshop (see pages 215–219), but when feasible it is always better to fix the problem as early as possible—when taking the photo, rather than in post-production after the photo has been taken.

Creating fill lighting using a reflective surface is often easy to achieve at the time you take a photo (see the diagram below)—even if you are in a remote location. I prefer to use a reflective surface—often called a fill card—for this purpose rather than a light (such as an ordinary flashlight). By reflecting light into the subject as opposed to shining light on it, I am most likely going to avoid problems with unnatural looking light.

Obviously, if you plan to use fill lighting you should make sure to bring something you can use for this purpose where you will be photographing. The simplest and most neutral fill device is simply a piece of white cardboard, which you will need to hold, or place, where it is out of the camera's field of view. By the way, you can use a piece of black cardboard in the opposite way—to "beam" darkness into a reflective surface that is too bright.

Commercial fill gizmos range from extremely portable—these fold up and can be shoved in a camera bag or pocket and carried anywhere—to large affairs with frames that resemble nothing so much as hang gliders. It's worthwhile experimenting with metallic reflectors as well as white ones. A gold metallic fill device reflects glowing, warm light into the dark areas of the subject, and can be particularly effective in outdoor portraiture.

Fill lighting

predominant lighting

subject

shadows

fill light

fill light

camera

▶ This photo illustrates two different kinds of fill lighting in the course of a single, extremely long exposure.

Many people know about the spectacular Tunnel View overlook above Yosemite Valley, California—but fewer know that the original vista point, Inspiration Point, is several miles above Tunnel View, and only accessible by trail.

From the old Inspiration Point, moonlight lit Yosemite Valley from the east (the right side of the photo)—the first fill lighting source. To lighten the dark side of the tree trunk facing the camera, I "painted" it with a small flashlight for a short burst, creating the second kind of fill lighting.

12mm, about 30 minutes at f/8 and ISO 100, tripod mounted

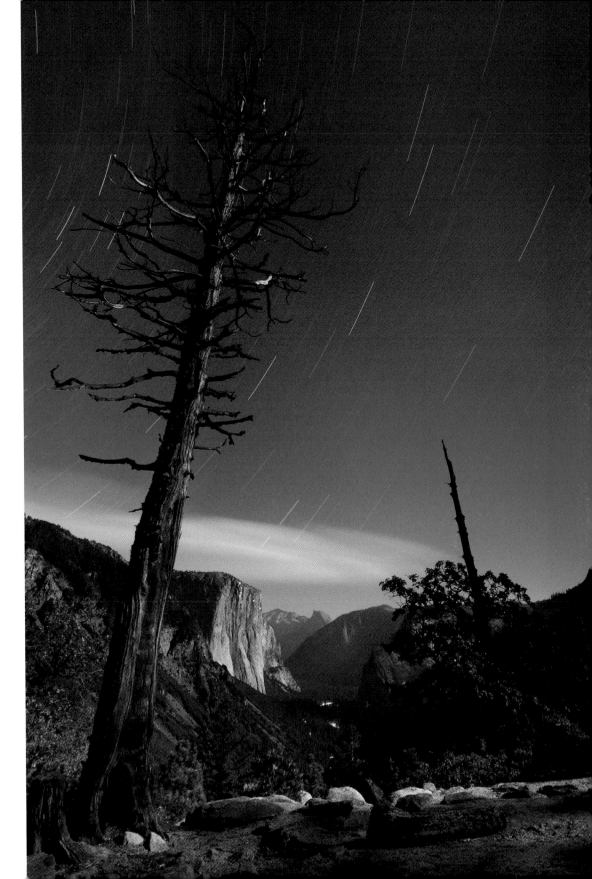

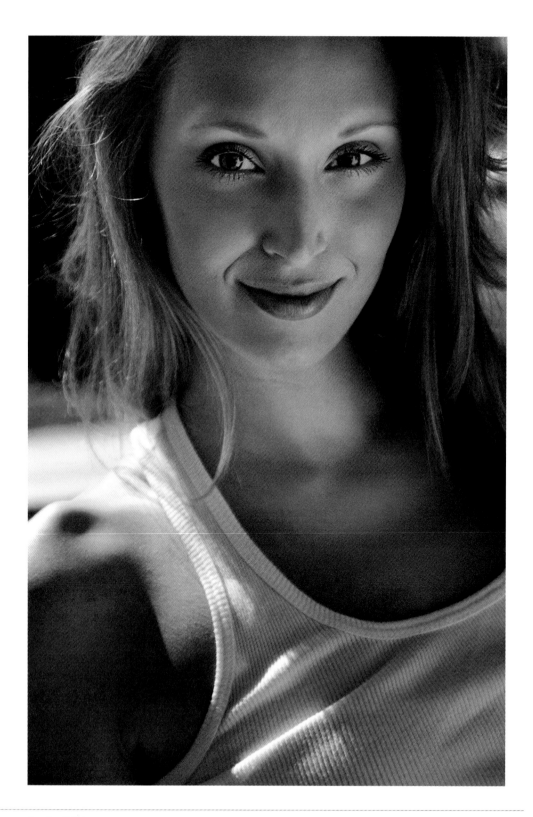

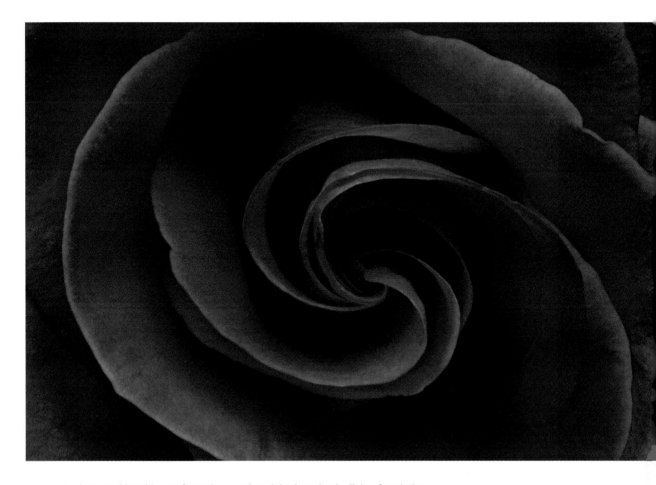

▲ Photographing this rose from above and straight down by the light of a window, I noticed that the left side of the rose was extremely dark—the light was predominantly coming from the right and above the flower. So I positioned a piece of white cardboard to reflect light into the lower left of the composition, and held the white cardboard in position using duct tape.

50mm macro lens, 1 second at f/32 and ISO 100, tripod mounted

◀ In this casual, outdoor portrait of Lauren you can see the predominant—and very strong—lighting is early afternoon sunlight coming from behind and to Lauren's right. The impact of this lighting was to leave Lauren's face in dark shadow. I had an assistant hold a large, metallic gold reflector to lighten the shadows, and to create a pleasing quality of light.

65mm, 1/1600 of a second at f/5 and ISO 250, hand held

Using Flash as Supplemental Lighting

One approach to correcting dark, shadow areas in a back or side lit subject is to add some supplemental flash lighting from the front. It's easy to use a flash as a supplemental light if you take care that the flash doesn't overwhelm the natural light. As always when using flash, it is also best to get it off your camera, so your supplemental light is not coming from exactly the direction of the camera.

On automatic settings, your camera and flash are likely to assume they are the only light source, and completely overpower the existing light. My bias in these situations is that there is something attractive about the available light, so overpowering it simply will not do. The goal is to work with the existing light to supplement it as needed, not to replace it.

To use a flash as supplemental lighting without overwhelming the natural light you can take a number of approaches:

- Manually control the light output of the flash unit (see the documentation for the flash unit for instructions about how to do this)

- With your camera set using Manual exposure controls, intentionally choose a shutter speed that is slower than the camera's flash-synch speed, so that the exposure ends up using ambient light as well as light from the flash

▶ I set my camera up near Cyclops Arch in the Alabama Hills formation above Lone Pine, California to make a series of captures that could be combined to show star trails. The problem with the lighting was that the inside of the arch (facing my camera) was in blackness, so on one frame I walked nearer to the arch and painted in light using a low power setting from my small strobe unit.

18mm, 30 captures stacked in Photoshop, each capture 4 minutes at f/4.5 and ISO 200, tripod mounted (total exposure time 2 hours)

- On very long exposures, you can pop the flash manually for an extremely short burst of lighting; there's no need in this kind of situation to synch the flash with the camera at all

All of these approaches can be highly effective ways to create fill illumination—light that "fills in" the shadows and dark areas without overwhelming natural lighting, which can be attractive, interesting, and realistic. After all, when I want to entirely create my own lighting I work in the studio—and this is not the point of location photography. However, be prepared to experiment with your exposures and flash outputs before you get it right. Take some test shots and review them carefully in your LCD before you assume that your flash-as-supplemental-lighting setup works the way you want it to.

▲ I used two wireless macro flash units mounted on a ring at the end of my telephoto macro lens to stop the motion of the bee on this dahlia. The exposure was calculated to allow ambient light on the flower to be rendered as part of the photo.

200mm macro, 1/60 of a second at f/16 and ISO 100, tripod mounted

▶ The predominant light on the stairs came from a large, frosted window at the top of the stairs, leaving Tanya's front in deep shadow. I used a small, supplemental off-camera flash unit to lighten Tanya's face and body in this appealing portrait.

18mm, 1/160 of a second at f/5 and ISO 100, hand held

Using Window Light

Window light—whether you are photographing through the window, or using the light coming through a window to illuminate your subject—often has very special properties. Depending upon the location and direction of the window, the kind of light source behind the window, how clean or dirty the window is, and the window treatment, window light can be one of the most qualitatively romantic light sources in the world. Windows are a great source of diffuse light (see pages 40–43).

If you are shooting a photo such as a romantic portrait using window light as the lighting source, look for chiaroscuro lighting—situations in which there are patterns of light and dark, with strong contrasts. Since this kind of lighting situation can be fairly dim, consider boosting your ISO so that you can use a faster shutter speed—particularly if your subject is potentially moving, for example, when you are making a portrait.

When photographing through a window, look for situations where the window has altered the light thrown off by the subject outside the window. In effect, shooting through the window creates a new kind of lighting—one in which standard views can become abstractions that are more interesting than a more "straight" photo.

▲ Construction dirt on this window in Fort Point obscured the view of the Golden Gate Bridge, and a construction worker had drawn a smiley face on the outside of the window. I saw an opportunity to create an interesting composition by using a small aperture (f/29) to create substantial depth-of-field. I used the lighting coming through the window to make the window look almost like a solid piece of reflected art. The view of the bridge through the window looks flat like a poster or print, rather than a view through a transparent window.

36mm, 1/5 of a second at f/29 and ISO 100, tripod mounted

▶ I positioned this bouquet of Fourth of July roses so they were attractively lit by soft light coming in through a window. Then I composed the photo so the flowers were captured through the divided window panes in a glass door.

112mm, 3 seconds at f/36 and ISO 100, tripod mounted

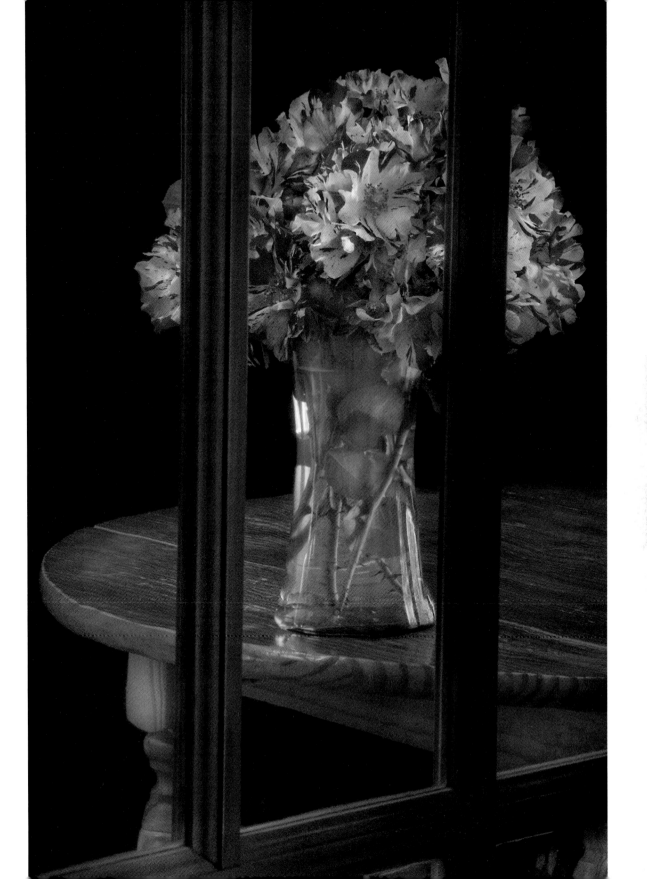

▲ Coiled rope, deep in the shadows of the boathouse, was lit by a shaft of late afternoon sunlight coming through a window. The fact that the window was dirty only enhanced the quality of the light.

I positioned my Nautilus shell in the center of the shaft of light from the window, and quickly composed my photo before the light disappeared.

82mm, 1/5 of a second at f/22 and ISO 100, tripod mounted

◄ The "sweet" quality of morning light coming in through the windows matches the radiant expression on my daughter Katie Rose's face.

32mm, 1/80 of a second at f/5.6 and ISO 800, hand held

Night Photography

In a letter to his brother Theo, the artist Vincent van Gogh wrote, "It often seems to me that the night is much more alive and richly colored than the day." There is a great deal of truth to van Gogh's observation, and night photography offers some incredible opportunities. However, night photography also poses some special problems related to exposure and lighting.

Typical city scenes at night are quite bright—at least compared to deep night landscapes away from lights. Exposure times typically range from 10 to 30 seconds for city scenes, and it is a good deal easier to see what you are going to get under these conditions than when it is really dark.

In night city photography, the lighting comes from a variety of sources including cars, building lights, street lights, and ambient light from celestial sources. This mixture of lighting sources can create a jumbled sense of many lights with different colors—but it can also add to the energy and excitement of urban night photography.

Night photography in the deep night of the countryside or wilderness is an act of faith. You don't know what you are going to get until after you have spent hours making the photo—and the LCD on your camera is itself unreliable. I find that I do not know what my deep night images contain until I have teased the data out of the RAW files using a powerful computer in my studio.

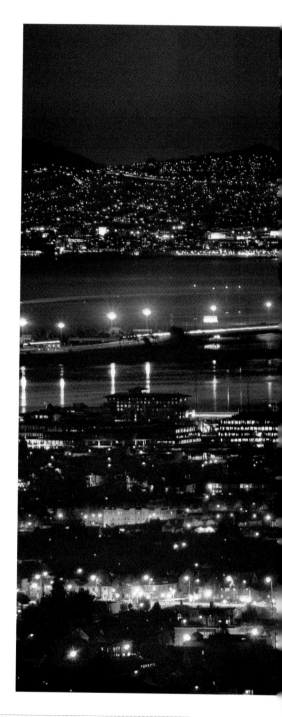

▶ I scouted in advance a rooftop location with a clear view of the Bay Bridge, Yerba Buena Island, and downtown San Francisco. On a clear, autumn afternoon I climbed a ladder to the roof, and waited until after sunset to take this photo with a moderate telephoto lens.

170mm, 30 seconds at f/8 and ISO 100, tripod mounted

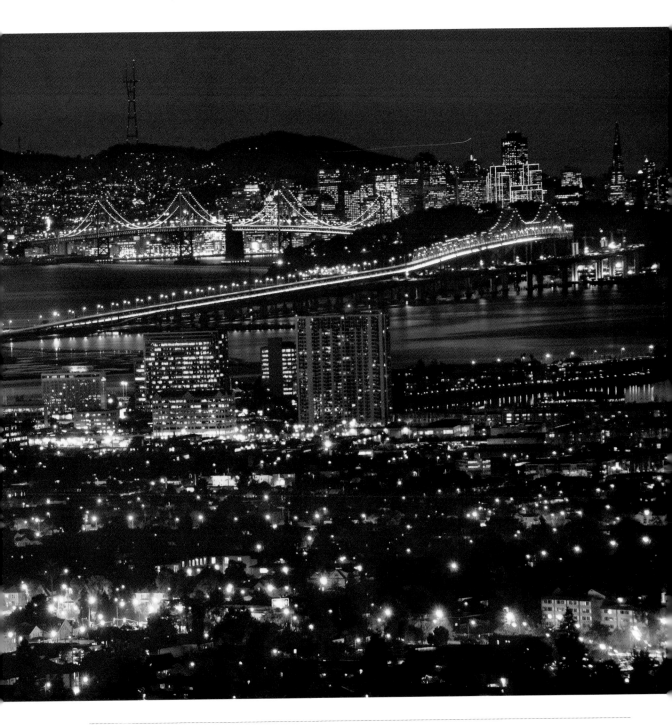

The key issue with nighttime exposures is that there is not much light. Extremely low light conditions compel long shutter speed times, which result in concerns and problems related to noise.

One technique that works well to combat noise from long exposure times is to segment the exposures into many shorter exposures. These multiple "shorter" exposures—each of the exposures is often three or four minutes on its own—are combined using a technique called *stacking*. Stacking uses a pre-defined algorithm to blend the pixels of the multiple images—for example, "pick the brightest one." A stacked image organically contains far less noise than a single exposure that was as long as the sum of the individual exposures that make up the stack.

Photoshop provides several different techniques for stacking, and there are a number of low cost or free software programs available that also do the job well.

Besides exposure length, extreme darkness also leads to the problems with lighting at night, which are primarily perceptual. Although digital cameras can record many of the colors of the night, for the most part

▶ If you look at the tent in this photo, you'll see a shadow inside. That shadow is me, and the tent is lit with my headlamp while I was reading.

This is a shot of my campsite in Death Valley. I set my camera up on its tripod, and used a programmable interval timer. Then I went to bed, leaving my camera to capture the starlit scene.

I set the camera to take multiple 4 minute exposures with a gap of 4 minutes between each exposure—which is why these star trails appear dashed.

10.5mm digital fisheye, 60 captures stacked in Photoshop, each capture 4 minutes at f/32.8 and ISO 320, tripod mounted (total exposure time about four hours)

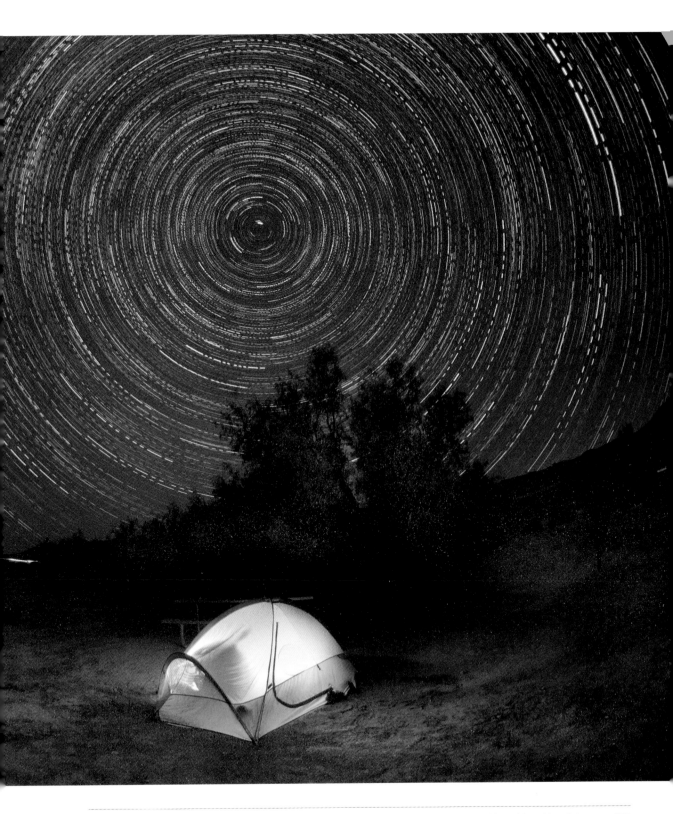

we cannot see them. This means that you will find it hard to understand the ambient lighting conditions for a night photo until you have made your image—and making a single image can take most of the night.

If you haven't tried night photography, give it a whirl. Learning to photograph in the darkness teaches you about exposure in a very significant way—and also how to read the clues that lighting leaves when it can barely be perceived. Experienced night photographers know that there is a great thrill in rendering darkness visible and creating images against all expectations. Many of them are hooked on this kind of lighting, and live for their sessions in the dark!

For more information about night photography techniques, and about processing night photos, see the suggestions in the resources section on page 250.

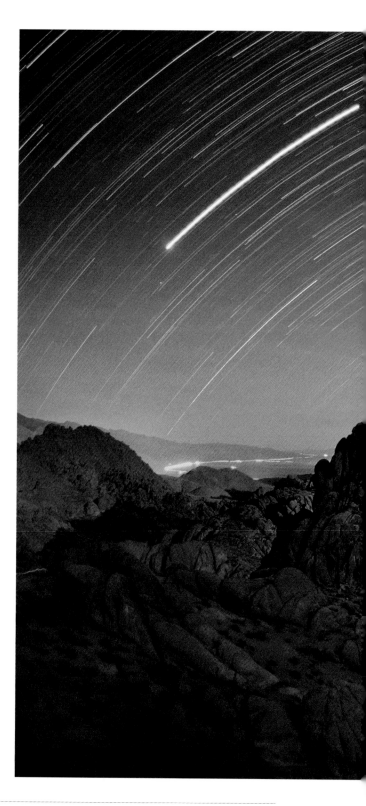

▶ The Alabama Hills are a jumbled area of rocks and textures above Lone Pine, California, and below Mount Whitney, the highest mountain in the continental United States. The area has long been known for its scenic grandeur, and in fact many well-known movies have been filmed here.

To make this image, I got in position on top of a rocky promontory before darkness fell. With my camera and tripod firmly in place, I shot a version while there was still some light so I could add some detail into the foreground when I post-processed the image later. Then I used a programmable timer to shoot multiple exposures over the course of almost two hours to capture the scene by star light.

10.5mm digital fisheye, 25 captures stacked in Photoshop, each capture 4 minutes at f/3.2 and ISO 250, tripod mounted (total exposure time 1 hour and 40 minutes)

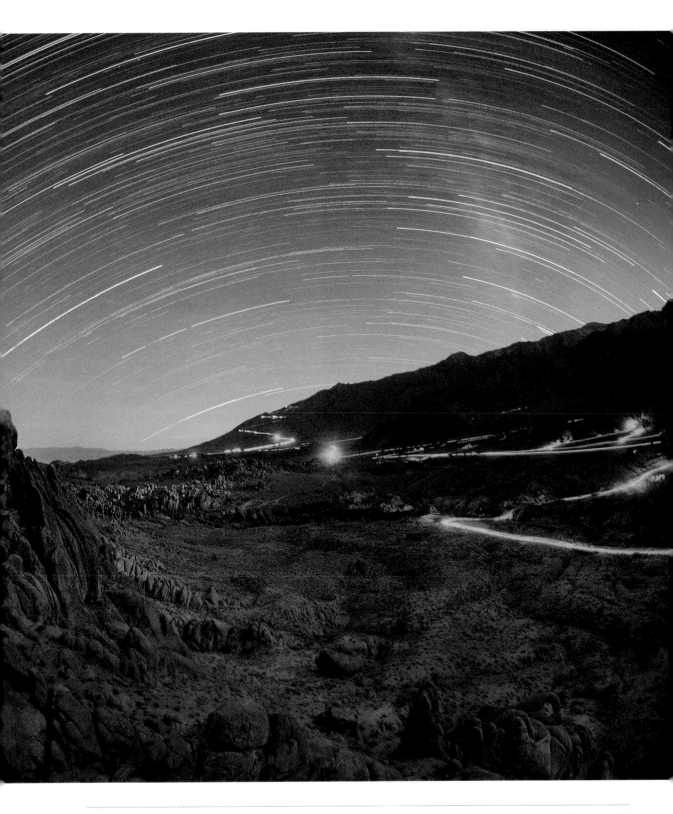

▶ In Death Valley National Park, the Devil's Golf Course is a formation of seemingly endless crystallized salt spires arranged, well, like a diabolical golf course. The Devil's Golf Course is located near Badwater—the lowest point in North America, and several hundred feet below sea level.

I pulled up to this formation after dark, opened the side door of my van that faced north, and positioned the camera to photograph the formations and star trails in the sky. While my camera made the exposures over the course of the night, I snoozed in the van. Before dawn, a sliver of the new moon rising front lit the crystalline formations in the foreground—otherwise the foreground would be completely dark.

10.5mm digital fisheye, 77 captures stacked in Photoshop, each capture 4 minutes at f/2.8 and ISO 400, tripod mounted (total exposure time about ten hours)

Light Painting

Painting with light can be accomplished in a dark, or almost completely dark, room—or, more commonly, outdoors at night. In this kind of photography, the lighting is the subject of the photo—either itself, or when the light illuminates subjects that would otherwise be shrouded in the ambient darkness.

Almost any kind of light source can be used for light painting. If you only have a flash light with you, that can work just fine. You can also come prepared for light painting with fancy colored lights. If you are willing to improvise, you might be amazed at what will work as a lighting source—it's likely that even your favorite mobile device can be programmed to generate interesting light colors and patterns (see photo on page 161).

To effectively paint with light, it's a good idea to wear dark, or black clothes, so that you won't show in the final image—unless the idea is to appear in the image. Some light painters go so far as to apply dark paint on their faces before making their images.

You should set your camera up on a tripod, and plan to have your shutter open for the duration of the light painting "performance." It may take a bit of trial and error to find out the right length of

▶ During a night photo workshop I was giving at Mare Island, a large, abandoned naval shipyard in Vallejo, California, we started playing with colored lights, creating the exotic-looking scene you see here.

12mm, 2 1/2 minutes at f/9 and ISO 200, tripod mounted

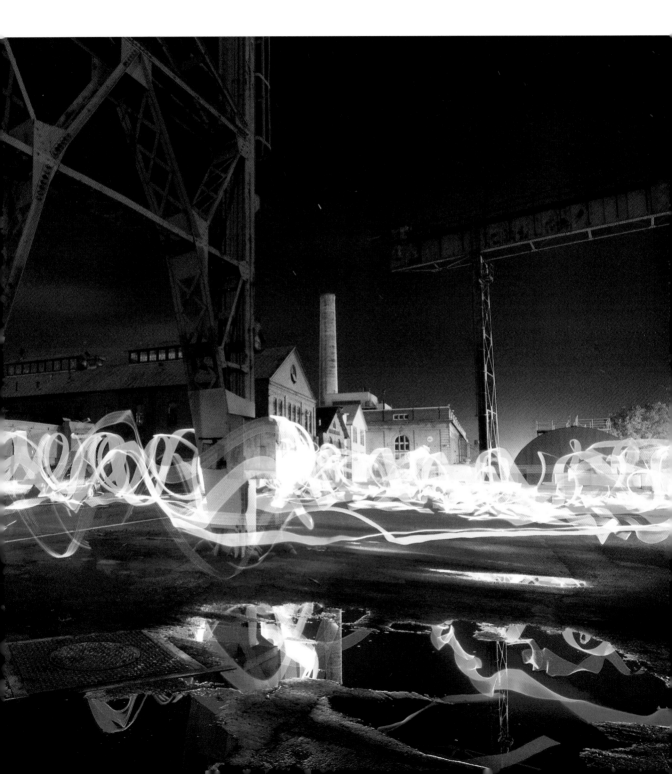

time to hold the shutter open, and also the aperture and ISO to use to get a good exposure, considering the shutter speed you are using.

Try to keep moving as you paint with light. If you stop too long in one spot, you are likely to appear in the image—and your light source may become too bright compared to the surrounding light.

It's usually not a good idea to point the light you are painting with directly at the camera. The strongest light painting lines are usually created by moving the light perpendicularly to the camera.

Light painting is akin to performance art—it is never the same twice and it often is more fun when many people do the light painting. While some people do carefully plan their light painting images, improvisation is often the name of the game…in which case, you never know what you are going to get until you try.

▶ All kinds of things can work as lighting sources at night. This shot shows a person walking down a flight of stairs with an iPhone set to blink.

18mm, 15 seconds at f/16 and ISO 200, tripod mounted

▼ By wearing dark clothing at night people disappear and all you see is their lights. To create this shot, I set my camera on a tripod and "danced" with someone holding the blue light (I was the red one)—to create a ghostly "pas de deux."

22mm, 30 seconds at f/8 and ISO 200, tripod mounted

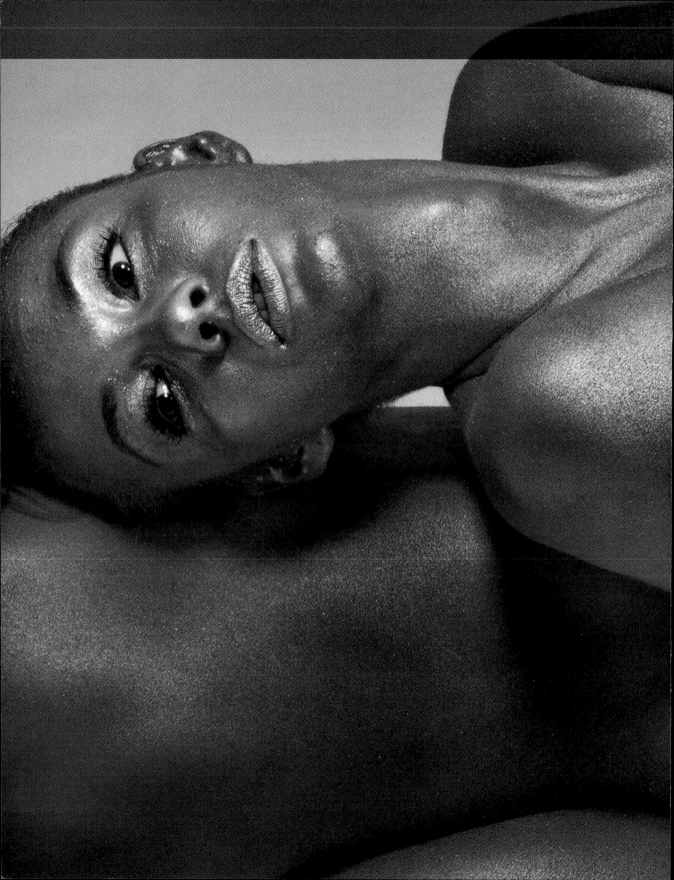

Continuous Lighting

▲ Lowel's Omni is a flexible and versatile continuous light source that uses a tungsten-halogen bulb, shown here with barn doors and a grid lighting modifier (image courtesy of Lowel-Light Mfg, Inc).

▶ I used two light sources to create this macro of marbles. One light was positioned to the right of the marbles; I used mostly closed barn doors to control the light beam and make a narrow, intense, and focused beam of light. The second light was a more general and diffuse lighting source, placed behind and to the left of the marbles. I used this light to create an illusion of transparency by gently backlighting the marbles.

200mm macro, 15 seconds at f/36 and ISO 100, tripod mounted

▲ Pages 162-163: At first glance, the skin tones of the models in the studio shot look rather dark. Actually, these are fair-skinned models that have been painted with metallic body paint. It's a trick of the lighting—combined with relative underexposure—that the skin tones in this photo look darkish, rather than painted as it actually was. A moral here: controlled lighting can change almost everything, including the apparent skin tone of subjects.

62mm, 1/125 of a second at f/16 and ISO 100, hand held

Continuous lighting is another way of referring to common, everyday lights that you can see because they remain on. It's called "continuous" because—unlike studio strobe lighting—when you turn it on, it stays on with a constant illumination. Sometimes the term *hot lighting* is used to describe this kind of lighting because continuous lights used for photography can get very warm depending upon the kind of bulb you use.

If you buy continuous lighting intended for photography, you generally have three choices of bulb type:

- Tungsten-halogen
- LED
- Fluorescent

Of these, my preference tends to be tungsten-halogen, for the quality of light these bulbs put out—but there are some applications (for example, when excessive heat is a serious issue) in which these bulbs are not the best choice. LED lighting is rapidly becoming able to output sufficient light for many photographic applications, and can be an excellent choice.

You can consider almost any common household light a continuous light source for photographic purposes because the ability to color-correct for white balance in post-processing means that the color temperature of the light source is less important than it used to be. Unlike in the past, improvising lighting with good results is possible—at least when your subjects are small in scale, and there is no critical issue of color matching.

Larger size subjects—such as living people—require a great deal more overall illumination. To light a large tableau containing models and

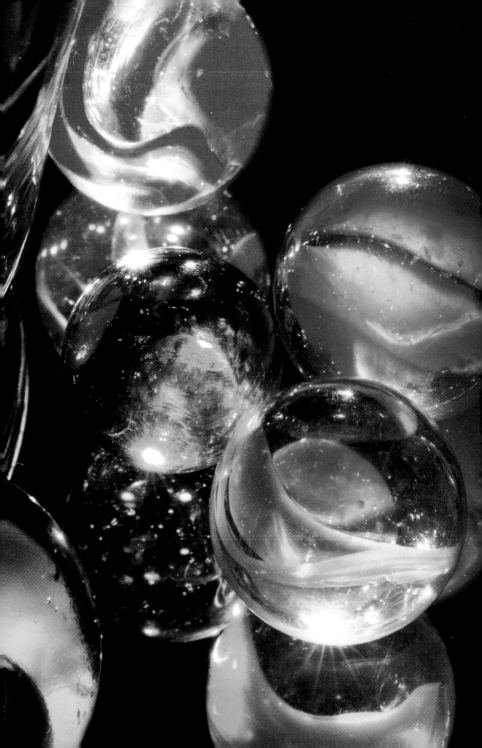

a set with continuous lighting would take a number of high wattage lights, consume a good bit of power, and put out tremendous heat. While this kind of arrangement was used in Hollywood before the Second World War for glamour portraiture (as well as the movies), it makes more sense these days to use studio strobes. More generally, the advantages and disadvantages of continuous lighting compared to studio strobe lighting are shown in Table 1 below.

As you can see from Table 1, for still lifes and small tableaus—assuming nothing is in motion, and heat isn't an important concern—continuous lighting is usually the best choice, because it is inexpensive and it is easy to see the impact of changes you make to your lighting.

With continuous lighting, whether you use improvised lighting, or fixtures specifically intended for photography, you do need a mechanism for controlling the quality and intensity of the light. With continuous lighting you can usually reduce the intensity of light simply by moving the light fixture further from your subject, or increase the intensity by moving the light closer.

Table 1: A comparison of continuous and studio strobe lighting

	Continuous	Studio Strobe
Light output	Moderate light at a continuous level of illumination	Extremely short bursts; each burst can have a great deal of lighting power
Cost	Inexpensive startup costs	Ranges from moderate to very expensive
See what you are doing	WYSIWYG—what you see is what you get	Harder to visualize in advance of the strobes firing; modeling lights help with this
Complexity to setup	None—you plug them in and turn them on	Strobes take a bit of a learning curve, both in using the equipment and managing the light
Can stop motion?	In a word, no	Yes
Temperature	Can run very hot	Usually not a problem
Best use	Small still life setups; flat art; anything that does not move and is not large in size	People; anything that moves; large setups

▶ These colorful—and very hot—small peppers come from local California farms. To photograph the hot peppers, I arranged them on a mirror. My idea was to create an arrangement that resembled a bouquet of flowers when looked at from above. I used a black velvet cloth as the background, and lit the peppers using sunlight from a window and a continuous tungsten light. You can see the window light in the reflections in the red pepper in the front and center of the image because it appears to be more blue than the overall light. I aimed the continuous light up at the warm-tinted walls of the room I was in, so it helps to give the peppers a nice, warm tone (compared to the relatively blue daylight).

85mm perspective-correcting macro, 13 seconds at f/48 and ISO 100, tripod mounted

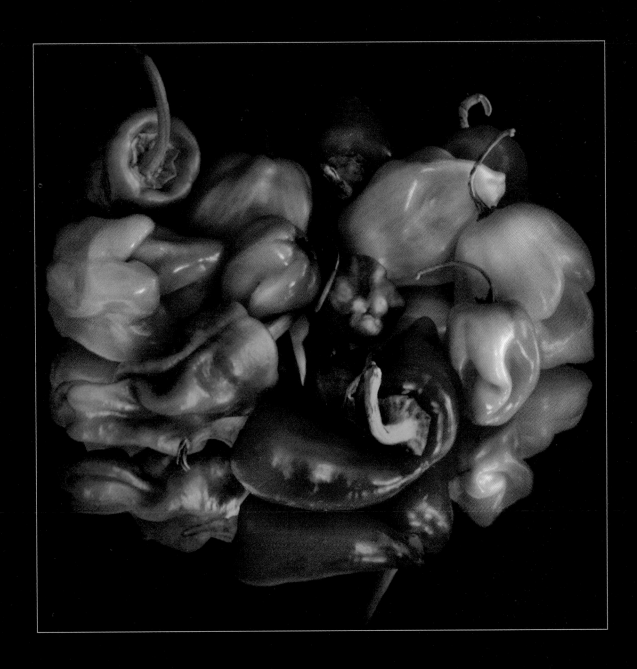

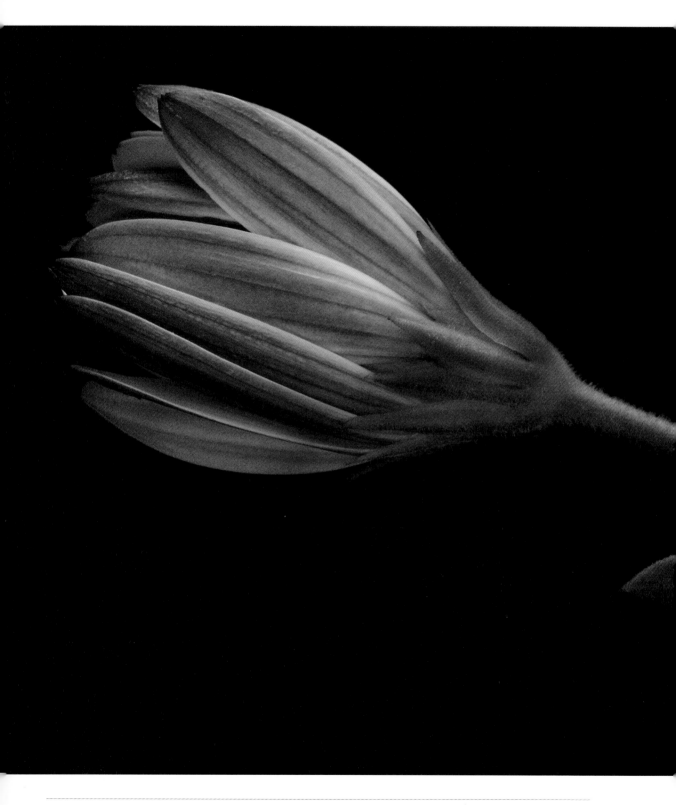

The key points are that you need to be able to illuminate with hard, direct light or diffuse soft light—depending upon your aesthetic goals. If the lighting is hard, you want to be able to control whether it is used as a pin-point illumination source, or whether it lights your subject more globally. You can establish these options using continuous lighting equipment meant for photography with modifiers such as soft boxes (to diffuse the light) or barn doors (to narrow the scope of what is illuminated).

As I've noted, it is relatively easy to improvise this kind of lighting modifier—tape, foil, cardboard, and an old white sheet you can cut up work wonders—if you don't want to buy them. In addition, some professional continuous lighting setups allow you to "focus" the light, essentially giving you more control over the quality of light and how hard or soft it seems.

With two or three lights—whether improvised or purchased as part of a professional continuous lighting kit—that can be controlled for the hardness or softness of light, and the angle of the subject that is lit, you pretty much have what you need to unleash your imagination— at least upon the stage of the small, still life photo!

◄ I placed this gazania in a small vase, and silhouetted it against a black background, illuminating the flower with a single, continuous light.

100mm macro, 1.6 seconds at f/11 and ISO 500, tripod mounted

Setting the Stage

▲ This light tent—also called a light box—was put together from a kit. It consists of a lightweight frame with translucent white fabric that ties onto the frame, with a slit at the back for inserting backgrounds. The light tent is shown here on a make-shift trestle-top table, with continuous quartz tungsten-halogen lights pointed at the light box (these lights are not in the picture).

A light tent such as this can be used effectively as the stage for many photographs with shadowless lighting—with the downside that the lighting effects you can create are limited and tend to be a bit monotonous. Some compositions cry out for the excitement of strong shadows (see pages 60–63 and 182–185).

▶ To photograph the core of this rose, I placed it on a white background in the light tent shown above. To take advantage of this shadowless lighting, I needed to be able to place the rose core in an upright position. I used a small dab of museum gel to keep it in place.

200mm macro, 36mm extension tube, 1 second at f/36 and ISO 200, tripod mounted

It's all very well to organize continuous lighting to photograph your still life tableaus—but you also need a background and something to photograph your subjects on. It is the case that your choice of background can influence lighting decisions (and vice versa).

It's also true that a single background for a still life composition and the related lighting can work for more than one image—essentially, with the right choice of neutral background, you can just rotate your subjects onto the stage one after the other. This is particularly true of cut-and-dry product photography. If you are shooting small objects for a catalog or for an eBay listing, depending upon the context of the products, you may just want to put them on a black or a white background.

Regarding a white background, note that a normal white piece of paper—such as a white seamless background—will look dull and gray in a photo if it is exposed normally. To obtain the illusion of an extremely bright, white background you need to place the object on a light box—made of translucent white material and illuminated from behind—as well as overexpose the background.

A common stage setup that can be used over and over again is a light tent. This can be purchased as a kit, or made from trans-lucent material such as a white sheet. In either case, gentle, diffuse light is created by shining continuous light through the light tent. The resulting shots don't show shadows and can be used for run-of-the-mill

product photography. However, the same setup can also be used to easily create more interesting and artistic effects.

When you think about the stage for a still life composition, as I've mentioned, there's the physical issue of what you are photographing *on*. I like to use simple trestle tables that can be moved into position anywhere, and easily taken down to save space when I don't need them.

It's pretty easy to rig light stands and clips (available in any hardware store) to hold backgrounds up on a small table. I like to keep my backgrounds simple: usually white or black, with an occasional burlap or cotton duck cloth to add texture. It's also sometimes fun to experiment with unusual backgrounds like a gnarled piece of wood—

this is most likely to be feasible when you are photographing something small. Another interesting possibility is to use a mirror as part or all of your photographic background—although this can make framing your composition more difficult as the mirror is likely to show things you don't want as well as things you do.

The three elements of the still life composition are the subject, the lighting, and the setting. All three are interrelated: for example, usually by changing the stage, you also change the impact of the lighting. So as you light your compositions pay attention to the backgrounds, stage, and setting—and watch carefully how changes in the stage impact and alter your lighting at the same time.

▲ I placed these pears (and solo nectarine) on a mirror, and used a piece of canvas as a background. The cloth was tacked to a cross bar on the top, and tucked below the mirror. I made sure to position the fruit in the center of the mirror, and used a moderate aperture (f/11) to make sure there was sufficient depth-of-field to keep the fruit in focus while throwing the background slightly out of focus.

50mm macro, 2 seconds at f/11 and ISO 100, tripod mounted

◀ To create this simple tableau of stuffed animals (what my son Nicky calls his "stuffies"), I placed the animals on white seamless paper clamped to a rod at the top. The curve in this background creates what is sometimes called a *cyclorama*—although the term is generally applied to larger sets—meaning there are no visible horizon lines. I used a light with a piece of blue color cellophane taped to it to create the color you can see at the top of the photo.

85mm macro, 4 seconds at f/64 and ISO 200, tripod mounted

Using Natural Light

I am in what may be a relative minority of professional photographers when it comes to natural light and still life subjects: I really love the quality of sunlight, and I like to use it in my studio still life work whenever I can. Although it may sound like an easy option—because when I am working this way I don't have to bother with setting up lighting—in fact still life photography with natural light takes careful observation and good timing. Good natural light doesn't last forever because it is very ephemeral and transient.

Just as location photographers chase perfect lighting conditions, when I am shooting a still life by natural light I find myself rushing around with a subject and

a stage. Is the light better upstairs? Let's move there and see. Oh—the sun has gone behind a cloud! What great bright but diffuse light. And so on.

To take advantage of natural sunlight with still life compositions, I normally start with a small subject. This technique won't work so well with larger subjects. Next, I need to improvise and construct a background stage that is portable. Usually, this means placing my composition on a board or a small table, and using a simple black or white background. Finally, there's the issue of waiting for the right light.

As with continuous lighting fixtures, you can expect—to some degree—to control whether the light is hard (direct sunlight)

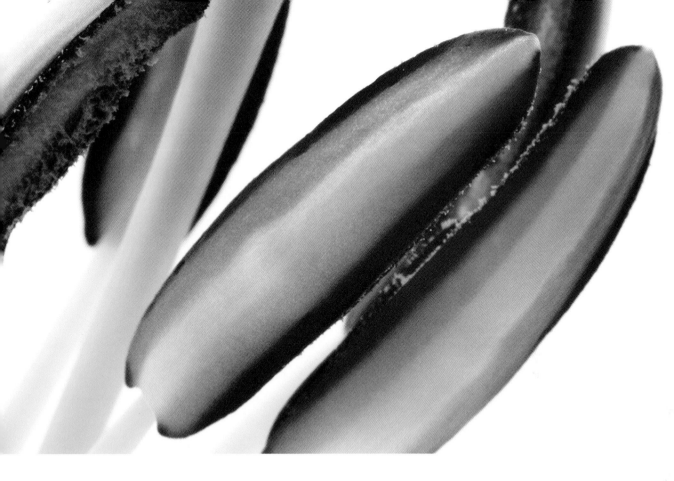

▲ I used a number of cardboard fills—white cardboard that reflects light onto the subject—to reflect daylight onto these daylily anthers. While the illumination source for this photo is sunlight, getting it to properly light this tiny subject probably took more work than if I had been using continuous, artificial lighting.

200mm macro lens, 36mm extension tube, 2 seconds at f/36 and ISO 100, tripod mounted

◀ This shell is very small, about 1/4" across. I placed it on a black velvet cloth, and used window light to provide illumination. I had to wait until the light was just right—coming in through the window strongly, but not falling on the shell in a way that would create distracting reflections.

50mm macro lens, 36mm extension tube, 30 seconds at f/32 and ISO 100, tripod mounted

or diffuse (the sun is behind a cloud), although your mechanism for control is simply waiting the weather out. You can also control the angle of light that illuminates your subject by positioning the stage containing the subject. For example, I sometimes move the stage near a window and use blinds or shades to modify the lighting. If necessary, I also use black cardboard barriers to restrict the light from some areas of the subject.

By the way, it makes perfect sense to use white pieces of cardboard to provide fill lighting as needed. You can also use a board covered with foil to reflect in "accent" lights, and black cardboard when you want to "take away" light from part of the subject.

If you are interested in using natural light in your still life compositions, I'd suggest taking a very careful look at all the locations that may be available to you. Try to understand how well they might work as lighting locations for your staged compositions at different times of day and in different weather conditions.

Still life photography using natural light can take a surprising amount of patience—and good observation. But I think you'll agree with me that the quality of lighting in the resulting images can make it worth it.

Integrating Natural Light with your Still Life

Much as I like using natural sunlight in my still life setups, even I have to admit that sometimes it is just not enough! When sunlight isn't enough, what can you do? The obvious answer is to add some light.

Generally, when I add light to a still life subject that is primarily illuminated using sunlight, I don't worry too much about the color temperature of the light I am adding. The truth of the matter is that sunlight itself varies greatly, depending upon the time of day, time of year, and atmospheric conditions. Many compositions are largely lit by reflective light rather than direct illumination from the sunlight—the light comes in through a window, bounces off walls and ceilings and then reflects onto your subject. The color temperature of sunlight is hugely variable, and mostly I don't try to measure it.

I like to start with the sunlight illuminating my subject. Sometimes this lighting is sufficient, but if not I'll add artificial light without worrying too much about whether my light sources are very different from each other.

As I've noted, natural daylight as a lighting source is fleeting. Perhaps the single most important technique when working with this kind of light is to "seize the day." Therefore, I regard adding artificial light into the mix as more art than science. It is an act of improvisation that depends upon what is available, and where every second can count. The implication of my approach is that it sometimes doesn't work—but when it does, the results can justify the improvisational process.

▶ Ambient daylight lit the ceramic bowl in the background; I used a continuous photo light with a tungsten-halogen bulb to light the camellias in the center of the bowl, which are lit with slightly warmer light than the bowl itself.

50mm macro, 1 second at f/32 and ISO 100, tripod mounted

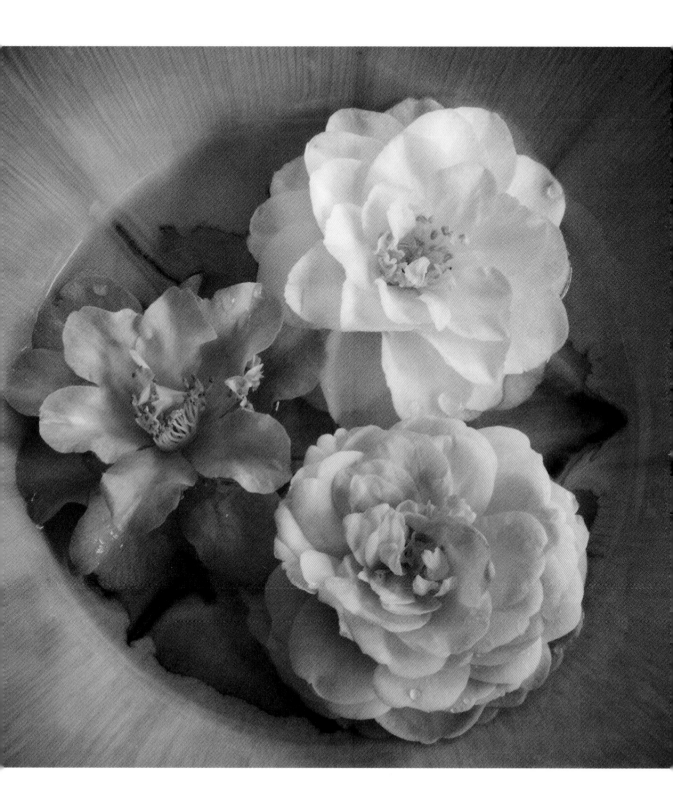

Creating Transparent Effects

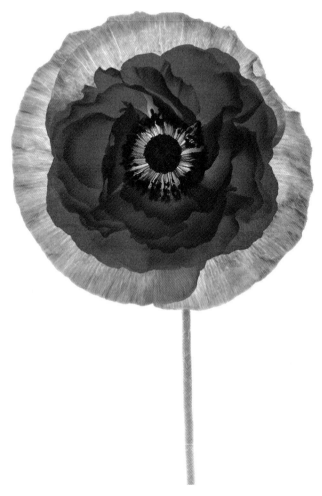

▲ To create this translucent image of a single spectacular *Papaver rhoeas* poppy, I backlit the flower using the strong daylight of the late afternoon sun coming through a window in my studio.

200mm macro, six exposures combined in Photoshop at shutter speeds from 1/13 of a second to 3/5 of a second, each exposure at f/36 and ISO 100, tripod mounted

▶ This prize-winning shot of a trio of dawn chorus poppies was created using backlighting from a light box projected through the flowers.

70mm, 1/8 of a second at f/22 and ISO 200, tripod mounted

For the most part, transparency in photography is impossible. If your subject were truly transparent, then it would be invisible—and you would neither be able to see nor to photograph it. Outside of the realms of invisibility cloaks, it is better to understand that by *transparent* we really mean *translucent*—and that the best transparency effects are really providing an illusion of translucency.

By whatever name, I've got tremendous mileage in my studio work by creating a transparent effect—and you can too!

Apparent transparency in a still life composition depends upon these factors:

- The natural translucency of the subject. For example, stained glass is quite translucent, as are the wings of a butterfly. A brick is not, and probably cannot be made to look translucent or transparent.

- The light that is being transmitted through the translucent surface. Strong backlighting works best.

- Contrast in the image. High contrast between dark areas that seem to have full opacity and areas that are much lighter produces the illusion of transparency. This is an effect that can often be created using selective overexposure.

- Super whiteness of the background. As I've previously noted, a white background illuminated with reflective light is likely to appear gray in a photo—and will not help give your subject the illusion of transparency. Using a rear illumination system such as a light box will provide a

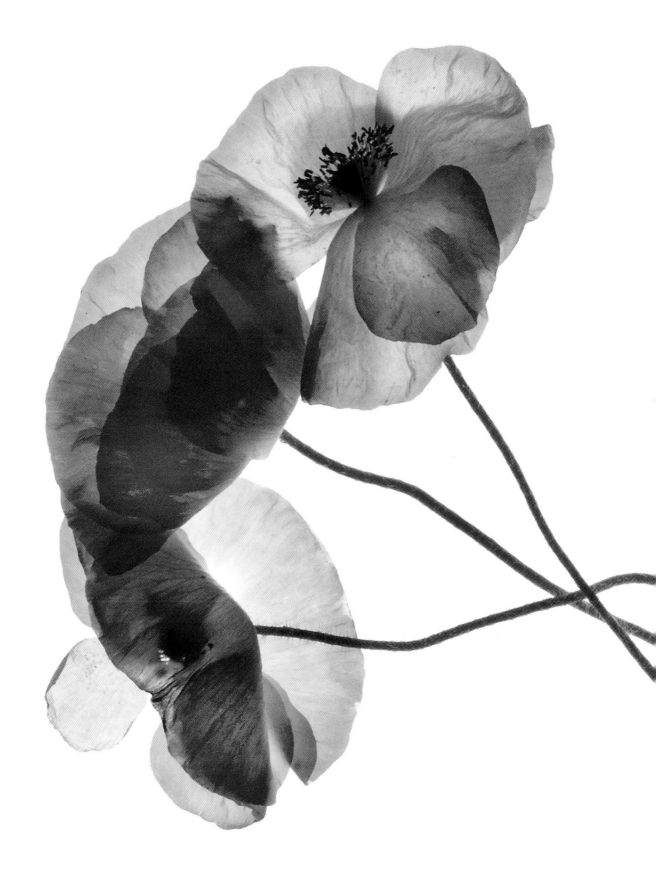

background that truly appears bright and white—which helps support the sense of transparency of a subject placed on the light box.

Creating compositions of still subjects that appear transparent is primarily a trick of lighting and exposure—although as I've observed it helps to start with a subject that is naturally translucent. And remember there are some objects that will never seem transparent no matter what you do.

I've noted that selective overexposure is one of the keys to simulating transparency. To start with, to create a transparent seeming image, I look for an exposure histogram that is biased to the right (see pages 78–81 for more about exposure histograms).

The selective overexposure technique is accomplished by making a number of exposures, each one more overexposed than the last. I usually bracket to the overexposed side by about a single f-stop

(or factor of two), although it is smarter to bracket using shutter speeds than aperture. It is important not to move the subject or camera and tripod between the exposures.

In the digital darkroom, it is usually not hard to "paint" the overexposed versions over the initial version, using layer masks.

In my experience, one of the neat things about this trick of transparency is that it can be viewed as a starting place. An image that seems to depict transparency is showing something unusual that may not often be seen. This can become the starting place for further adventures in digital image making that take advantage of the transparent effect without it being apparent in the end result that transparency was involved in the image's creation (see the image of the Dragonfly shown below and to the right).

▶ This colorful dragonfly is a combination photograph and digital Photoshop illustration that has been published many times.

To make this creation, I started with the very transparent looking photo shown to the left. This original photo was made by shooting straight down on a light box. The light box was used to create the backlighting and enhance the transparency of the dragonfly's wings.

Before preparing the final version, I inverted the image so the dragonfly appears to be on a black background.

200mm macro, 2 seconds at f/36 and ISO 100, tripod mounted

Working with Shadows

Shadows are extremely important to the success or failure of still life photos because they inform us about the spatial relationship of an object to its background, and to other objects in a composition. In addition, a shadow tells a story that we respond to subconsciously. At some level of visual perception, the shadow of an object may tell a truer story about the object than the object itself.

Shadows are fairly easy to manipulate with lighting, so it is surprising that more photographers don't pay close attention to the shadows cast by objects they are photographing— or even make the shadow itself an important compositional element, as I often like to do.

Shadows only become a significant part of a composition when the darkness of the shadow contrasts with a lighter background. At the same time, in order to control shadows, you need a setup and stage that does not rely upon overall diffuse lighting. In other words, strong shadows are by definition the result of directional lighting. The harder and more focused the lighting, the more hard edged the shadow will be.

Beware of cross-shadowing. This takes place when you set up light sources from several directions; if the two sources of light are roughly balanced, the result will not produce strong shadows in any direction.

Front lighting creates a shadow that stretches behind the object, with the precise direction depending upon the angle of the lighting (see example on page 184) while back-lighting a subject produces shadows facing towards the camera (see example on page 185).

▶ This Rodin sculpture in an outdoor garden casts interesting shadows at night, with the light source based on the ambient and installation lighting. If you study and understand shadows in various different lighting conditions, you are more likely to be able to create plausible and interesting shadows in your studio compositions.

105mm macro, 30 seconds at f/18 and ISO 200, tripod mounted

You should also bear in mind that a light that is positioned lower in relationship to your subject will produce a longer shadow, and the further away from the object your light is, the sharper the edges of the shadow will be.

Provided you are working in a fairly dark room, it's easy to see these effects by placing an object such as a small statuette on a white seamless background. You can then move your light from back to front, side to side, and up and down while observing the impact on the shadows on the back of the seamless "stage."

While it is easiest to control shadows in a studio environment, bear in mind that surprisingly strong shadows can appear— even in low light conditions—created by ambient light sources (see pages 182–183 for an example). Noticing, and taking advantage of, these impromptu shadows can make the difference between mundane and special photos.

▶ White paper as the background and a single light source made for ideal conditions for experimenting with the shadows cast by this glass vase.

50mm macro, 0.3 of a second at f/32 and ISO 100, tripod mounted

▼ The shadow of this Lego creation made by one of my sons seemed to be a lot more sinister than the toy itself.

62mm, 1.6 seconds at f/32 and ISO 100, tripod mounted

Reflections

▲ I picked up this example of desert rose—a crystal rosette formation containing the minerals gypsum and barite, along with sand—at a gift shop in Death Valley. My idea in creating this composition was to choose my aperture carefully to control the depth-of-field. I wanted the desert rose itself to be tightly in focus, while the reflection was somewhat out of focus—to distinguish the rock from the reflection. It took some experimenting, but finally f/16 worked so that the rock itself was sharp and the reflection is definitely not.

200mm macro, 1/6 of a second at f/16 and ISO 200, tripod mounted

Adding reflectivity to an image is often an excellent way to make your subject matter more interesting, particularly when you are working on a small scale. First of all, forgetting about issues of color and lighting, adding a reflection of the object is likely to make your composition more formally interesting—because of the mirrored symmetry of the reflection.

I like to shoot still life compositions using a mirror as part of the background, generally placing objects on the mirror. Besides adding some compositional pizzazz, this arrangement helps to add some glowing light underneath the subject of the photo—an area that is often dark and unattractive. The downside to using a mirror in this way is that you have to be very careful about how you position your camera. Small shifts in camera position can have a big impact for good or evil—if the scaffolding and duct tape that you've used to hold your still life together shows, then the camera position is likely a mistake.

Note that adding a reflection to an image may also add some concerns about where you focus—and how much of the image should be in focus. This is particularly true in the context of macros and small-scale subjects because even at small apertures (such as f/36) there may not be enough depth-of-field to keep both an object and its reflection sharp.

Depending upon the situation, you may intentionally decide to choose a point of focus and an aperture that keeps only part of the image in focus. This can work well with images that include reflections when the primary subject appears sharp, but its reflection does not. Getting focus and aperture right may take a great deal of trial and error in this kind of photography.

▲ With a mirror placed inside a light tent (see page 170), I was able to position this flower so that it appears to be admiring its own reflection—the flower also presents a strong contrast to the neutral "whiter than white" background.

200mm macro, 2 1/2 seconds at f/36 and ISO 100, tripod mounted

▲ At an antique car show, the reflections in the polished chrome present a world that is similar to our "real" world, but subtly different. This subtle difference—caused by reflection combined with mild refraction—provides a dream-like effect that can be used as the basis for interesting photos. Looking for reflections in the "real world" will help educate your eye when it comes to working with reflections in the studio.

200mm macro, 1/8 of a second at f/36 and ISO 100, tripod mounted

▲ The concave reflective surface of a metal spoon will reflect—and appear to take on the coloration of—whatever objects and colors you place near it; for example the small umbrella shown in this spoon was placed above the spoon while the spoon itself was photographed in a light tent.

200mm macro, 2 seconds at f/36 and ISO 200, tripod mounted

Refractions

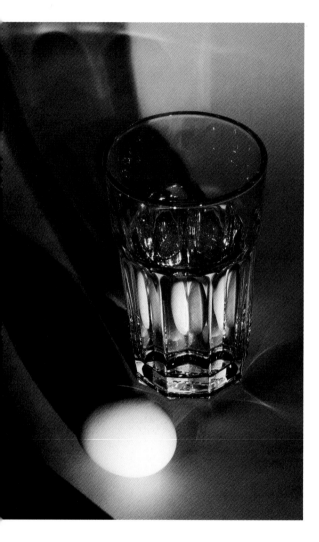

▲ I positioned one egg in front of the glass and one egg behind the glass. The object of this sleight-of-hand was to create a relatively complex composition. This composition uses the refraction of the egg that is behind the glass. In addition, the glass and foreground egg are front and side lit to create an exotic shadow pattern.

85mm, 1/4 of a second at f/17 and ISO 100, tripod mounted

Refraction is curvature and distortion caused by a change in a light wave in relation to its speed. Refractions are often seen in conjunction with reflections—for example, when the reflective surface is slightly curved rather than flat. Distortion caused by refraction also occurs when light passes through glass or water—or, in one of my favorite setups, through a glass that also contains water.

Of course, you need more than a glass partly filled with water to make interesting refractions. First, it helps if your glass is curved, or faceted. Areas near the curves or facets will produce more pronounced refractions.

Naturally, you should also expect to add something interesting to the composition. Most often, this is accomplished by adding something colorful to the inside of the glass, such as the flowers shown in the close-up image to the right.

Another creative possibility is to place an object behind the glass, which will then appear in its refracted state when you shoot through the glass, as does the egg that I placed to the rear of the faceted glass in the shot on the left. In this case, the viewer isn't quite sure at first whether the egg in the foreground is being reflected in the glass—but inspection shows, of course, that there are two eggs.

If you are aiming to capture interesting refractions, it's important to use lighting that brings out the refractions without creating direct reflections. This is often an issue of carefully positioning the lights and checking out the results. A place to start is to assume that you want the bulk of the lighting to be outside of the family of angles of reflections (see pages 52–54) so that you are getting diffuse reflections, rather than direct reflections.

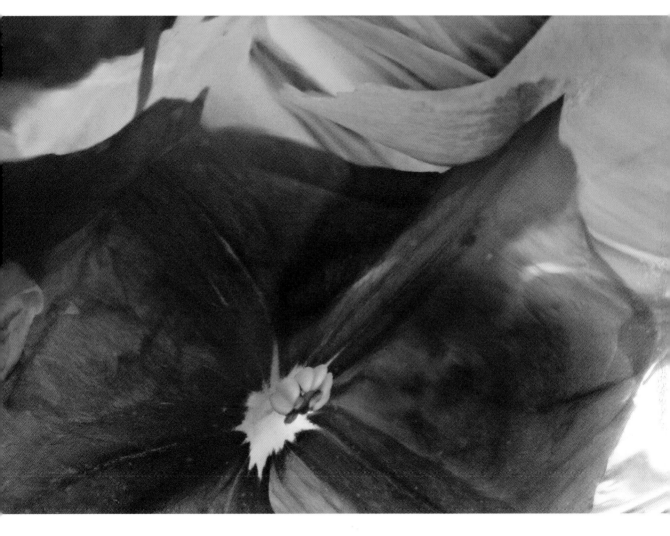

▲ These flowers in water as shot through a faceted glass create an impressionistic, watercolor effect based on the refractions from both the water and the glass. You can see the setup in the light tent on page 170.

200mm macro, 1/3 of a second at f/36 and ISO 100, tripod mounted

Metal

Metal, particularly polished metal, is a chameleon-like substance to photographers, since its color and overall appearance will depend almost completely on what you reflect into it. In classic product photography, the idea is generally to keep the metal bright and neutral by reflecting white into the metal (if it is silver) and by keeping the camera and photographer out of the photo.

But this book is about *creative* lighting, not boring old product photography. So I say, use metal as your blank canvas, the wilder the better! Take advantage of the reflective and refractive properties of metal to reflect into your objects anything you'd like. For example, it's easy to put a colorful umbrella into a spoon (page 189)—or your own hand if you prefer (see page 195).

There's also nothing wrong with letting your own reflection, or the reflection of your camera, appear in the photo. This should be a matter of aesthetic choice— if it adds to the photo, do it. To remove your camera from an image, try using a longer lens from farther back and shifting your position until you can no longer see your camera in the reflection.

Instead of expecting metal to be neutral in color, experiment with reflecting bright colors into the metal objects in your composition. People will still recognize your shots for metal, and they won't necessarily realize the colors within the metal come from reflected lighting.

Some of the most fun I have in the studio comes when I work with the reflectivity of metal surfaces—but I try to never light the metal object the way you see conventional products lit. Who needs another toaster oven, or a perfect fork or spoon? In my bag of tricks, I tape cellophane over the lights I use when I photograph metal, and I use colored pieces of cardboard to send specific colors into parts of a metal object. If all this fails, why not use a colorful umbrella or patterned clothing, that is out of focus so it is unrecognizable.

When it comes to lighting a reflective surface such as a metal object, it is important to be clear that the direct illumination from your lighting source is only part of the game. Managing reflective light—coming from your lighting source and bouncing off objects such as colored cardboard and umbrellas—is equally important. If you take this perspective, and experiment with beaming colors, shapes, and lights into metal you are working with, you are almost certain to come up with some very creative and enticing results!

▶ With highly reflective and curved metal surfaces such as the chrome of this antique car, it is hard to control what the reflections in the metal will show (the shot shows my reflection, along with my tripod). Outside of the studio, the best approach is to realize that the unexpected will likely be part of your composition—and to make the best of it using careful observation and placement.

200mm macro, 1/20 of a second at f/36 and ISO 100, tripod mounted

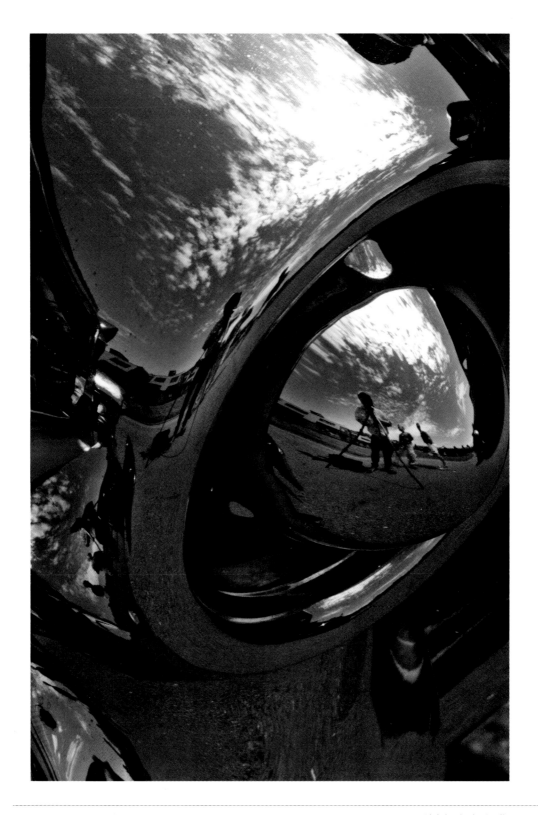

▲ This shot shows kitchen pots and pans reflected in the stainless steel surface of a large casserole. If you look closely, you can see my tripod carefully camouflaged in the folds at the center of the image. Note that as opposed to conventional product photography of "perfect" high polished kitchen utensils, I intentionally shot a pot that shows the scratches and defects on its surface from long term usage. My idea was to create an effect of a rich surface patina, such as you might see on an antique statue.

105mm macro, 20 seconds at f/36 and ISO 200, tripod mounted

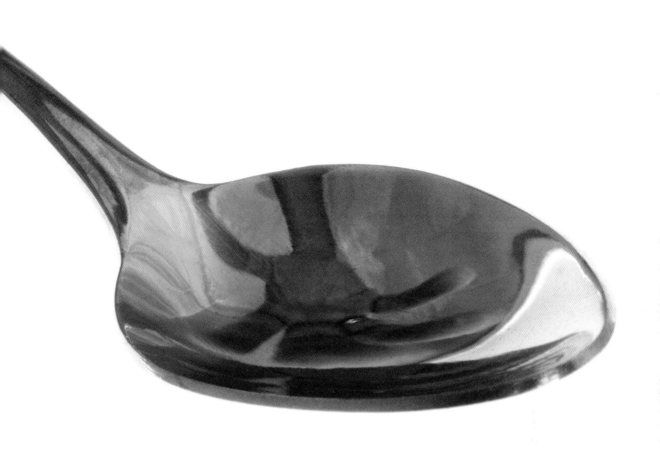

▲ I worked hard to position my left hand correctly to create the reflection in this spoon—not as easy an endeavor as it might seem. The spoon was placed in a light tent, with overall illumination from warm-ish tungsten lights. I used a remote release to fire the camera with my right hand when my left arm was reflected in the spoon. The problem was that the reflection of my hand was only positioned correctly with very precise placement—and I couldn't look through the camera to see it if was right. Getting the shot took quite a few tries.

200mm macro, 1 second at f/36 and ISO 200, tripod mounted

Strobe Lighting Equipment

Strobe lighting in the studio differs from continuous lighting in two key respects:

- Instead of putting out steady, continuous light, a strobe generates an extremely short—but powerful—pulse of light

- There's no real way to see the actual impact of firing a strobe before you make your exposure (because of the short duration of the flash)

Okay, so there are also some other differences between strobes and continuous lighting; chiefly, strobes cost more, and they don't get hugely hot. But from a lighting perspective, the key issue is the short duration of the light put out.

In practice, the short duration of the pulse of light generated by one or more studio strobes (usually 1/1000 of a second, and sometimes a great deal shorter) means that in terms of the lighting hitting your

sensor the strobe is controlling the length of the exposure—not your camera's shutter speed setting. Most of the time—unless you want to combine ambient light with the strobe exposure—you set your camera to the maximum flash synchronization speed (often 1/160 to 1/250 of a second). In other words, this setting is pre-determined and fixed for most studio photography with strobes.

With shutter speed out of the picture as a variable in the studio-strobe shutter equation, only your aperture and ISO are left—along with the possibility of manipulating the lights up or down by controlling the intensity of the strobe units, moving them, or adding additional lighting units.

On the topic of exposure, since you can't see the light the strobe units will generate, how do you find the right exposure? For that matter, how do you judge the visual

◀ The studio strobe shown on the stand is reflecting light off an umbrella. A power pack is shown idly standing by, not doing anything. (Image courtesy: Profoto.)

▶ In this shot using fairly standard studio lighting for portraits, Gabriella is lit by a single, large soft box above her and to her left (you can see the reflection of this light source in the "catch lights" in her eyes). I used a white board mounted on her right side to reflect light and fill in some of the deep shadows that would otherwise have been distracting. To see a diagram of this lighting setup, turn to page 198.

100mm, 1/160 of a second at f/11 and ISO 200, hand held

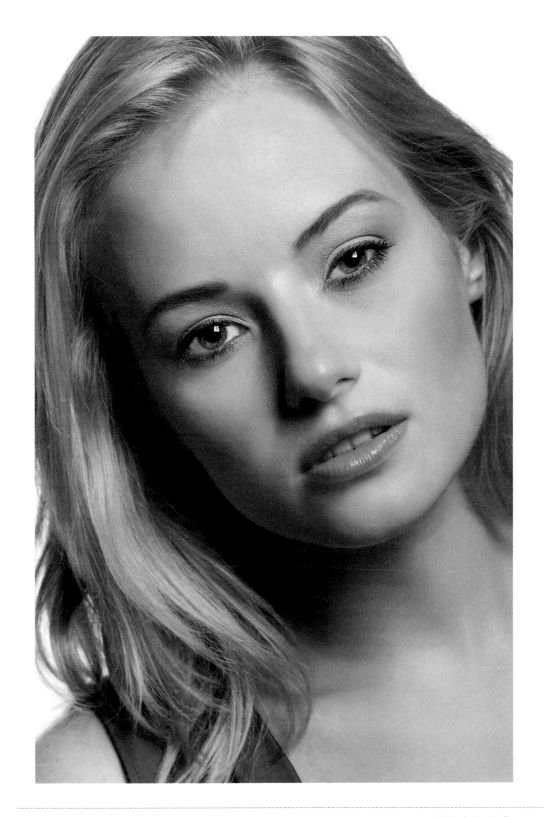

and aesthetic impact of lighting that you can't actually see?

You can use a flash light meter to help you find the f-stop (aperture) you should use at a given ISO, or to adjust the ISO. Trial and error also works, along with the feedback that digital photography provides on the LCD. Of course, experience also helps give you a sense of how a particular lighting setup will work—as do the modeling lights provided on many strobe units. These are continuous lights that you can use to at least get a sense of the direction of the light that will be generated—even if they don't help that much in judging quality or intensity.

Besides exposure settings, you may also wonder about white balance when working in the studio. Nominally, most studio strobes are balanced to daylight, although there is some variation. In situations where

▼ This is a studio lighting kit from Profoto. The two strobes are mounted on stands and the lights reflect off the umbrellas.

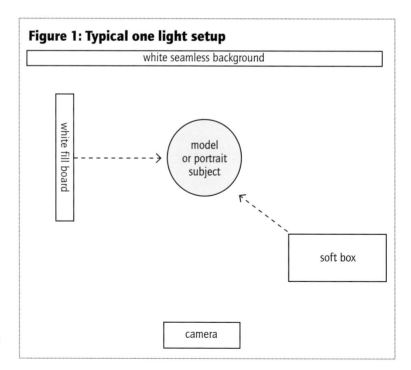

Figure 1: Typical one light setup

white seamless background

white fill board ----> model or portrait subject

soft box

camera

▶ This is a diagram of the lighting setup that was used for the model headshot on page 197.

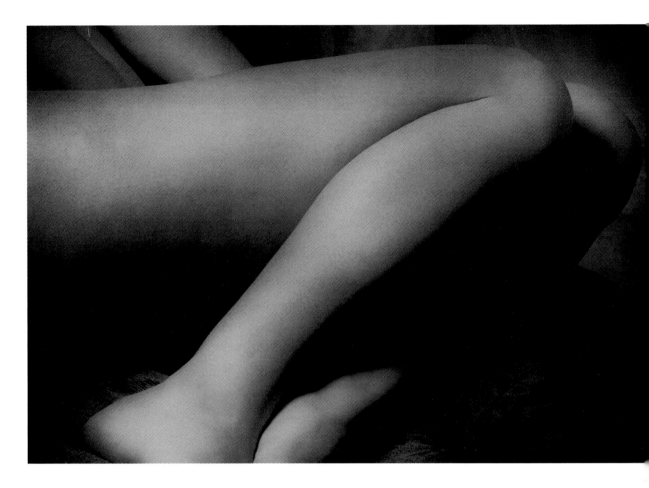

color is critical, you can create a custom white balance for a specific setup (refer to your camera manual for instructions about how to do this). Otherwise, set your camera to either Auto, Strobe, or Daylight white balance—they should work fine.

Studio strobe equipment is triggered optically or by remote radio control units such as the Pocket Wizard. (You can also fire strobes using synch cords, but this is pretty much a nuisance.) Optical firing means that the strobe goes off when it senses a burst of light, so it is typical in a multi-light setup to fire one via radio control, and have the other "slave" units set to go off optically when the first one fires.

Generally, studio strobes are used with modifiers that intensify, diffuse, or otherwise direct the lighting. For example, umbrellas are used to reflect light (or to diffuse it when light is shone through a white umbrella). Soft boxes are used to diffuse light, and barn doors can be used to concentrate light within a certain path.

▲ I used a single strobe with a reflector to create this high contrast image showing a model's legs.

95mm, 1/160 of a second at f/11 and ISO 100, hand held

Lighting People in the Studio

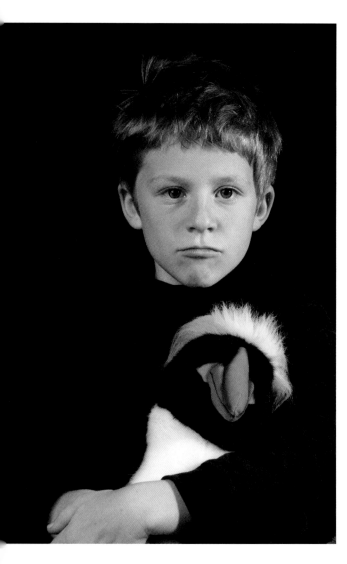

▲ This is fairly typical portrait lighting with two lights (see Figure 2 on page 201). The appeal of a portrait of this sort comes from character more than lighting—in this shot Nicky is trying to mimic the expression of his stuffed penguin.

82mm, 1/160 of a second at f/11 and ISO 100, hand held

You can generally achieve pretty good portrait lighting in the studio using a single, well-positioned key light (for example, see the photo on page 197). Generally, overall results are enhanced using some fill lighting, which creates more interesting light that comes from more than one direction.

But even if your lighting setup will ultimately become more complex than a single light setup, it is a good idea to start with a well positioned primary light. In studio lighting jargon, this primary light is called the "key" light.

Once you have the key light in place, adding an additional light (or two) can amp up the impact of your lighting by adding pizzazz, contours, intensity, and directionality. But you don't need multiple lights to get great studio lighting.

There are two take-aways regarding your key light here. First, it's worth taking the time to practice and find out what you can do with a single light. Second, even when you have the resources of a fully equipped studio to draw from, the most efficient approach is to start with a single light. Get that right—and if you've followed my advice and practiced with one light you should have no problem—and you're the bulk of the way towards a creative lighting setup that works.

In the photo of my son Nicky with his stuffed penguin to the left, I used two lights, one from either side—with the key light coming from the left providing an overall diffuse and bright effect, and the more intense light on the right adding detail in the eyes and hair, as well as an overall brightness to Nicky's left

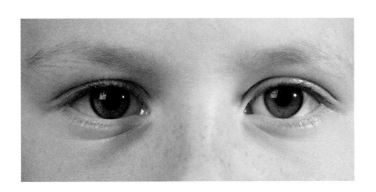

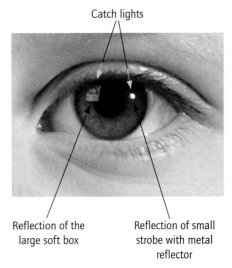

Catch lights

Reflection of the large soft box

Reflection of small strobe with metal reflector

▲ By looking at the catch lights in the eyes of a subject in a studio shot, you can usually tell a great deal about the lighting that was used.

This is a close up of Nicky's eyes from the photo on page 200. Looking closer at his left eye (above right), you can see reflections of the shapes of the lighting sources that were used.

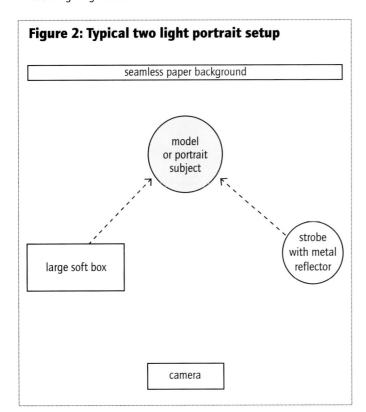

Figure 2: Typical two light portrait setup

seamless paper background

model or portrait subject

large soft box

strobe with metal reflector

camera

Reading the Catch Lights

For me, one of the best ways to learn about photography is to look at photos. When I see a photo I like, I try to understand how the photo was made.

In the same way, I like to learn about studio lighting by deconstructing how images were lit.

If you weren't there when the lights were arranged, the best way to figure out a lighting setup is to look closely at the catch lights—the reflections of the lighting sources that you can usually find in the eyes of a photo's subject.

◄ This is the lighting setup that was used in the portrait of Nicky on page 200. The shapes of the light sources appear as catch lights in Nicky's eyes.

side. The portrait wouldn't have been bad with the single soft box as illumination, but I wanted to open up the lighting on Nicky's face a bit more, and to make sure he was really tonally separated from the black background. A diagram of this lighting setup is shown in Figure 2 on page 201.

By the way, one of the best ways to analyze and learn about lighting in a studio portrait shot is to look closely at the subject's eyes (see the sidebar on page 201). The catchlights reflected in the eyes will usually tell you everything you need to know about how the portrait was lit.

For example, looking at Nicky's eyes at the top of page 201, it is easy to see the reflection of the light with the soft box diffuser coming from the left—it is the rectangular shape. The pinpoint round reflection coming from the right was made using a small metal reflector on a strobe positioned quite low and roughly at the subject's eye level.

▶ If you look closely, you'll see cross shadows in this shot of a model, indicating that at least two lights were used coming from opposing directions. In addition, I used a third light to create the background effect.

48mm, 1/160 of a second at f/7.1 and ISO 100, hand held

▼ This is the lighting setup that was used for the model photograph shown on page 203.

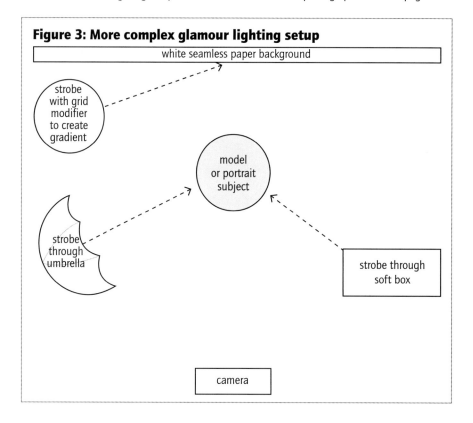

Figure 3: More complex glamour lighting setup

white seamless paper background

strobe with grid modifier to create gradient

model or portrait subject

strobe through umbrella

strobe through soft box

camera

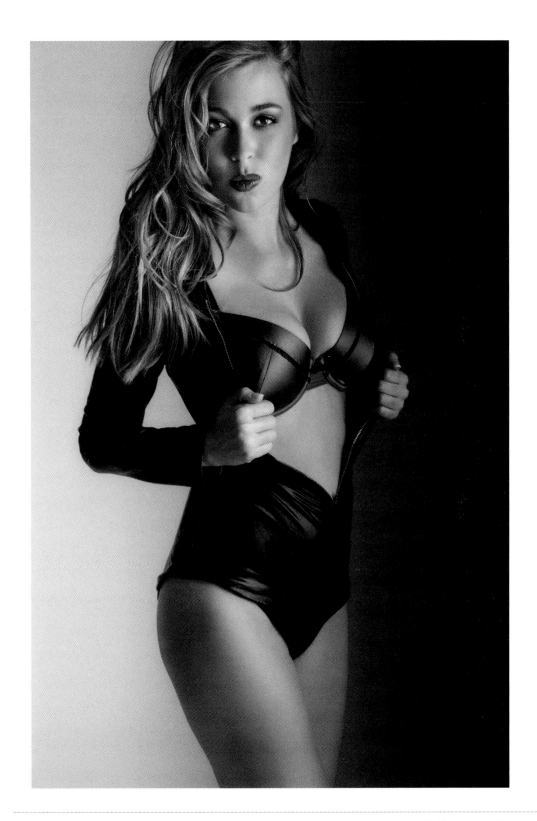

With two lights in place, if you want to get more elaborate, the next step is usually to add a third light—either to provide definition for the subject's hair or to create an interesting effect for the background, as in the photo on page 203—or maybe both at the same time. Figure 3 on page 202 shows the lighting used to create the photo on page 203.

Finally, in terms of creative lighting, why be normal? Remember, you don't have to illuminate an entire subject. Sometimes less is more. If you only reveal part of a face, a profile, or portions of a body, the part that is mysterious and not revealed may seem more interesting than what you have revealed. Consider intentionally only lighting portions of your subjects, or playing with high-key and low-key lighting. The photo on page 205 shows how a darkened room and a big soft box can create a dramatic portrait.

▶ I asked this model to move the plane of her face away from the large soft box positioned to the model's left. Without fill, the right side of the model's face disappears in the shadows—which helps create a dramatic contrast to her beautiful eyes and hair, because viewers automatically see this striking face in contrast to the darkness that surrounds it.

200mm, 1/160 of a second at f/5.6 and ISO 100, hand held

▼ This is the lighting setup I used to create the photo to the right. Notice how simple it is—only one giant soft box and a darkened room. You don't have to have a lot of fancy equipment to make a dramatic photo.

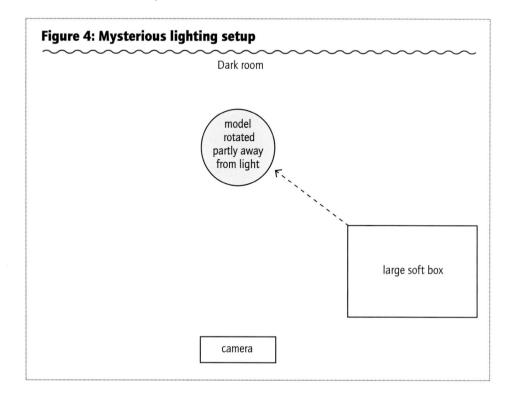

Figure 4: Mysterious lighting setup

Dark room

model rotated partly away from light

large soft box

camera

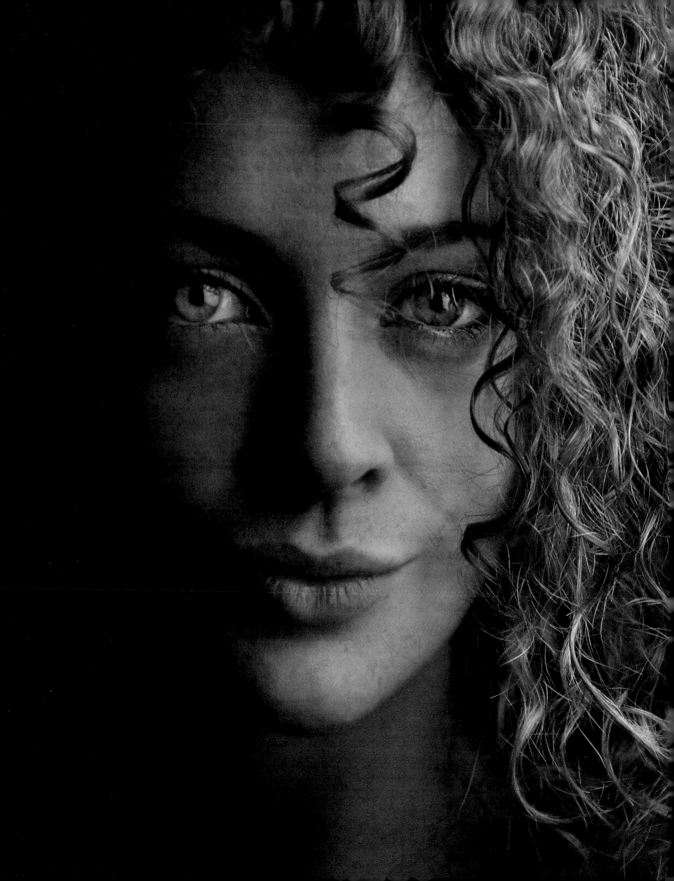

Studio High-Key and Low-Key Lighting

High-key images—meaning those that are bright, white, and supposedly overexposed—and low-key images—photos that are dark, black, and supposedly underexposed—have a place in creative studio photography whether you are using continuous lights or strobes.

A high-key subject isolates features against a background of white. To pull off a high-key portrait or still life, you need a subject that is compositionally interesting, placed on a bright background. The next step is usually to overexpose with the high-key effect in mind.

In this way, an apparent disadvantage (overexposure and excessive brightness) can be turned into an advantage that empha-sizes the form of the subject. For example, high-key portraiture flatters elegant cheekbones in a face, and also helps make various skin blemishes less of an obstacle.

Some high-key images are essentially mono-tonal, meaning besides a bright background the subject doesn't vary much in tonal range. But in studio portraiture, the most creative high-key effects involve islands of color: eyes and lips stand out against a stark white background.

In some respects, low-key photography is the opposite of high-key: subjects should be photographed on a black (or very dark) background, typically with selective illumi-nation of the subject, and usually underex-posed. The point here is to create a sense of mystery—and to highlight the portions of the subject that are lit in contrast to the dark overall cast of the image.

▲ I carefully placed this fragile snake skin on a translucent surface and lit it from underneath with a strobe. The snake skin is much more dramatic than it would be on a variegated background because it is presented as a high-key image on super-white.

50mm macro, 1/160 of a second at f/5.6 and ISO 200, tripod mounted

▶ This is essentially a single light portrait, positioned to the model's left. Overexposing the photo, to emphasize the high-key aspects of the rather harsh lighting created an interesting and creative portrait that is almost mask-like rather than human.

200mm, 1/160 of a second at f/9 and ISO 200, hand held

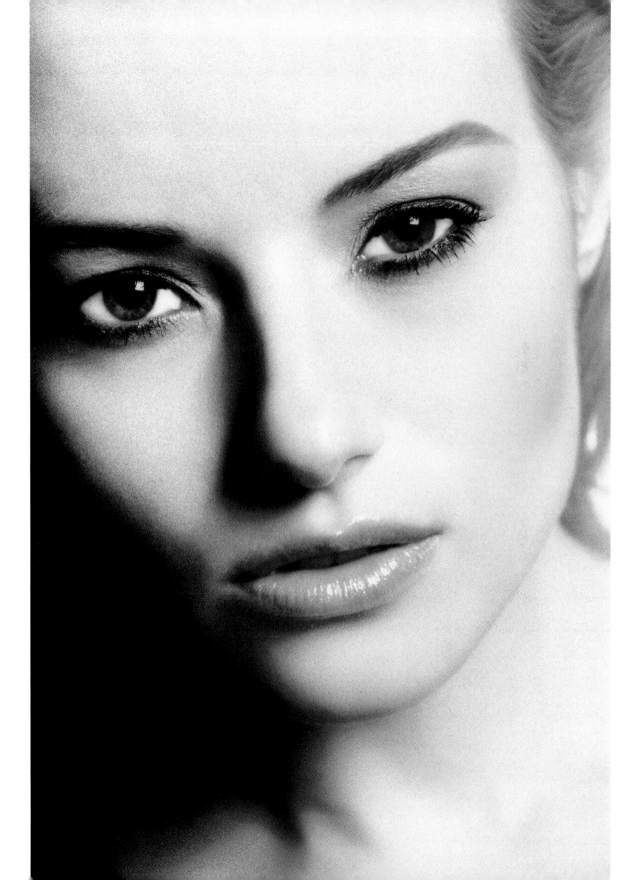

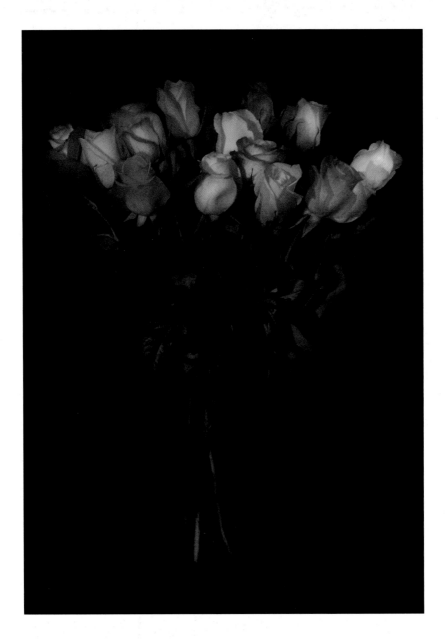

▲ In this studio shot of a bouquet of roses, I placed the flowers on a black background and intentionally underexposed, creating a low-key effect where the roses stand out but the background—and even the vase and greenery—fade so they are not noticeable. All the viewer really sees are the rose blossoms.

50mm macro, 1/160 of a second at f/16 and ISO 400, tripod mounted

▶ I positioned this model on a black seamless background surrounded by darkness, only relieved by a single light positioned above her head to her left. As with the roses, all the viewer really looks at is the model, apparently standing under a spotlight.

44mm, 1/160 of a second at f/13 and ISO 100, hand held

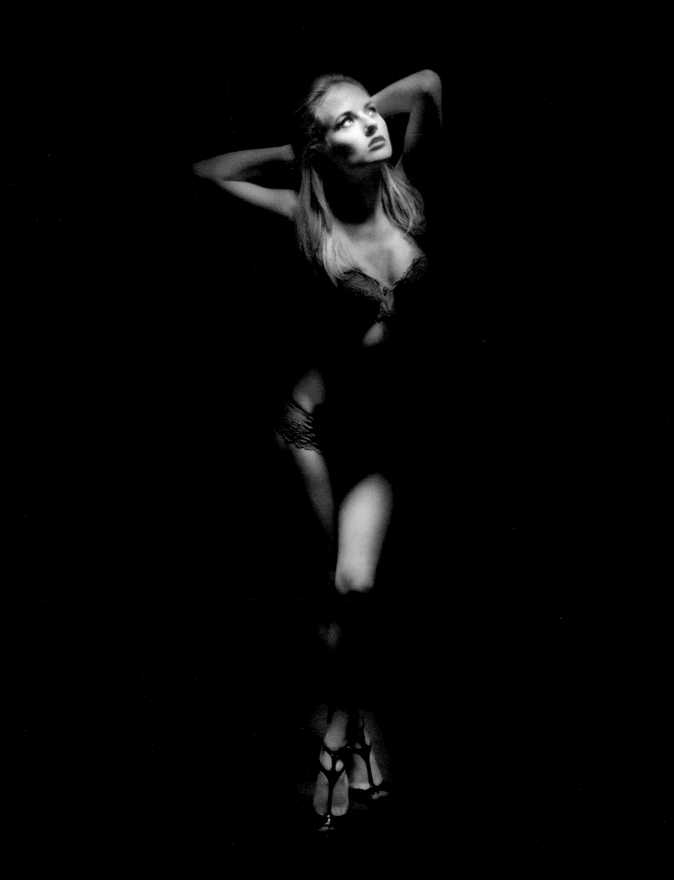

Multi-RAW Processing

Have you ever had the experience of snapping a photo and thinking it was an epiphany of perfect composition and lighting, but upon returning home and opening the image on your computer it didn't measure up to your expectations? This has often been my experience! The good news is that what you see on your computer—or on your camera LCD—is the way a computer renders your image, not the way it is. This rendition is only one of the myriad potential images that can be made from your RAW file, but only if you shoot RAW.

You are smarter than your computer—or even than your camera! If your camera is rendering an image one way, but you see it in your mind's eye a different (read: better) way, there's a pretty good chance your image can be fixed.

Multi-RAW processing is the first line of attack in this kind of situation. Let me explain.

You might think you are done with lighting when you click the shutter on your camera and make your exposure. But with digital photography, you'd be very much mistaken! Almost every aspect of lighting—including intensity, quality, color temperature, and even the direction of the light—can be adjusted in the digital darkroom.

In many cases, you can also add special effects—for example, make an image seem to be high-key or low-key—even when an image wasn't shot that way.

It's better, of course, to light a photo as well as you can in the real world, and carefully choose the best exposure settings. But this isn't always possible. And even when it

ACR versus Lightroom—and Photoshop

While Lightroom and ACR (Adobe Camera RAW) look pretty different in terms of user interface, the underlying RAW processing engine that converts RAW files into something usable in these two popular programs is the same engine. Furthermore, in both programs to combine multiply-processed RAW files into a single image you need additional software—usually Photoshop.

Due to space limitations, *Creative Lighting* cannot be a book about basic Photoshop processing. I don't want to be one of those authors who says, "To learn the real deal you need my other book!" But the fact is that I cannot teach you Photoshop in the context of this book.

If you need more help with layers, masking, and how to integrate Photoshop in your workflow with either ACR or Lightroom, please take a look at my suggestions on page 250.

▶ In the clear light of a November day, I strode up the canyon created by the Virgin River in Zion National Park, Utah. Following the course of the river was wet work, and I struggled up the labyrinth of the Virgin Narrows making sure to keep my camera equipment dry—which was more than could be said for me.

A couple of miles up the river, around a bend, the sun from the shortened autumn day filtered down and backlit this tree on a cliff wall. I paused to grab a shot, then the light was gone and the Narrows plunged into shadows.

56mm 1/60 of a second at f/5.6 and ISO 320, hand held

▲ Pages 210-211: I used some of the techniques shown in this section to enhance the colors and contrast in this double rainbow image.

42mm 1/160 of a second at f/6.3 and ISO 200, hand held

might be possible, sometimes it is less work to fix a lighting problem in post-processing.

My advice is to get it right in the camera whenever possible. But theoretical perfection is the enemy of the good. Photography as a craft is about what is possible, and the trade-offs you need to make in order to make "the possible" happen. Sometimes as a practical matter it is simply less work to adjust things on your computer after the photo has already been taken than to get every detail exactly right during the shoot—and some things are possible in the digital darkroom that could not be achieved during the shoot itself.

Ansel Adams famously compared his work to a musical composition, with his negative as the score and a print made from that negative the performance. This metaphor carries over to digital photography, with the RAW capture the composition, and what you do with it the performance. By the way, fine print making from digital files is itself a challenge, craft, and an art—so I suppose in digital photography a print is a performance of a performance of a score!

The phrase "RAW capture" is important. RAW file formats differ depending upon the camera manufacturer, but they all preserve the entire range of data in the original capture. Most better digital cameras—including almost all DSLRs—allow you to make RAW captures. Check your camera manual for information about how to set your camera so it saves exposure files in the RAW format.

Your camera will probably be able to capture in JPEG—a compressed file format—or in RAW. By the way, it's likely that you can set your camera to make both JPEGs and RAW files, with the advantages of both—imme-diacy on the one hand, and the ability to

access all the exposure data on the other—at a small cost in extra space being required on your memory cards.

I almost always save my captures as RAW files because to get the most out of your digital exposure, you need to make sure you've captured the image data in RAW format.

It's pretty well known that within a single RAW capture you have a great deal of exposure latitude. Using tools that include Adobe Camera RAW (ACR), Adobe Lightroom, and software provided by camera manufacturers, you can open images with lighter and darker exposure values. This change in exposure often translates visually into an apparent change in lighting.

By pulling different versions processed from a single RAW file into Photoshop and combining them you can control distinct areas of a photo—for example, lightening part of a photo without lightening the overall image. For some examples, and a more detailed explanation of the process, see pages 216-223.

It's less well known that besides exposure, you can also change many creative aspects of the lighting including its appearance, quality, and color. Anything that can be modified or enhanced in a RAW file—and that speaks to almost every aspect of a photo—can be used selectively in the final image, thanks to the power of layers and masking in Photoshop!

I'll show you some examples of using the power inherent in RAW to change the emotional impact of the lighting on pages 222-223.

By the way: Image modifications via multi-RAW processing don't have to be huge. Sometimes I'll use this technique just

to make minor modifications in an image. For instance, I might want to present the subject against a darker background (see page 221 for an example).

Controlling Exposure with Multi-RAW

Using the Exposure slider on the Basic tab of ACR, you can move the exposure settings applied to an image up or down in either direction by four f-stops. By the way, the underlying ACR RAW conversion engine works in exactly the same way as the Adobe Lightroom RAW conversion process—it's just the user interface wrappers that are different.

Four f-stops in either direction translates to an eight f-stop range. Since each f-stop lets

in half the light of the one that precedes it (see pages 82–83 for more about f-stops), this an enormous range, something like a theoretical 64 times from darkest to lightest. Of course, in the real world this extended range is never completely usable—but you do have a great deal of control over how you render a photo from its RAW file.

When you first open many images in ACR (or Lightroom) you may not like the way they look that much. For example, the problem may be that the image is too dark in the foreground—but the sky is basically okay. Adjusting the image overall to make it lighter would make all parts too light. This is where multiple processing comes in.

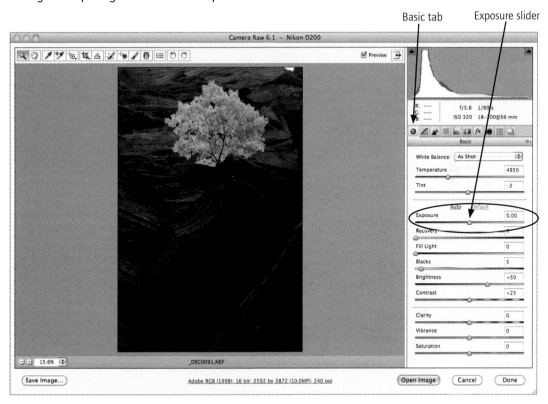

▲ At default settings in Camera RAW the image looks pretty dark, particularly in the foreground. If you processed the photo using the default settings, it would be too dark and nothing to really write home about.

Exposure slider moved to +0.80

▶ Step 1: In Adobe Camera RAW (ACR), slide the Exposure slider to the right to open up the foreground rocks. For this version of the image, concentrate on how the rocks in the foreground look. The tree may become too light, but don't worry about it.

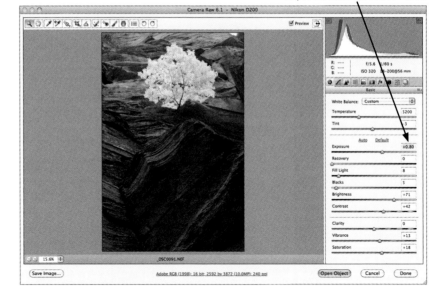

▶ Step 2: Hold down the Alt key to change the Open Object button to Open Copy. Click the Open Copy button. The image will open in Photoshop in an image window.

▶ Step 3: In Photoshop, choose Layer ▶ New ▶ Layer From Background and name the layer "Foreground Rocks." If you look in the Layers palette, you'll see the layer.

Step 4: Open the RAW image in ACR again. Use the Exposure slider to get the tree just the way you want it. The foreground rocks may become too dark, but that's okay.

Exposure slider moved to +0.15

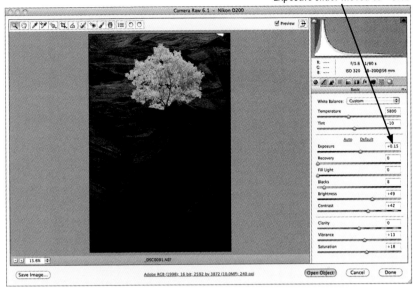

Step 5: Hold down the Alt key to change the Open Object button to Open Copy. Click the Open Copy button. The image will open in Photoshop in an image window.

Step 6: With the tree image window that you created in step 5 still selected, choose Layer ▸ New ▸ Layer From Background and name the layer "Tree."

You now have two versions of the capture—one processed for the foreground rocks and one processed for the tree—open in two different image windows in Photoshop.

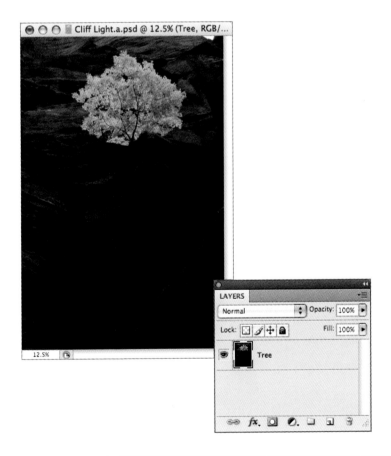

▶ Step 7: Make sure the tree image window is selected. Hold down the Shift key and drag the "Tree" layer from its image window onto the "Foreground Rocks" layer in its image window.

There are now two layers, "Tree" and "Foreground Rocks," in the Layers palette.

You will only be able to see the "Tree" layer in the image window. The "Foreground Rocks" layer will be hidden.

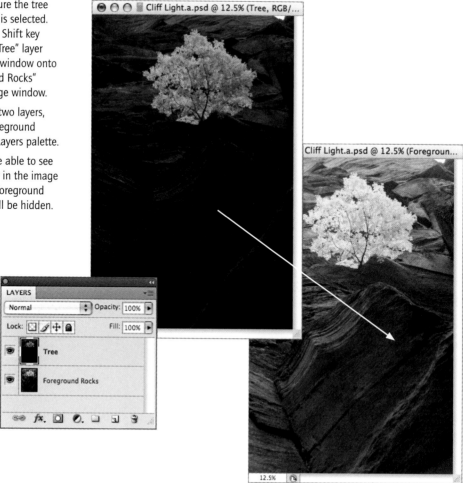

▶ Step 8: With the "Tree" layer selected in the Layers palette, choose Layer ► Layer Mask ► Hide All to add a layer mask to that layer.

The Hide All layer mask hides the layer it is associated with (in this case the "Tree" layer) and appears as a black thumbnail in the Layers palette on the "Tree" layer.

▶ Step 9: Select the Gradient Tool from the Toolbox.

Gradient Tool

▶ Step 10: In the Layers palette make sure the layer mask is selected on the "Tree" layer.

Click the Default Colors button in the Toolbox or press D on the keyboard to set white as the Foreground color and black as the Background color.

Default Colors button

▶ Step 11: Use the Gradient Tool to drag a black-to-white gradient starting at the bottom of the image window, and extending up to just under the tree. This will leave the foreground rocks lighter and blend in the "Tree" layer in a natural-looking way.

If you look at the layer mask thumbnail in the Layers palette, you'll see the gradient you just created.

The final multi-RAW image is shown on page 213.

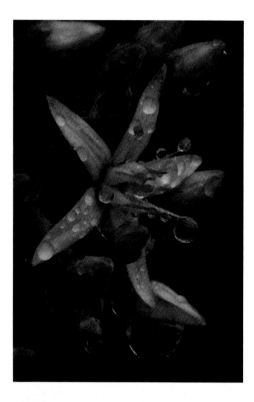

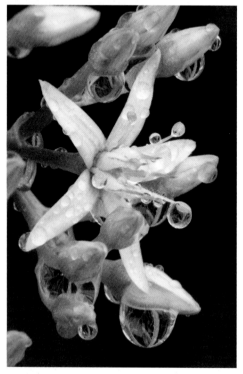

Creative Effects using Multi-RAW

I often use multi-RAW processing to creatively change the lighting in an image. For example, with the rain drops on a flower shown here on these two pages, I wanted to present the composition against a rich, black background. This was easy to do with simple multi-RAW processing.

First, I processed a darker version using Adobe Camera RAW (left). Then I processed a separate, lighter version with ACR (bottom left). I combined the two versions as layers in Photoshop, and then added a Hide All layer mask to the lighter version. Finally, I painted in the flower in the lighter version at partial opacity, using the layer mask.

The idea here—and in a great deal of multiple RAW processing—is to harness the exposure range within each and every RAW file. There's no reason that you have to process the entire image based on only a single one of these potentialities. You can pick and choose which parts of your image should be processed at which exposure—up to the range of the exposures that are inherent within the RAW file.

Furthermore, it is not only the exposure settings that can be changed during the RAW conversion process. Controls such as Fill lighting, Brightness, Black, and Contrast give you a great deal of power to impact the apparent quality of the light in an image—or in selective portions of the photo. Additionally, controls related to Color Temperature, Tint, and Saturation allow you to play with overall (or selective) light color and quality.

▶ The lighting was overcast but bright following a rainstorm. When I saw these water drops on a jade plant, my idea was to isolate the plant on a black background, almost as if it were a studio shot. To accomplish my vision, first I underexposed the image and then I processed the RAW file twice: once for the flower, and once to make the dark background go black. The final step was to retouch out a couple of distracting elements at the top and bottom left of the image that didn't belong to the main portion of the flower.

200mm macro, 36mm extension tube, 1 second at f/40 and ISO 100, tripod mounted

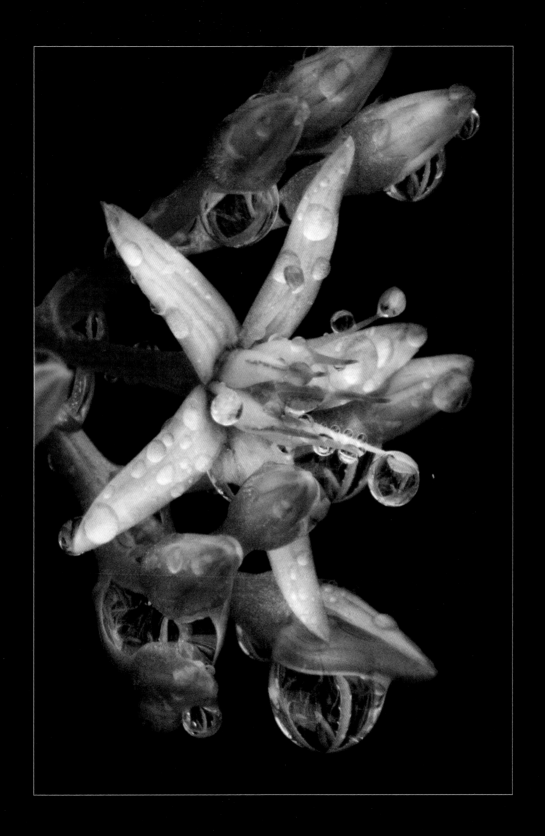

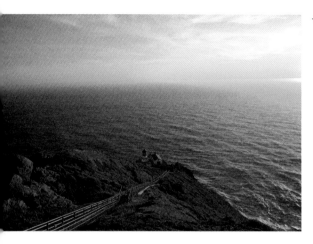

With this sunset image of the Point Reyes Lighthouse at the Point Reyes National Seashore, the default settings weren't bad and produced a perfectly acceptable background. But I wanted to creatively enhance the tonality of the image to cut the haze, make the sunset colors seem more vivid, and make the sky a more dramatic blue above the area where the sun was setting.

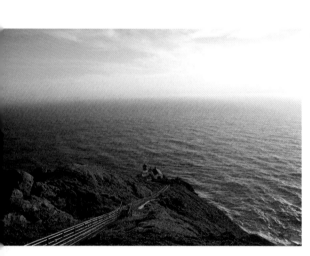

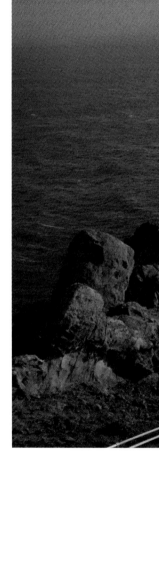

To accomplish the effect I was looking for, I processed two versions in ACR: a lighter and bluer version (left) and a darker more saturated version (bottom). I combined the two versions in Photoshop and used a layer mask to blend them together (see pages 216–219 for more about this technique). The darker version was used to accentuate the sunset colors, and the lighter version was used to add dramatic blue to the sky and ocean.

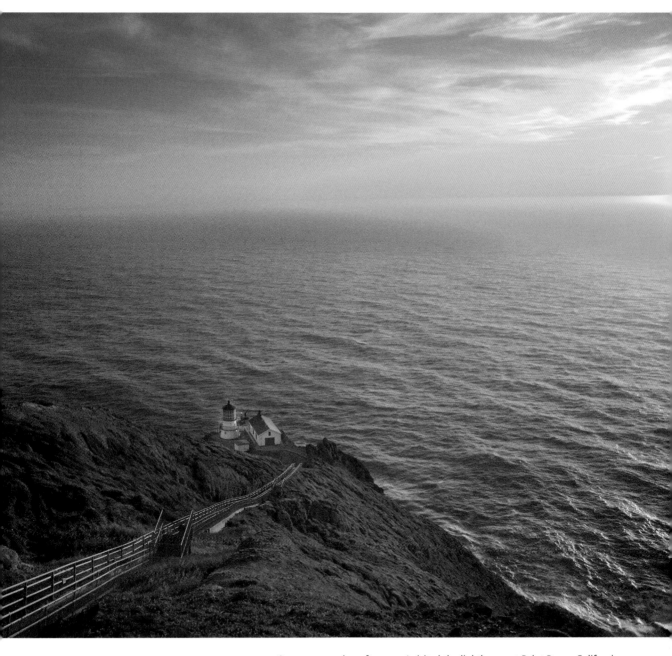

▲ On a warm spring afternoon I visited the lighthouse at Point Reyes, California. This extremely exposed western promontory is often covered with fog and subject to extremely high winds. So it was a pleasure to photograph the lighthouse in balmy weather at sunset.

I used multi-RAW processing to creatively enhance the drama of the photo by amplifying the lighting effect already created by the sunset.

18mm, 1/160 of a second at f/6.3 and ISO 100, tripod mounted

HDR and Lighting

You may have noticed that some of the images in this book are created from more than one exposure. This section explains why and how.

If something is good, than more than one of the thing must be better, right? That's the logic behind taking the expansion of tonal range possible in a single RAW file—and extending the tonal range further by throwing in more than one RAW file, with each version shot using different exposure settings.

The logic is basically flawless: if you have three captures of the same subject matter, and—with all the other settings unvaried—you make exposures at 1 second, 2 seconds, and 3 seconds then you have clearly increased the range of possible exposure values over a single exposure when you selectively combine the three exposures. The additional dynamic range garnered from the additional exposures may easily be perceived as creative lighting enhancements. You have added to the already vast exposure range inherent in any RAW capture.

So what's the catch? Photography is an art of what is possible, and the craft of making images always involves trade-offs. You can make informed decisions about techniques only if you know the pluses and minuses of the possibilities.

▶ A brisk autumn morning found me, my camera, and my tripod poised before dawn to capture the lighting as the sun rose to strike the top of Mt. Whitney, the tallest mountain in the continental United States. While the scene that unfolded in front of me was very beautiful, I knew that no single exposure could capture the entire tonal range that I saw—so with my camera firmly in place on my tripod, I bracketed the shutter speed to create exposure variations. Using these variations, my plan was to pick and choose based on the lighting, and use the best portions of each capture in a combined image.

48mm, 3 exposures combined in Photoshop with shutter speeds of 1/10 of a second, 1/30 of a second, and 1/80 of a second; each exposure at f/8 and ISO 100, tripod mounted

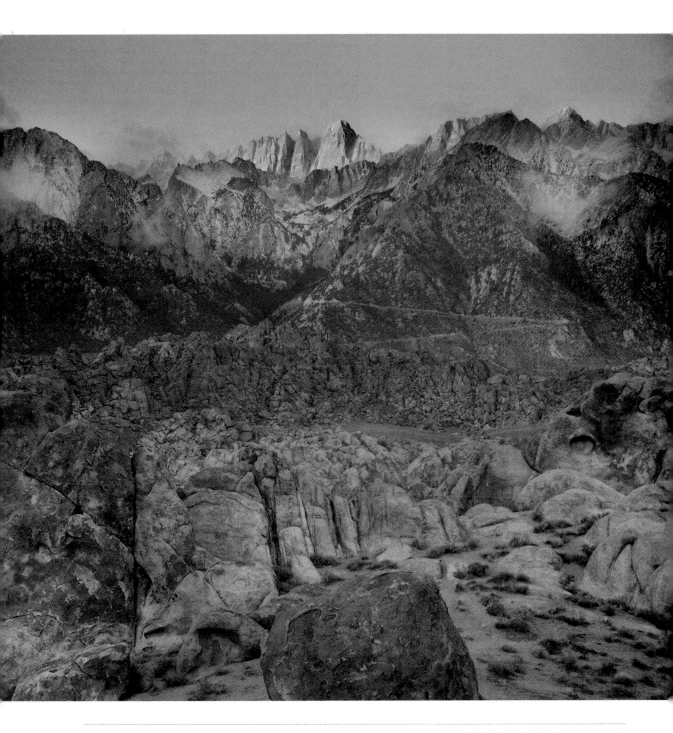

With HDR, there are a couple of important "gotchas":

- The requirement that the captures be "of the same subject matter" implies (usually) that your subject isn't moving. The camera shouldn't move either. This means that HDR works best with static photography of motionless subjects such as landscapes—although I have seen effective HDR images captured using a flash fired in quick succession.

- Another problem is that combining the exposures when the subject matter is complex can be a daunting task. Automated HDR software such as HDRsoft from Photomatix or Merge to HDR Pro in Adobe Photoshop attempts to help with this, but the software doesn't really "know" how you want to change the lighting. The overall effect from HDR software can be quite interesting, depending upon the image—and I am sometimes very happy using this software. But essentially, you are not going to be able to specify which

areas you want to adjust the way you can when you put multiple exposures together via hand layering.

Hand-HDR—the process of combining different exposures using layers and layer masks—is the only way to effectively use the lighting in different exposures for different areas of the final image, precisely as you'd like. This technique works well, but it does take time and individual attention to each image.

You also should usually plan to bracket—which is simply fancy photographer jargon for "varying"—the shutter speed rather than the aperture. If you bracket the aperture, you risk changing the depth-of-field in the images that will comprise your finished photo—not an issue when the shutter speed is varied. If the entire image is in focus at infinity, then this isn't an issue and you can feel free to bracket using aperture or shutter speed, or both.

By the way, I usually bracket my HDR imagery using manual exposure mode, instead of using the bracketing programs

▼ My first shot became the background for the image shown on page 225. I liked the moderate tones—it was a good solid base for the image.

▼ My second shot became the sky, because it was darker and preserved the rich tones of the sky and Mount Whitney.

▼ I used the third, lighter shot to bring out the foreground details that were obscured in both the background and darker versions.

_DSC9110.NEF
11/8/10, 6:34 AM
1/30 s at f/8.0 -0.67, ISO 100
48.0 mm

_DSC9111.NEF
11/8/10, 6:34 AM
1/60 s at f/8.0 -0.67, ISO 100
48.0 mm

_DSC9112.NEF
11/8/10, 6:35 AM
1/10 s at f/8.0 -0.67, ISO 100
48.0 mm

built into my camera. I find that when I vary the shutter speed I am better able to decide how much lighter and how much darker I need to go to get the lights and darks that I need to composite together my final image.

For example, as the sun cleared the Panamint Range to the east, it lit the rocks and textures of the Alabama Hills and the snowy elevation of the High Sierra crest all the way up to Whitney. Camera on tripod, I shot three exposures at 1/10 of a second, 1/30 of a second, and 1/80 of a second. Each capture was taken at 48mm, f/8 and ISO 100.

The 1/30 of a second exposure became the background layer in Photoshop because it was the best overall exposure, although the sky was too light and the foreground rocks were too dark. It was easy to use the 1/80 of a second exposure to darken the sky, and the 1/10 of a second exposure to lighten the foreground.

▶ All three exposures (right) were put together in Photoshop using layers and layer masks. If you look at the layer mask thumbnails in the Layers palette (below), you can see that the masks were primarily created using the Gradient Tool, just like the multi-RAW processing example shown on pages 216–219. The difference between multi-RAW and hand-HDR is that with hand-HDR you combine several *different* captures to get a wider dynamic range. With multi-RAW you process the *same* capture several times to get the exposure range you need.

▲ "Lighter" layer

▲ "Darker" layer

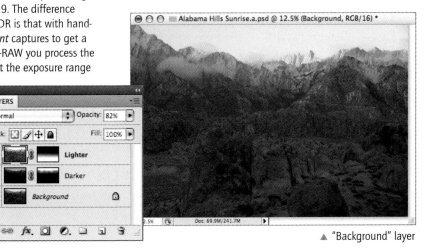

▲ "Background" layer

▲ "Highlights" layer

◄ Standing in a stairwell, and looking up, I knew the contrasts between light and dark were too great for a single shot. With my fisheye lens pointed straight up, I made the three exposures shown to the left and combined them in Photoshop using layer masks and the Brush Tool.

If you look at the layer masks above and below, you'll see soft strokes created using the Brush Tool with the Foreground color set to white, and the Brush Tool's Hardness set to 0%. I varied the Master Diameter of the Brush Tool as needed.

▲ "Midtones" layer

▲ "Background" layer

The Layers palette tells the story: I started with a capture that had a nice overall exposure, then I added a second capture that enhanced midtones, and finally added a third, lighter capture for highlights.

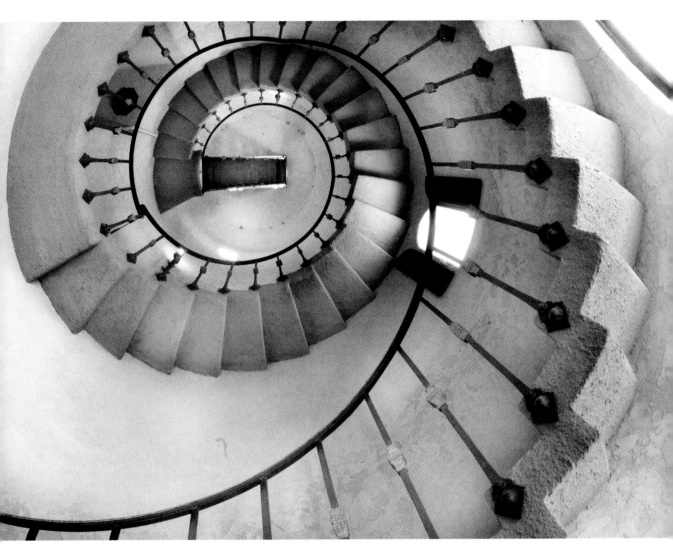

▲ Scotty's Castle is a tourist attraction in a remote corner of Death Valley National Park in California near the Nevada border. This fantastic mansion was built in the desert in the 1930s.

10.5mm digital fisheye, 4 exposures combined in Photoshop with shutter speeds of 1.6 seconds, 4/5 of a second, 2/5 of a second and 1/5 of a second; each exposure at f/22 and ISO 200, tripod mounted

_DSC4937.NEF
6/27/10, 4:24 PM
3.0 s at f/32.0, ISO 100
200.0 mm

_DSC4938.NEF
6/27/10, 4:24 PM
2.0 s at f/32.0, ISO 100
200.0 mm

_DSC4939.NEF
6/27/10, 4:25 PM
1.0 s at f/32.0, ISO 100
200.0 mm

_DSC4940.NEF
6/27/10, 4:25 PM
0.5 s at f/32.0, ISO 100
200.0 mm

_DSC4941.NEF
6/27/10, 4:25 PM
1/4 s at f/32.0, ISO 100
200.0 mm

_DSC4942.NEF
6/27/10, 4:26 PM
1/6 s at f/32.0, ISO 100
200.0 mm

▲ The six exposures of the dahlia I used to create the Hand-HDR version are shown in Adobe Camera RAW.

▶ The layers that comprise the dahlia are shown in the Layers palette going from lighter (the "Background" layer at the bottom of the stack) to darker ("Layer 5" at the top of the layer stack). The thumbnails of the layer masks show how I used the Brush Tool to create masks that added detail to the flower.

I found a nearly perfect dahlia growing in one of the protected side-yard raised beds that I use for growing flowers. To make this image, I positioned the flower in a vase in front of a west-facing window.

My plan was to use the strong late afternoon sun as my sole light source. I hung a piece of translucent white tracing paper to act as a diffuser between the window and the flower.

Since this dahlia is relatively opaque, the front of the flower was in deep shadow because the backlighting from the sun didn't reach it. I used a small piece of white cardboard as a reflector to add a touch of fill light to the front of the flower.

To make the background appear truly white (as shown in the final image on page 231), I shot a series of images at bracketed exposures, all biased to the high-key (or overexposed).

In Photoshop, I started with the lightest exposure (3 seconds, bottom layer in the Layers palette). In this version, the background was completely white and the flower was hardly visible. Using darker versions, layers, masks, and the Brush Tool, I successively layered in the details in the flower.

▶ My idea with this dahlia is that it would look perfect backlit on a white background, but it took a little work in Photoshop to get there.

200mm telephoto macro, 6 exposures combined in Photoshop with shutter speeds of 3 seconds, 2 seconds, 1 second, 1/2 of a second, 1/4 of a second, and 1/6 of a second; each exposure at f/32 and ISO 100, tripod mounted

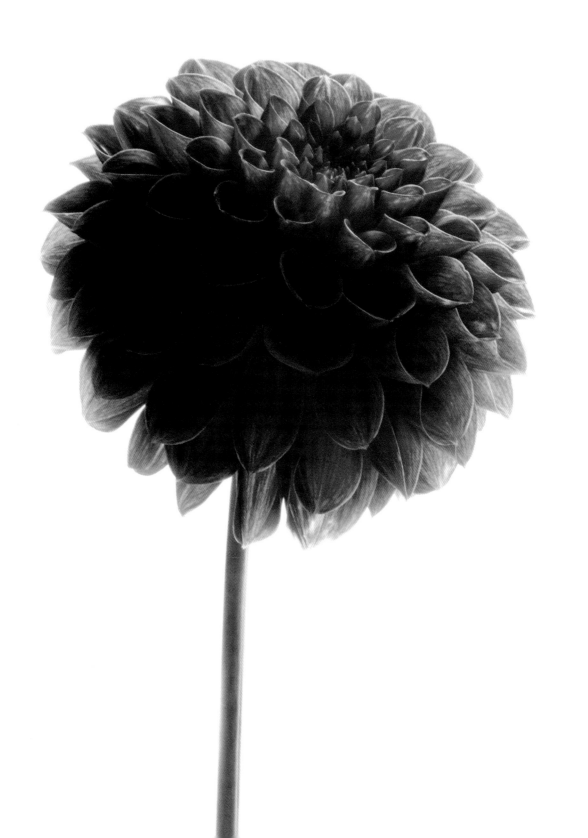

_DSC8464.NEF
3/19/10, 12:51 PM
0.4 s at f/21.0, ISO 100
85.0 mm

_DSC8465.NEF
3/19/10, 12:51 PM
1/5 s at f/21.0, ISO 100
85.0 mm

_DSC8466.NEF
3/19/10, 12:51 PM
1/10 s at f/21.0, ISO 100
85.0 mm

On pages 230–231 I showed you how I use hand HDR processing to present a flower (or any other subject) on an apparently completely white background. The same technique in reverse can be used to present your subject on a black background.

First, of course, you need to photograph your subject on a dark—preferably almost black—background. In the example shown here, I snipped a ranunculus flower from a plant in my garden. Next, I placed the bud in a small vase. I covered the vase with a small black velvet cloth.

Black velvet turns out to be particularly effective for this purpose because it absorbs light with less of the highlights that you'll find when shooting a fabric background with a more typical "sheen." You'd be surprised at how much reflectivity there is from fabrics that at first glance appear to be black!

◀ Here are the three exposures of the flower that I used to create the Hand-HDR version shown to the right.

▼ The Layers palette shows how the layers were stacked from darkest (the "Background" layer) to lightest ("Layer 2" at the top of the stack).

The layer masks tell the story. The layer mask associated with "Layer 1" lets the entire flower show through as a good base for the image. The mask associated with "Layer 2" adds highlighted areas.

▶ I created this image of this intricate and striking flower on a black background (a *Ranunculus asiaticus*) using three exposures, each exposure using a different shutter speed. I then layered the three versions together in Photoshop and used layer masks to "paint" in a luminous flower on a fully black background.

85mm macro, 3 combined exposures (1/10 of a second, 1/5 of a second, and 2/5 of a second), each exposure at f/21 and ISO 100, tripod mounted

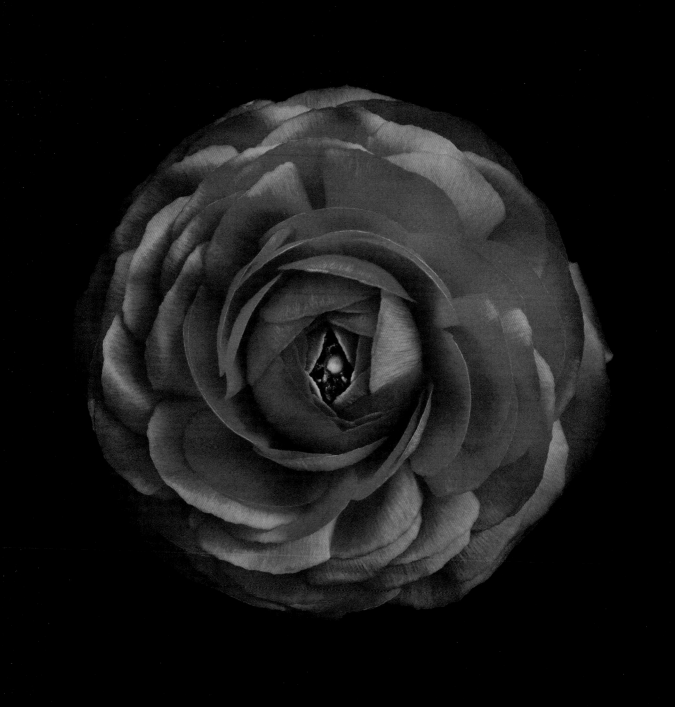

Enhancing Lighting with Adjustment Layers

When it comes to enhancing lighting in post-processing in the digital darkroom once a photo has been converted from the RAW file, I have good news and bad news. Both the good and the bad come down to this: there are many ways to go about almost anything. If you are an experienced user of Photoshop or other software, you undoubtedly have enhancement techniques you already like to use. Otherwise, you may be baffled by the myriad possible choices, and ways to change the appearance of the lighting in a photo.

In the remaining pages of *Creative Lighting*, I'll show you some of the techniques I use to enhance lighting once a photo has been converted from RAW and brought into Photoshop. Photoshop isn't the only software you can use to create many of these effects, and the way I show you to go about things is not the only way—but these techniques will show you some viable approaches and provide you with a place to start thinking about lighting in post-processing.

Adjustment layers are a great tool for enhancing images because they are generally easy to apply, you can see the impact of what you are doing as you do it, and they are notionally non-destructive. The tools available through adjustment layers can be accessed in alternative ways in Photoshop—but adjustment layers provide a kind of one-stop, easy shopping. Adjustment layers also don't add much to image file size—which may be important to you.

If you open the Adjustments palette (Window ▸ Adjustments), as you can see in the figure below left, you have access to 15 adjustments (each adjustment is represented by an icon at the top of the palette).

I find that the adjustments I use most frequently with my photos are:

- Brightness/Contrast
- Curves
- Exposure
- Color Balance
- Channel Mixer

◀ The Adjustments palette gives quick, one-stop shopping for enhancing images. If you hover over the buttons on the palette, a tool tip will appear telling you what each one does.

▶ I photographed these professional acrobats as they modeled on a white background using two soft boxes for lighting. Using a Brightness/Contrast adjustment layer in Photoshop greatly improved the overall look of the lighting in the image.

28mm, 1/160 of a second at f/7.1 and ISO 100, hand held

These Adjustment layers are pretty powerful, not to mention a great deal of fun. I recommend playing with them. For example, I often need to adjust the brightness and contrast in my photos.

Brightness/Contrast Adjustment

Check out the photo of two acrobats on a white background on page 235. The woman appears to be floating in midair. Of course, there's no real magic—only a gifted performer with amazing body strength.

The image itself when originally converted from the RAW capture seemed dull and the background didn't appear white (below left).

One way to resolve these issues, and to make the lighting in the overall image seem more attractive, was to apply a simple Brightness/Contrast adjustment. By taking down the Contrast and increasing the Brightness, the overall appearance of the image was greatly enhanced.

▶ When originally converted from the RAW capture, the photo of the acrobats appears dull and the background isn't white.

▶ Step 1: To enhance the photo, open the Adjustments palette (Window ▸ Adjustments), and click the Brightness/Contrast button.

▶ A Brightness/Contrast adjustment layer is added to the Layers palette and the Adjustments palette changes to show settings and sliders.

Notice that a white Reveal All layer mask is also added on the adjustment layer in the Layers palette. If you wanted to limit the adjustment to a specific area of the image, you could paint on the layer mask with the Brush Tool and set the Foreground color to black to hide the adjustment from that area. This will work for all types of adjustment layers.

Reveal All layer mask

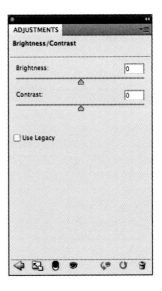

▶ Step 2: Move the Brightness and Contrast sliders to enhance the image as you wish. For this image, I set the Brightness to 48 and the Contrast to –19.

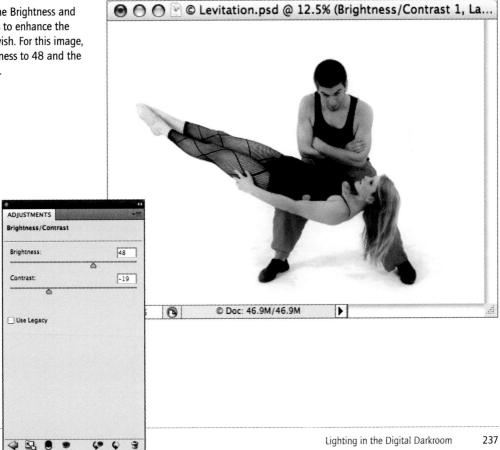

Light Quality and Blending Modes

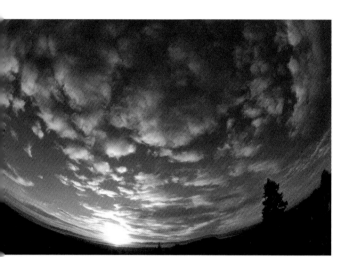

As the clouds rolled in from the Golden Gate, they crossed San Francisco Bay and dissolved into translucent water vapor when they hit the hills of the California Coastal Range. To the left is my fisheye lens shot from a promontory showing this cloud action at sunset.

For a truly dramatic image, there could be some enhancement of the lighting effects, particularly on the clouds. In fact, this is the case with many photos when you look at them in Photoshop—a challenge that can be handled using blending modes.

▲ I took this photo from a rock formation in the hills overlooking San Francisco Bay using a fisheye lens. To make this image more dramatic, the sky and clouds could use some lighting enhancement—blending modes to the rescue!

You don't need to get really fancy (although you can if you want to) when using blending modes. A blending mode specifies how the pixels in a layer are combined with the pixels in the layer beneath it. With Normal blending mode specified at 100% Opacity, only that layer shows, but when you choose another blending mode besides Normal, pixels are combined in different—and sometimes interesting and exciting—ways. For more information about the way different blending modes work visually, check out the resources on page 250.

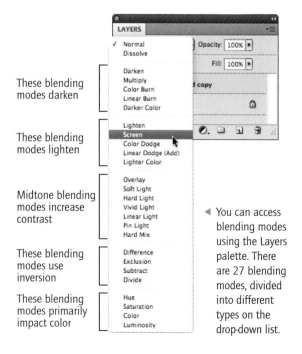

These blending modes darken

These blending modes lighten

Midtone blending modes increase contrast

These blending modes use inversion

These blending modes primarily impact color

◄ You can access blending modes using the Layers palette. There are 27 blending modes, divided into different types on the drop-down list.

The lighting in most background layers can be selectively enhanced if you duplicate the layer and choose a blending mode other than Normal to combine the duplicate with itself. You can see the drop-down list of blending modes that are available from the Layers palette shown to the left.

Note that you don't need to apply the blended layer at full opacity—if you do, it will often lead to effects that are heavy-handed and lack subtlety.

Try applying blending modes to your images to see how they can enhance lighting. Here's how:

▶ Step 1: Open an image in Photoshop that has one layer. In the San Francisco Bay image used here, there is a "Background" layer.

▶ Step 2: Select Layer ▶ Duplicate and name the duplicate layer "Test." The "Test" layer will appear selected above the "Background" layer in the Layers palette.

Click here to open the Blending Mode drop-down list

▶ Step 3: With the "Test" layer selected in the Layers palette, click the blue arrows to the right of the Blending Mode drop-down list to select a blending mode and apply it to the "Test" layer.

▼ Here's the image with the Color Burn blending mode applied to the "Test" Layer with an Opacity setting of 40%.

▲ This is how the image looks when the Linear Light blending mode is applied to the "Test" Layer at an Opacity of 60%.

▶ Four of the blending modes I use most often to adjust lighting in photos are Screen, Multiply, Soft Light, and Vivid Light. The impact of using these four blending modes is shown to the right.

I copied the "Background" layer (bottom right) four times and applied one blending mode to each layer.

When I combine the layers, I rarely do so as "one size fits all"—I use layer masks either with a gradient or selectively painted on to constrain the lighting effect created by the blending mode to specific areas. You can see this in the layer mask thumbnails in the Layers palette below.

Also, notice in the Layers palette that the Opacity of the selected "Vivid Light Blending Mode" layer is set at 15%. Besides selectively painting in the effects that you want using the layer mask, you can reduce the effect using the Opacity of the layer.

In the final version of the image, shown on page 241, there is a great deal of variegation and contrast in the lighting—much of this effect is due to selective and creative use of blending modes.

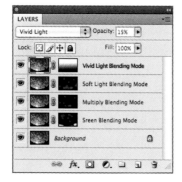

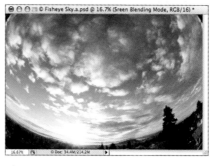

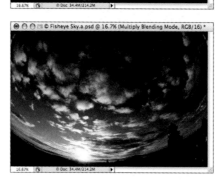

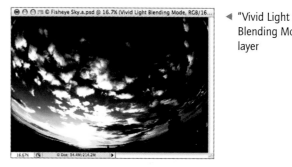

◀ "Vivid Light Blending Mode" layer

◀ "Soft Light Blending Mode" layer

◀ "Multiply Blending Mode" layer

◀ "Screen Blending Mode" layer

◀ "Background" layer

▲ This fisheye view of the open sky of the San Francisco Bay area from near where I live intrigued me with the way the entire sky looks like a giant round marble. In this photo, blending modes came to the rescue, and enhanced the already dramatic lighting effects.

10.5mm digital fisheye, 1/200 of a second at f/10 and ISO 200, hand held

Using the Lighting Effects Filter

▲ I saw a wasp resting motionless on my living room ceiling. Carefully climbing on top of a box on a coffee table, I photographed the insect using a telephoto macro lens.

105mm macro, 1/2 of a second at f/32 and ISO 200, tripod mounted

▼ Step 1: With an image open in Photoshop, duplicate the layer you want to add lighting effects to by selecting the layer in the Layers palette, and then choosing Layer ► Duplicate Layer. For this example, I've named the duplicate layer "Test."

So far, I've shown you ways to change the quality and intensity of light and lighting in your photos in the digital darkroom. It turns out that you can also change the directionality of lighting. Depending upon the image, this is not that difficult to achieve, and can be very desirable—although you do need to bear in mind the context of your photo and not try to create lighting coming from a completely implausible direction.

Consider this photograph of a wasp to the left (the insect, not the stiff-upper-lipped person). Clearly the lighting is pretty general and ambient, although a slight shadow shows some directionality to the lighting (the light is coming from left and below the insect).

It's pretty easy to change the direction of the prevailing lighting in the photo, and to make the direction what you'd like using the Lighting Effects Filter.

If you apply the Lighting Effect to a duplicate layer, there's nothing to stop you from lowering the Opacity setting of the layer to create a more subtle effect. You can also experiment with the impact of using different blending modes, and use more than one lighting effect on top of the background, as I did to add a little lighting drama to the photo of the wasp.

While the Lighting Effects filter is really quite comprehensive, flexible, and powerful, you may notice that it doesn't redraw shadows. In the image of the wasp this doesn't really matter much, as the shadows were not that pronounced to begin with. But in many cases, your final image may look a bit off if you don't also work to correct shadows—and this may require some manual retouching.

▶ Step 2: With the duplicate layer selected, open the Lighting Effects filter by choosing Filter ▶ Render ▶ Lighting Effects.

This filter only works with 8-bit RGB images. So if you are working at a higher bit-depth, you will need to convert the image to 8-bits by choosing Image ▶ Mode ▶ 8 Bits/Channel.

The Lighting Effects dialog box opens with the Default style selected in the Style drop-down list.

▶ Step 3: In the Lighting Effects dialog box, the Preview window shows you what the effect will look like once you click OK.

You can drag the center point to change the light's focal point, and drag the square handles around the edges of the oval to adjust the direction and shape of the lighted area. Use the sliders to adjust the Intensity, Focus, and other light properties. If you create a custom lighting setup that you like, you can save it by clicking the Save button at the top of the dialog box.

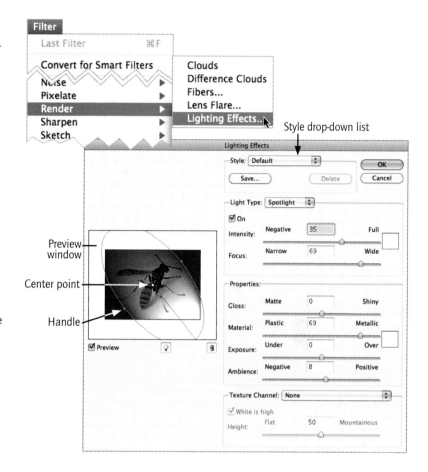

Style drop-down list

Preview window

Center point

Handle

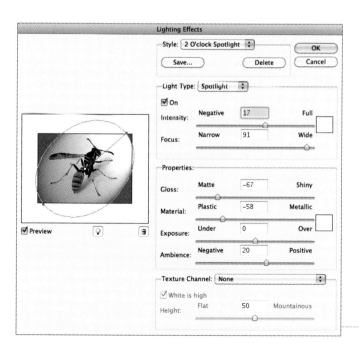

▼ You can quickly add a lighting effect using the Style drop-down list. In this case, I selected 2 O'clock Spotlight and left the lighting settings at their default values. Then I clicked OK to apply the lighting effect.

▶ Here the Lighting Effects dialog shows the default Flashlight Style settings. Notice that the focus of the light is on the wasp's back. To shift the focal point to the wasp's head, drag the center point in the Preview window.

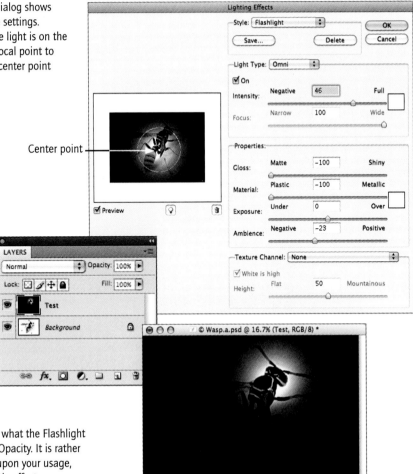

Center point

▶ When you click OK, this is what the Flashlight effect looks like at 100% Opacity. It is rather dramatic, but depending upon your usage, you may want a more subtle effect.

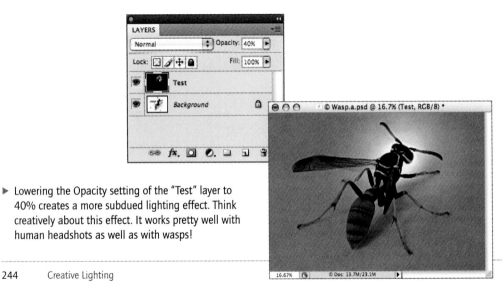

▶ Lowering the Opacity setting of the "Test" layer to 40% creates a more subdued lighting effect. Think creatively about this effect. It works pretty well with human headshots as well as with wasps!

▶ This dialog shows the default Triple Spotlight Style settings applied to the wasp in the Preview window.

While each preset Style is a great place to start, experiment and create your own lighting effects. For instance, the three lights in this Style use light yellow as the color for the lights. You could change that color by clicking the light yellow color square to the right of the Intensity slider and selecting a new color from the Color Picker. The window below shows the effect of three different color lights.

▶ Another way to dramatically change an image is to use a strong colored light. In this case, I selected the Blue Omni Style. I then increased the Intensity and Exposure settings, and decreased the Ambience setting. Play around with the sliders and see what you come up with. There's no "right" or "wrong" here, just do what you like and use your, ahem, artistic judgement.

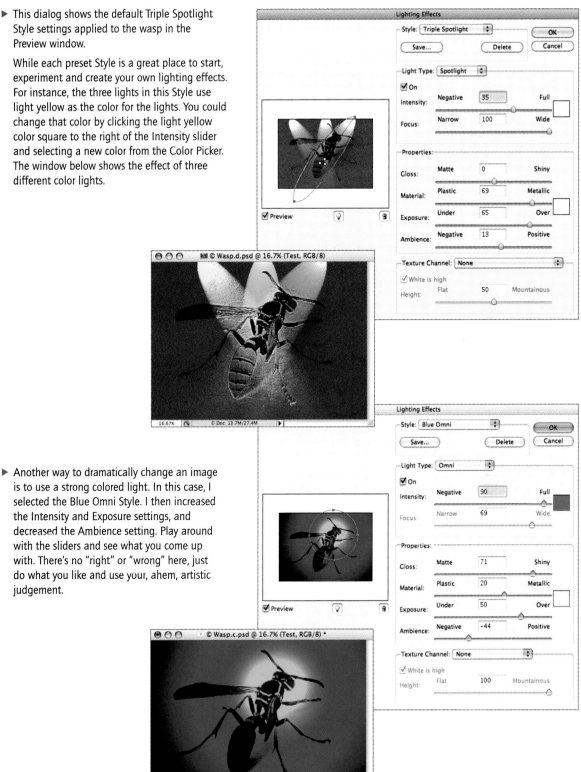

Third-Party Plugins that Enhance Lighting

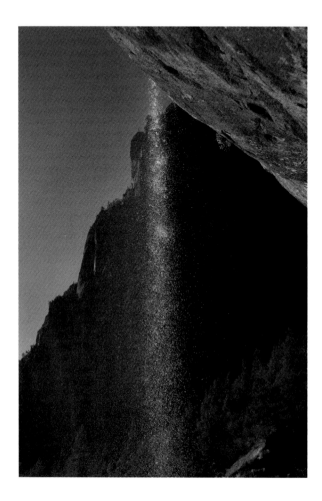

While there are a number of third-party plugins that can be used with Photoshop to enhance lighting in the digital darkroom, Photoshop itself has so many features—and is expensive. So I don't want anyone to think they have to buy third-party Photoshop enhancements—you can spend a lifetime and still not explore all Photoshop has to offer.

That said, many professional photographers and image creators do use third-party tools as part of their post-processing workflow to enhance the tonality and overall appearance of their images. For example, I regularly use some of the filters that are included in the Nik Color Efex Pro, Topaz Adjust, and Topaz Simplify plugins.

While you can sometimes use these filters to enhance the perception of lighting within an image, Mystical Lighting, from Auto FX Software, is a special case because it is specifically designed to create lighting effects that involve the direction and quality of light—and to enhance lighting.

Like the Photoshop Lighting Effects filter, Mystical Lighting only works in 8-bit mode; if you are working at a higher bit-depth you will need to convert to 8-bit (Image ► Mode► 8 Bits/Channel). Also, Mystical Lighting includes effects that can easily be overdone. It's wise to be judicious about how you use this plugin—and also to apply its effects to a duplicate layer so you can take down the opacity if you find the impact is overdone.

▲ From behind a waterfall in Zion National Park, I decided to use a fast shutter speed (1/1250 of a second) to stop the motion of the water. The light on the falling water is dramatic, and presents an opportunity to let Mystical Lighting strut its stuff because the presence of strong lighting is so apparent in the underlying image.

28mm, 1/1250 of a second at f/4 and ISO 100, tripod mounted

Lighting	Shading
Brighten Highlights	Black Shade
Brighten Shadows	Deepen Shadows
Light Beams	Shaders
Light Brush	Shading Brush
Light in the Dark	Shadow Play
Misty Light	
Mood Lighting	**Ambiance**
Radial Light Caster	Ethereal
Rainy Light	Fairy Dust
Snowy Light	Film Grain
Spot Lighting	Flare
Surface Light	Haze and Fog
Warm Sunlight	Lens Flare
White Out	Mist
	Rainbow

▲ The main Mystical Lighting menu gives you a choice of quite a few special lighting effects that you can apply to your photos.

▲ Radial Light Caster creates beams of lights that radiate from a central area you pick.

▼ Rainbow allows you to draw a rainbow in position.

▲ Light in the Dark casts a beam of light in a direction and width you specify.

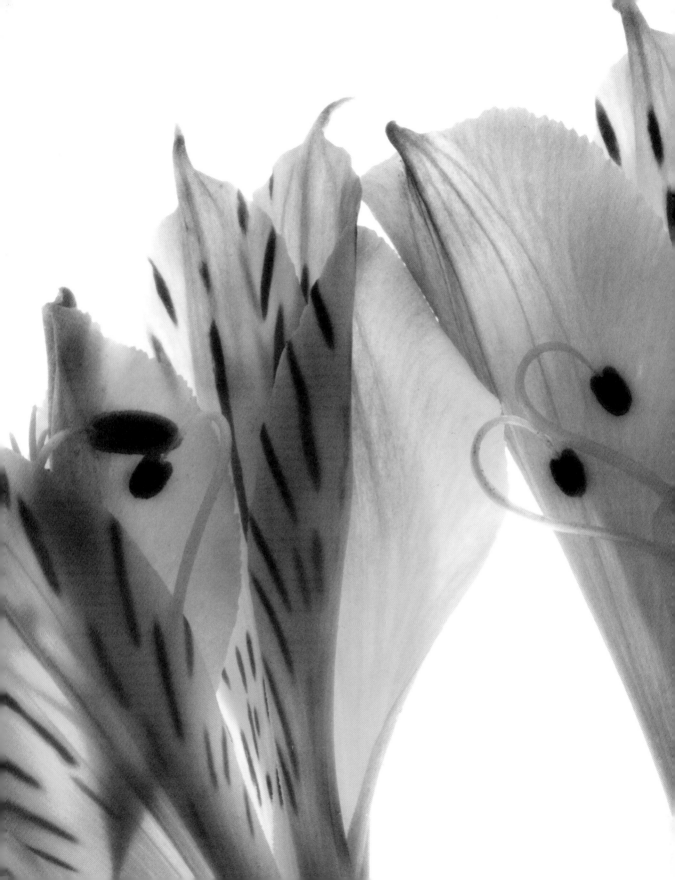

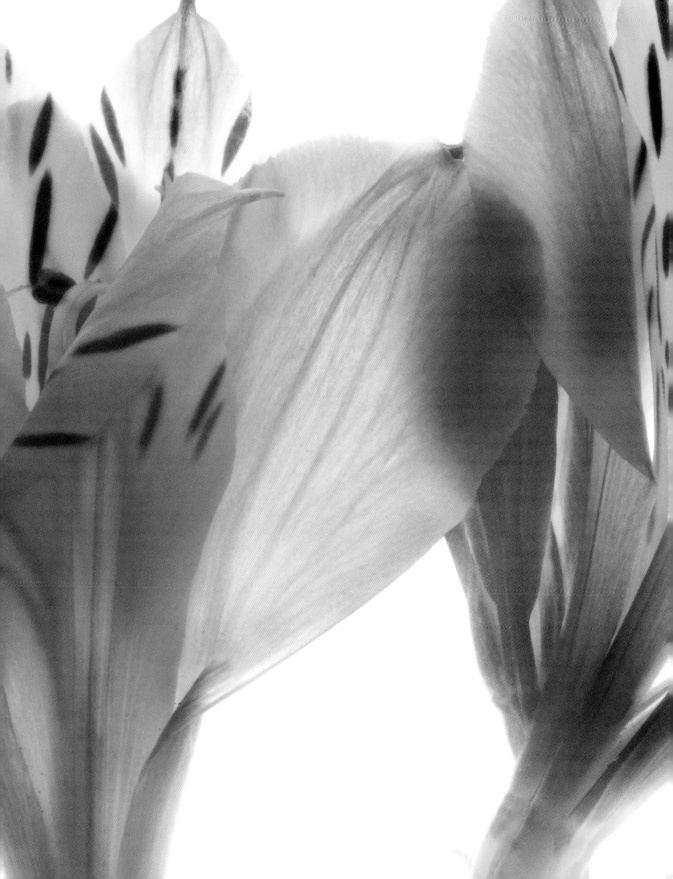

Notes and Resources

Further Reading

If you've enjoyed *Creative Lighting: Digital Photography Tips & Techniques*, I think you might also like some of my other books that cover other aspects of photography:

Creative Landscapes: Digital Tips & Techniques (Wiley, 2011)

Creative Portraits: Digital Tips & Techniques (Wiley, 2010)

Creative Black & White: Digital Tips & Techniques (Wiley, 2010)

Creative Night: Digital Tips & Techniques (Wiley, 2010)

Creative Close-Ups: Digital Tips & Techniques (Wiley, 2010)

Creative Composition: Digital Tips & Techniques (Wiley, 2010)

Practical Artistry: Light & Exposure for Digital Photographers (O'Reilly, 2008)

Please come visit my blog at www.digitalfieldguide.com/blog. You'll find thousands of photos and stories about photography—many of them concerning lighting.

Learning Photoshop

Creative Lighting: Digital Tips & Techniques is not a book about Photoshop—it's a book about learning how to see light, and how to use lighting in your photos. That said, the final part of the book is concerned with optimizing the lighting of your images in the digital darkroom using Photoshop. The emphasis is using RAW conversions and Photoshop adjustments to enhance lighting effects that are already present in photos, taking into account the way viewers are likely to perceive your photos and their lighting.

I've tried to include enough Photoshop information so that you can use the techniques with your own photos.

At the same time, I haven't included information on many basic Photoshop techniques—because there simply wasn't room in this book, and anyhow it is a book about lighting, not Photoshop.

If you need to brush up on Photoshop concepts and techniques, I think you might find one of my books that is specifically about Photoshop helpful. Please check out *The Photoshop Darkroom: Creative Digital Post-Processing* (Focal Press, 2010) and *The Photoshop Darkroom 2: Creative Digital Transformations* (Focal Press, 2011).

Sensor Size and Focal Length

Not all sensors are the same size. The smaller the sensor, the closer a given focal length lens brings you to your subject. For example, if a sensor has half the area of another sensor, then a specific focal length lens will bring you twice as close on a camera with the smaller sensor.

Since different cameras have different sized sensors, it is not possible to have a uniform vocabulary of lens focal lengths. So people compare focal lengths to their 35mm film equivalent by adjusting for the sensor size.

To make the comparison with 35mm film focal lengths, you need to know the

ratio of your sensor to a frame of 35mm film, which is called the *focal-length equivalency.* The photos in this book were created using Nikon DSLRs with a 1.5 times 35mm focal-length equivalency. To find out how the focal lengths I used compare with 35mm focal lengths, multiply my focal lengths by 1.5.

To compute the comparable focal lengths on your own camera if your sensor has a different size than mine, you need to know the focal-length equivalency factor of your sensor. Check your camera manual for this information.

For example, I took the photo of the alstroemerias on pages 248–249 using a 200mm focal length lens with my 1.5X sensor size Nikon DSLR. The 35mm equivalence is therefore 200 x 1.5 = 300mm.

Software

In the "Lighting in the Digital Darkroom" section of this book, I discuss a number of software programs that I use in the digital darkroom for post-processing photos. Here's the software that I mention, along with each publisher's website for more information, or to download trial versions:

Adobe Camera RAW (ACR), Adobe Lightroom, and Adobe Photoshop: www.adobe.com

Auto FX Software, Mystical Lighting 2: www.autofx.com

Nik Software, Color Efex Pro 3.0: www.niksoftware.com

PictureCode, Noise Ninja: www.picturecode.com

Topaz Labs, Adjust 4, Simplify 3: www.topazlabs.com

▲ High contrast in lighting is extremely important to monochromatic imagery—so when I saw sunlight coming through this old oak tree in Sonoma County, California, I immediately thought of black and white.

10.5mm, three combined exposures (at 1/250, 1/125, and 1/60 of a second), each exposure at f/5.6 and ISO 200, tripod mounted

▲ Pages 248–249: I backlit these alstroemerias (also called Peruvian lilies) to enhance the natural transparency of the flowers. I arranged them on a white background so that the separate blossoms almost seemed to be connected, and the white space between the flowers was pleasing to the eye. To find out more about the techniques I used to create this image, see pages 56–59 and 230–231.

200mm macro, 1/3 of a second at f/32 and ISO 100, tripod mounted

Glossary

Ambient light: The available, or existing, light that naturally surrounds a scene.

Aperture: The size of the opening in the iris of a lens. Apertures are designated by f-numbers. The smaller the f-number, the larger the aperture and the more light that hits the sensor.

Barn Doors: Black metal folding doors that attach to a light and are used to control the width of the beam of light.

Beauty Dish: Circular light modifier with an opaque center that softens light, particularly useful in creating attractive portraits.

Bracket: To shoot more than one exposure at different exposure settings.

Chiaroscuro: Moody lighting that shows contrasts between shadows and brightness.

CMYK: Cyan, Magenta, Yellow, and Black; the four-color color model used for most offset printing.

Color space: A color space—sometimes called a color model—is the mechanism used to display the colors we see in the world in print or on a monitor. CMYK, LAB, and RGB are examples of color spaces.

Composite: Multiple images that are combined to create a new composition.

Cucoloris: A wood, plastic, or cardboard sheet with cut-outs that can be placed over a light source to create a patterned effect.

Depth-of-field: The field in front of and behind a subject that is in focus.

Diffraction: Bending of light rays; unwanted diffraction can cause loss of optical sharpness at small apertures.

DSLR: Digital Single Lens Reflex, a camera in which photos are composed through the lens that will be used to take the actual image.

Dynamic range: The difference between the lightest tonal values and the darkest tonal values in a photo.

Ellipsoidal Spot: A spotlight that can vary both the size and focus of the spot, with the focus controlling whether the spot of light has sharp or soft edges.

Exposure: The amount of light hitting the camera sensor. Also the camera settings used to capture this incoming light.

Exposure histogram: A bar graph displayed on a camera or computer that shows the distribution of lights and darks in a photo.

Extension tube: A hollow ring that fits between a lens and the DSLR, used to achieve closer focusing.

f-number, f-stop: The size of the aperture, written f/n, where n is the f-number. The smaller the f-number, the larger the opening in the lens; the larger the f-number, the smaller the opening in the lens.

Fill card: a white or foil-covered card or board used to reflect light back into the shadow areas of a subject.

Focal length: Roughly, the distance from the end of the lens to the sensor. (The relationship of focal length to sensor size is explained on pages 250–251.)

Framing: In a photographic composition, positioning the image in relationship to its edges.

Grayscale: Used to render images in a single color from white to black; in Photoshop a grayscale image has only one channel.

Grid: A very useful light modifier that uses a pattern to create a concentrated spot of light comparable—but more diffuse—to the light created using a snoot.

Hand HDR: The process of creating a HDR (High Dynamic Range) image from multiple

photos at different exposures without using automatic software to combine the photos.

High Dynamic Range (HDR) image: Extending an image's dynamic range by combining more than one capture, either using automated software or by hand.

High key: Brightly lit photos that are predominantly white, often with an intentionally "over exposed" effect.

Hyperfocal distance: The closest distance at which a lens at a given aperture can be focused while keeping objects at infinity in focus.

Image stabilization: Also called vibration reduction, this is a high-tech system in a lens or camera that attempts to compensate for, and reduce, camera motion.

Infinity: The distance from the camera that is far enough away so that any object at that distance or beyond will be in focus when the lens is set to infinity.

Infrared (IR) photography: Captures made using infrared rather than normal, visible light.

ISO: The linear scale used to set sensitivity of a digital sensor.

JPEG: A compressed file format for photos that have been processed from an original RAW image.

Key light: Primary light used with a portrait subject.

LAB: Color model that separates luminance from color information.

Lensbaby: A special purpose lens with a flexible barrel that allows you to adjust the "sweet spot" (area in focus).

Low key: Dimly lit photos that are predominantly black, often with an intentionally "underexposed" effect.

Macro lens: A lens that is specially designed for close focusing; often a macro lens focuses close enough to enable a 1:1 magnification ratio.

Monochrome, monochromatic: A monochromatic image is presented as nominally consisting of tones from white to black; however, "black and white" images can be tinted or toned, and so may vary from straight grayscale.

Multi-RAW processing: Combining two or more different versions of the same RAW file to extend the dynamic range and create a more pleasing final image.

Noise: Static in a digital image that appears as unexpected, and usually unwanted, pixels.

Open up, open wide: To open up a lens, or to set the lens wide open, means to set the aperture to a large opening, denoted with a small f-number.

Photo composite: *See* Composite.

Pre-visualization: Before making an exposure, envisioning how an image will come out after capture and processing.

RAW: A digital RAW file is a complete record of the data captured by the sensor. The details of RAW file formats vary among camera makers.

RGB: Red, Green, and Blue; the three-color color model used for displaying photos on the web and on computer monitors.

Sensitivity: Set using an ISO number; determines the sensitivity of the sensor to light.

Shutter speed: The interval of time that the shutter is open.

Snoot: A tube used as a light modifier to direct a beam of light.

Soft box: A light modifier that diffuses light; in studio lighting, generally a fairly large rectangular unit.

Stop down: To stop down a lens means to set the aperture to a small opening; denoted with a large f-number.

Sweet spot: The area that is in focus when using a Lensbaby.

Toning: In the chemical darkroom, toner such as sepia or selenium was added for visual effect; in the digital darkroom, toning simulates the impact of chemical toning.

Umbrella: A light modifier that can be used to reflect light onto the subject, or light can be directed through an umbrella to create a diffuse lighting source.

Index

▼ Page 256: I was intrigued by these godetia seeds. I used harsh, direct lighting behind the seeds to make the shadows they cast darker and more pronounced.

85mm macro lens, 1 second at f/51 and ISO 100, tripod mounted